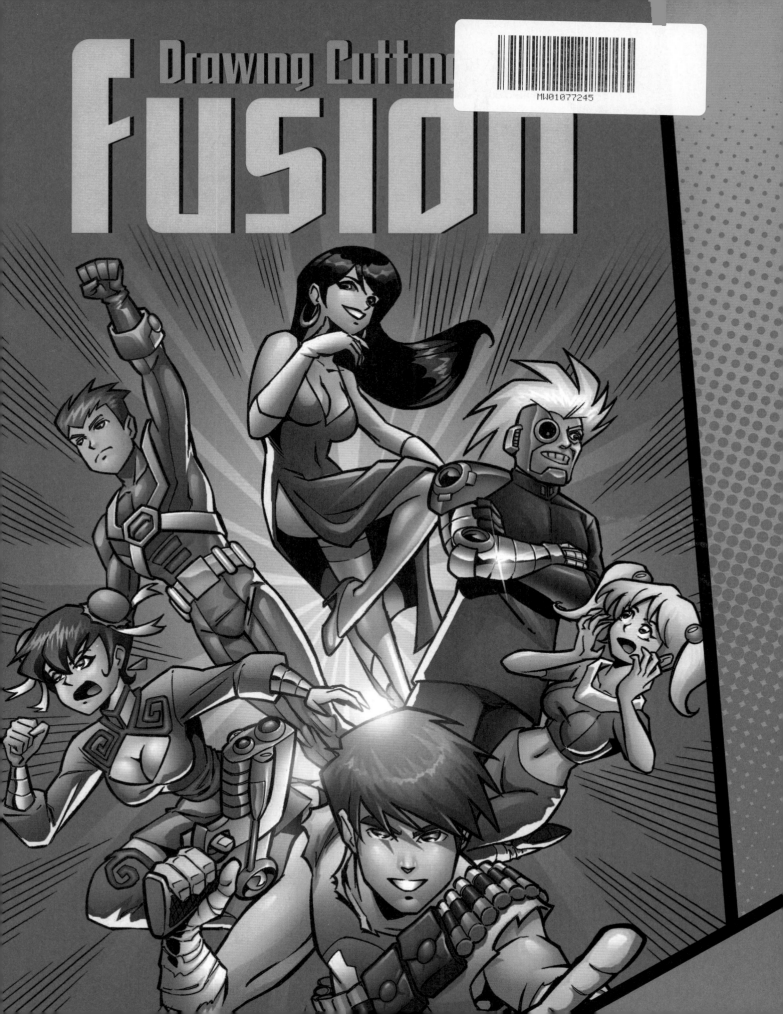

Drawing Cutting Edge
FUSION

Watson-Guptill Publications/New York

AMERICAN COMICS WITH A MANGA INFLUENCE

Christopher HART

SPECIAL THANKS TO:
Everyone at Watson-Guptill.

Executive Editor: Candace Raney
Design and color: MADA Design, Inc.
Front cover design: MADA Design, Inc.
Senior Production Manager: Ellen Greene

Published in 2005 by Watson-Guptill Publications
a division of VNU Business Media, Inc.
770 Broadway
New York, NY 10003
www.wgpub.com

Copyright © 2005 Art Studio LLC

Library of Congress Cataloging-in-Publication Data
Hart, Christopher.
 Drawing cutting edge fusion :
 American comics with a manga influence / Christopher Hart.
 p. cm.
 Includes index.
 ISBN 0-8230-0160-1 (pbk.)
 1. Human beings—Caricatures and cartoons. 2. Action in
 art. 3. Cartooning—Technique. 4. Comic books, strips, etc.—United
 States—Technique. 5. Comic books, strips, etc.—Japan—Technique.
 I. Title.
NC1764.8.H84H38 2005
741.5'973—dc22

 2005014139

Printed in the United States of America

1 2 3 4 5 6 7 8 9 / 13 12 11 10 09 08 07 06 05

CONTRIBUTING ARTISTS:

Jinky Coronado: 48–51
Roger Cruz: 13, 34–41
Chris Hart: 11 (all except left image), 12
 (all except bottom right), 16 (all except
 bottom image), 17 (top right, bottom
 left), 22–33
Fabio Laguna: 116–119, 126–143
Phil Moy: 102–116, 120–125
Khary Randolph: 2–3, 6, 76–85, 88–93
Diogo Saito: 60–61, 63–75
Steven Segovia: 8–9, 11 (left), 12 (bottom
 right), 15, 16 (bottom), 17 (top left,
 bottom right), 18–21, 42–47, 52–59,
 86–87, 94, 95–101

VISIT US AT

www.artstudiollc.com

CONTENTS

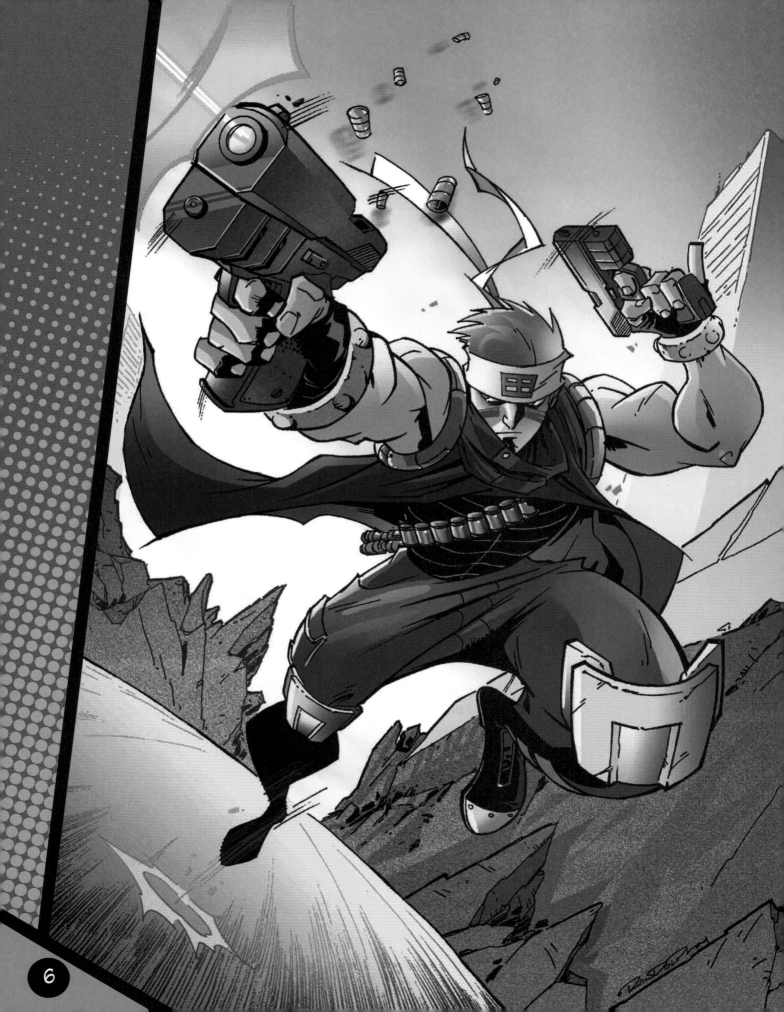

INTRODUCTION

Comic book artists have to stay current to be on top of their game. As new styles emerge and gain popularity, artists either adapt or go the way of the dinosaur. No one who reads comics can be oblivious to the huge impact manga has had on the industry. What started out as a trend has quickly turned into a colossal category that's here to stay.

Artists are quick to capitalize on the next new thing. But rather than attempting to create a clumsy imitation of manga (Japanese comics), American comic book artists have selected the coolest stylistic elements of manga and merged them with the mainstream American style of comics. The result is *Fusion*. It's bold and powerful—just as you'd expect from American comics—but with the elegance and gracefulness of Japanese comics. It's a sleeker, trendier look that focuses on characters with style and charisma rather than on overblown muscles and capes. The major comic book publishing houses, as well as the independents, have been working in this style for a while. Isn't it time you hopped on board?

Many American artists who don't necessarily want to draw manga nevertheless would like to incorporate some of its influence in their work, in order to stay edgy and relevant. No matter what kind of comics you like to draw, *Drawing Cutting Edge Fusion* will enhance your skills because it covers all aspects of comic book art, including: simplified anatomy, the use of the line of action, the creation of effective silhouettes, the staging of fight scenes, foreshortening, costume design, comic book panel design, and more.

This book also focuses on the *cartoon style* of Fusion, a new trend gaining popularity not only in comic books but in television animation, as well (a field in which many comics artists find successful careers as character designers, storyboard artists, and creative producers). This appealing style also belongs in your artistic repertoire.

And, as with all my books, my aim is to give you a complete course in drawing comics, with all the necessary basic, intermediate, and advanced techniques. This book contains many never-before-revealed secrets that the pros use to create amazing comic book images. If you want to draw comics, you can benefit from this book. Comics are an ever-evolving art form, and every artist needs an edge. Fusion can give you that edge.

SLICK CHARACTERS

When American comics meet Japanese manga, the result is a combination of guts and style: Fusion heroes have all the good looks of fashion models and the athletic builds of olympic champions—but without the overpumped pro-wrestler appearance of more traditional comic book characters. Fusion women have the three S's: sleek. sexy, and sultry. Their seductive eyes and fighting spirit make them popular on any comic book page.

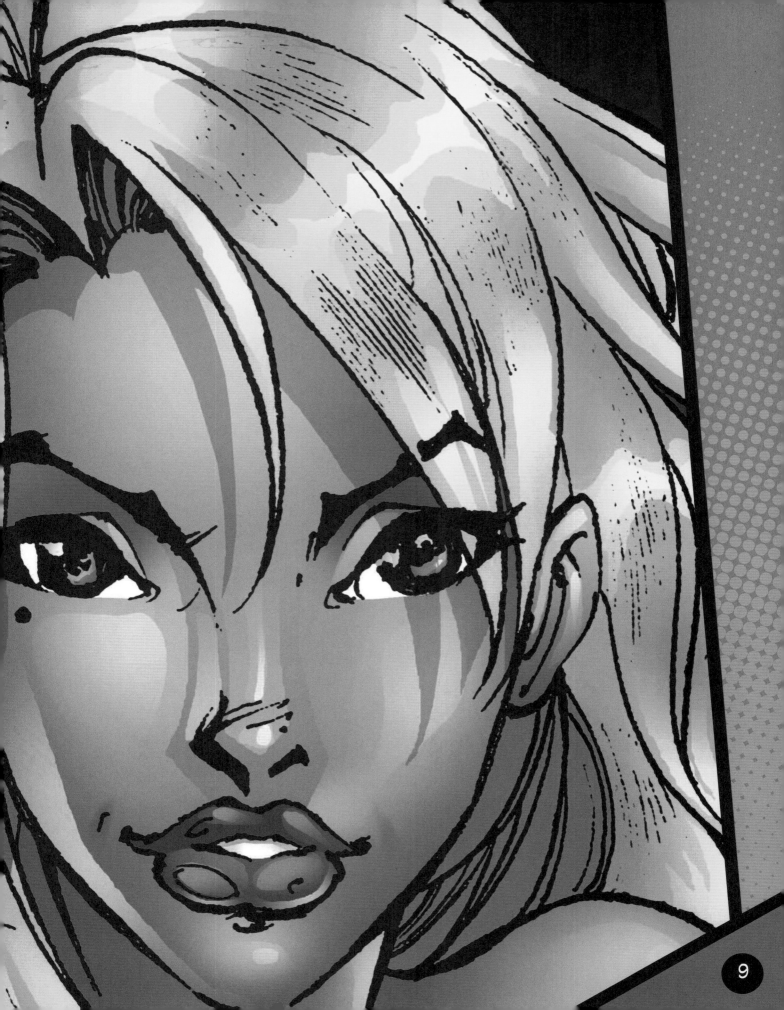

9

Fusion Men

The male face in the new Fusion style is rugged, but with matinee good looks. Unlike the classical American-style hero, the manga-influenced Fusion man does not have a square jaw or a huge neck that starts at his ears. The look is intense, yet refined—a perfect blend of power and style.

The pronounced cheekbones, combined with a narrow jawline, create the sleek look of the face. The lines delineating the cheekbones don't travel to the edges of the mouth, as they do in traditional comics, but to the bottom of the chin. The chin is small, which creates the desired narrow jawline.

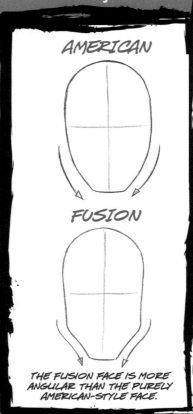

AMERICAN

FUSION

THE FUSION FACE IS MORE ANGULAR THAN THE PURELY AMERICAN-STYLE FACE.

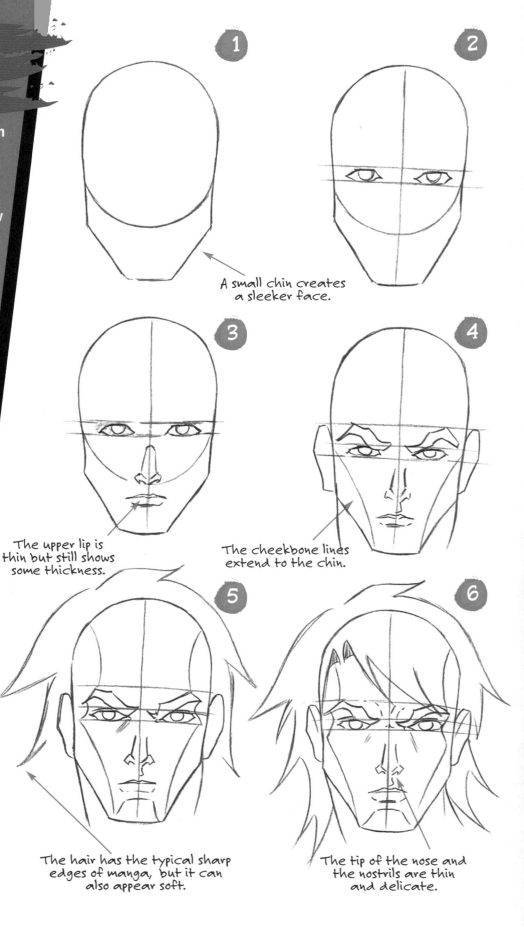

A small chin creates a sleeker face.

The upper lip is thin but still shows some thickness.

The cheekbone lines extend to the chin.

The hair has the typical sharp edges of manga, but it can also appear soft.

The tip of the nose and the nostrils are thin and delicate.

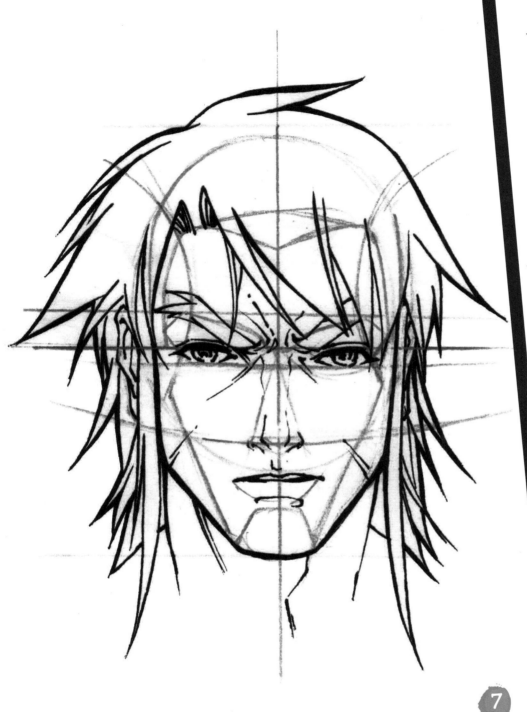

THE OUTLINES OF BOTH THE HEAD AND HAIR ARE DRAWN WITH A THICK LINE, BUT LIGHT, GRACEFUL LINES ARE USED FOR THE FACIAL FEATURES.

7

THE SECTIONS OF THE NOSE

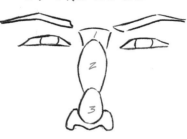

THE NOSE HAS THREE MAIN SECTIONS:

1 SINUS AREA (YOU KNOW, WHERE YOU GET THE HEADACHES)

2 BRIDGE (UPPER HALF IS BONE, LOWER HALF IS CARTILAGE)

3 TIP AND NOSTRILS (ALL CARTILAGE)

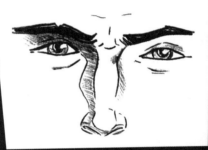

THE LOWER LIP

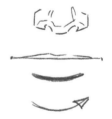

AMERICAN COMICS: THE CENTER OF THE LOWER LIP CURVES DOWN. THE RESULT: A HEAVY LOWER LIP.

FUSION: THE CENTER OF THE LOWER LIP CURVES UP. THE RESULT: A THINNER LIP.

11

3/4 View

When the head turns to a 3/4 view, the sharp jawline emphasizes the sleek look.

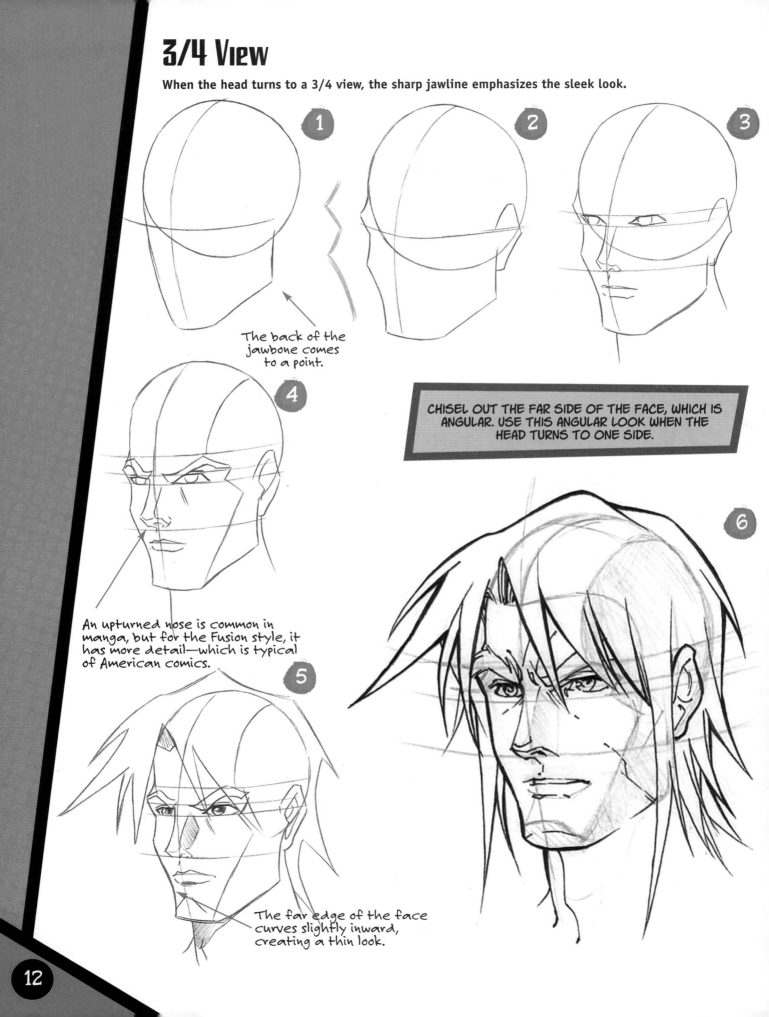

The back of the jawbone comes to a point.

CHISEL OUT THE FAR SIDE OF THE FACE, WHICH IS ANGULAR. USE THIS ANGULAR LOOK WHEN THE HEAD TURNS TO ONE SIDE.

An upturned nose is common in manga, but for the Fusion style, it has more detail—which is typical of American comics.

The far edge of the face curves slightly inward, creating a thin look.

Fusion

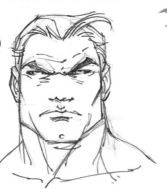

Minimal facial crease lines (unless strong emotion is expressed)

Elegant eyes

Angular jaw

Subtle chin

Traditional

Here's a practice page with some cool head poses. Notice the angularity of the jaw—but with the subtle chin—and the almost elegant eyes, which typify the Fusion style. Although this is obviously a formidable character, he is not your typical heavy-brow/square-chin hero, which is, well, boring. This guy straddles the fence between being a good guy and a bad guy, which makes him dangerous. And that ain't boring. (For more on different head angles, see pages 18–19.)

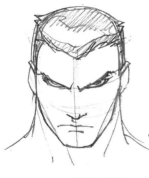

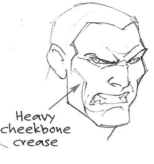

Heavy cheekbone crease

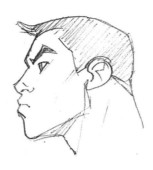

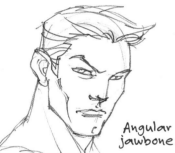

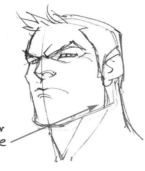

Angular jawbone

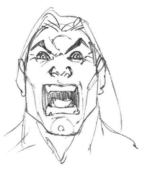

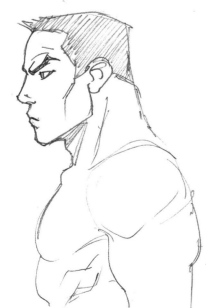

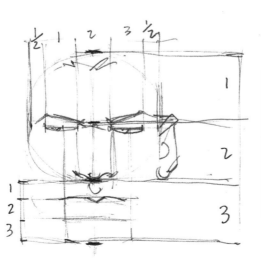

The head can be divided into roughly equal thirds from top to bottom. The jaw, which takes up the lowest third, is itself subdivided into thirds here to aid in the placement of the mouth, which falls on the upper subdivision line. The space bewtween the eyes is equal to the width of the nose at the outer sides of the nostrils, and each eye is also about this same width.

Fusion Females

Female Fusion eyes are large, with several shines in them, which is typical of manga. Heavy lines echo eyeliner to heighten femininity. The face is still sleek, with high cheekbones, but it's not boney or angular like the male Fusion face. Unlike true manga, the Fusion-style female has "turbo-lips" that look as though they were visited by the Collagen Fairy. But who can complain?

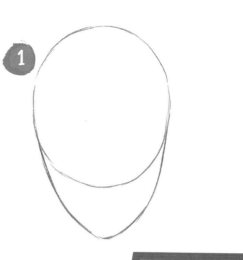

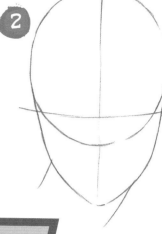

THE HEAD IS AN UPSIDE-DOWN EGG SHAPE.

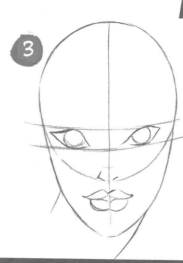

When drawing beautiful women, focus primarily on their eyes.

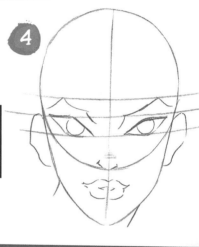

THE EYES TILT UP AT THE OUTER ENDS, WITH THE UPPER EYELIDS RESTING ON THE EYEBALLS FOR A SIMMERING LOOK.

THE EYEBROWS ARE NOT SMOOTH, ARCHING LINES BUT ARE IRREGULAR.

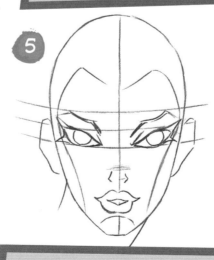

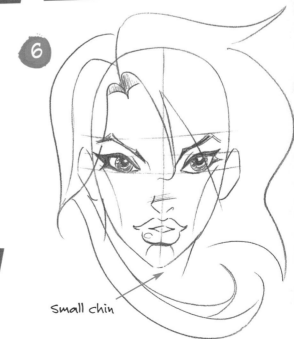

THE UPPER LIP IS WIDER THAN THE BOTTOM ONE. THE LOWER LINE OF THE BOTTOM LIP SHOWS A SUBTLE UPWARD INDENT IN THE MIDDLE.

Small chin

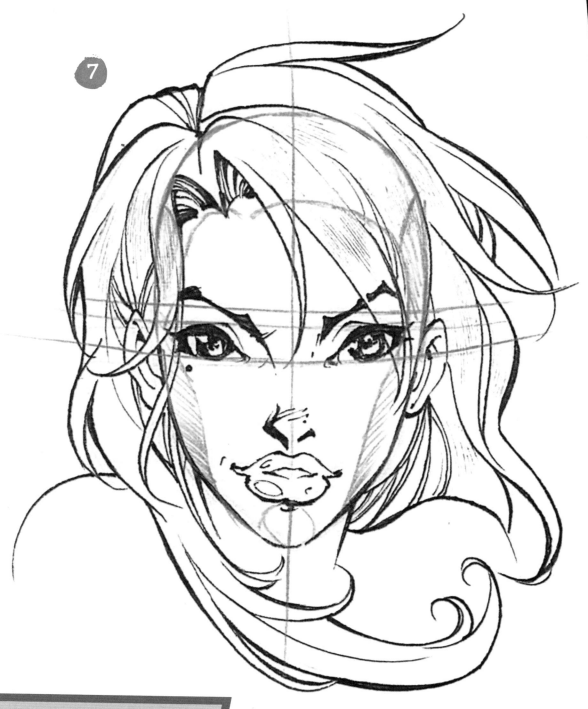

BORROWING FROM MANGA, THE HAIR HAS POINTY FLAIRS YET APPEARS SOFT AND FLOWING.

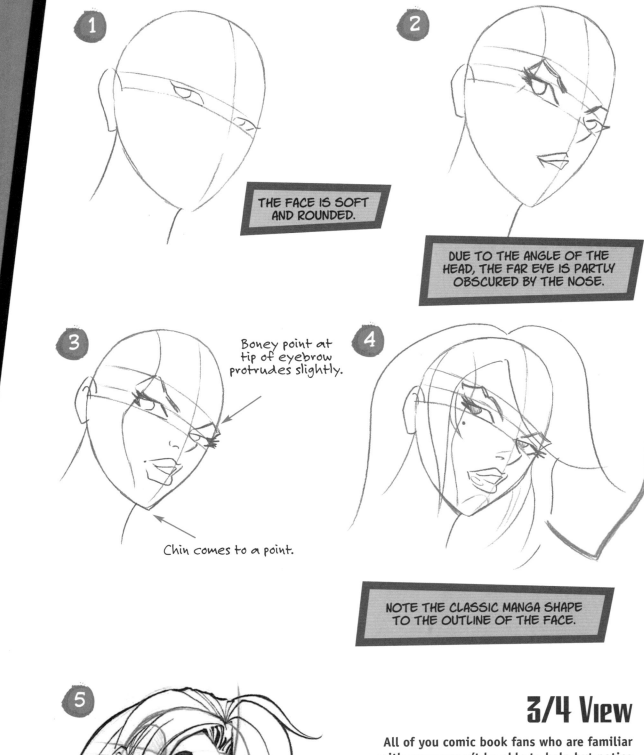

1

THE FACE IS SOFT AND ROUNDED.

2

DUE TO THE ANGLE OF THE HEAD, THE FAR EYE IS PARTLY OBSCURED BY THE NOSE.

3

Boney point at tip of eyebrow protrudes slightly.

Chin comes to a point.

4

NOTE THE CLASSIC MANGA SHAPE TO THE OUTLINE OF THE FACE.

5

3/4 View

All of you comic book fans who are familiar with manga won't be able to help but notice the manga influence in this pose. The face is soft and round, and the chin comes to a sleek point—that's so manga! The nose is small and upturned—again, the manga influence. And strands of hair fall in front of the ears. What is that, class? Manga influence!

Over-the-Shoulder Glance

Very appealing on female characters, the shoulder up/chin down pose is playfully seductive.

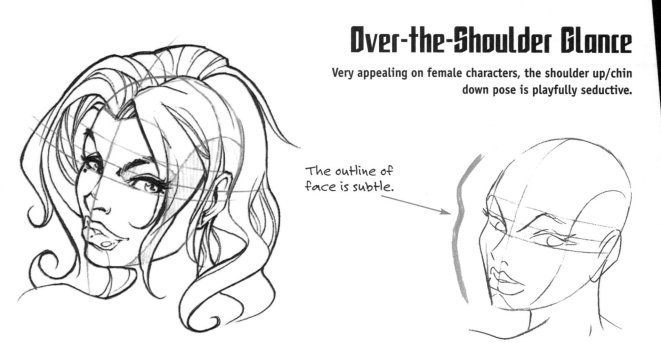

The outline of face is subtle.

Back of the Head: The Classic "Dialogue Pose"

Here's an essential pose for drawing two characters having a conversation. This is the position for the listening figure. You rarely see beginners using this pose, although they should. And it's relatively easy to draw.

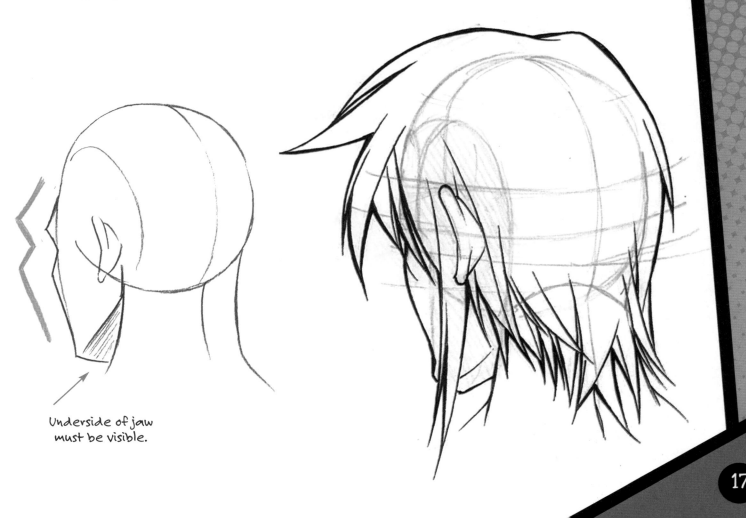

Underside of jaw must be visible.

"Up" and "Down" Angles

Hey, you're going to need these, too. You always see these poses in comics, because they're so dramatic. Yet, for some reason, most books on drawing comics leave them out. Maybe they think you won't notice. But you will when you need to draw one. What to look for: As the head tilts up, the nose and eyes appear to get closer together. As the head tilts down, the nose and the mouth appear to get closer together.

Extreme "Up" Angle

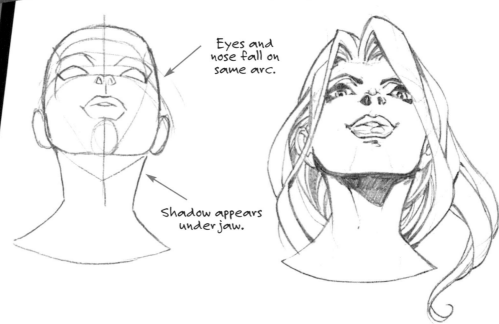

Eyes and nose fall on same arc.

Shadow appears under jaw.

Slight "Up" Angle

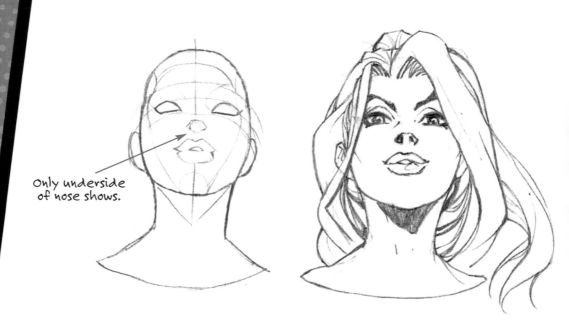

Only underside of nose shows.

Neutral Angle

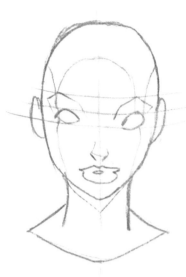
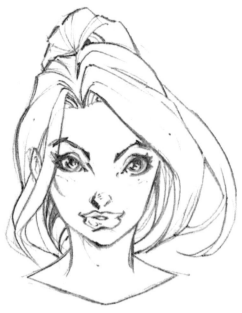

Slight " Down" Angle

Nose and lips
are closer
together.

Only top of
nose shows.

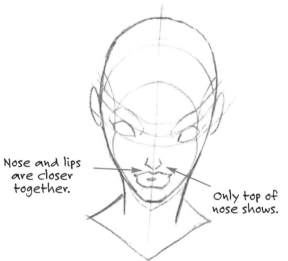
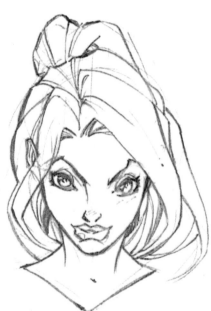

Extreme "Down" Angle

Tip of nose
partially
overlaps
upper lip.

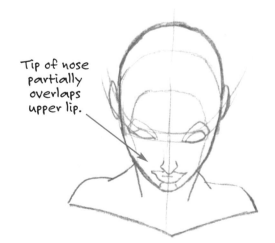
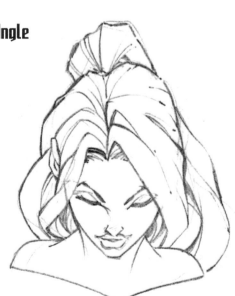

On today's standard American comic book heroes, every single muscle is gargantuan. Every inch of the body is ripped with articulated strands of sinew and popping veins. Hey, don't get me wrong—I'm a big fan of standard comics. But the Fusion comic book hero has a stylish, honed look that's not so in-your-face.

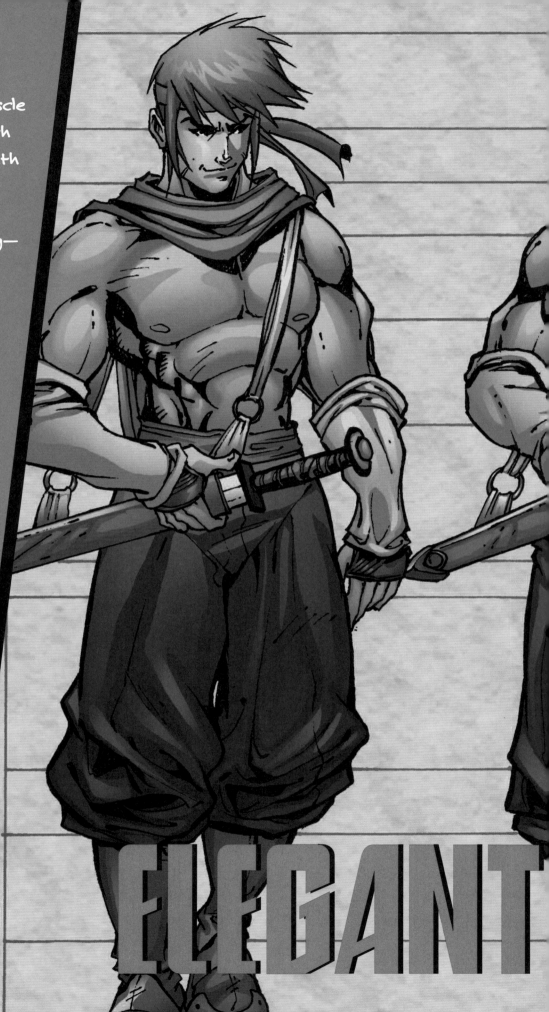

ELEGANT

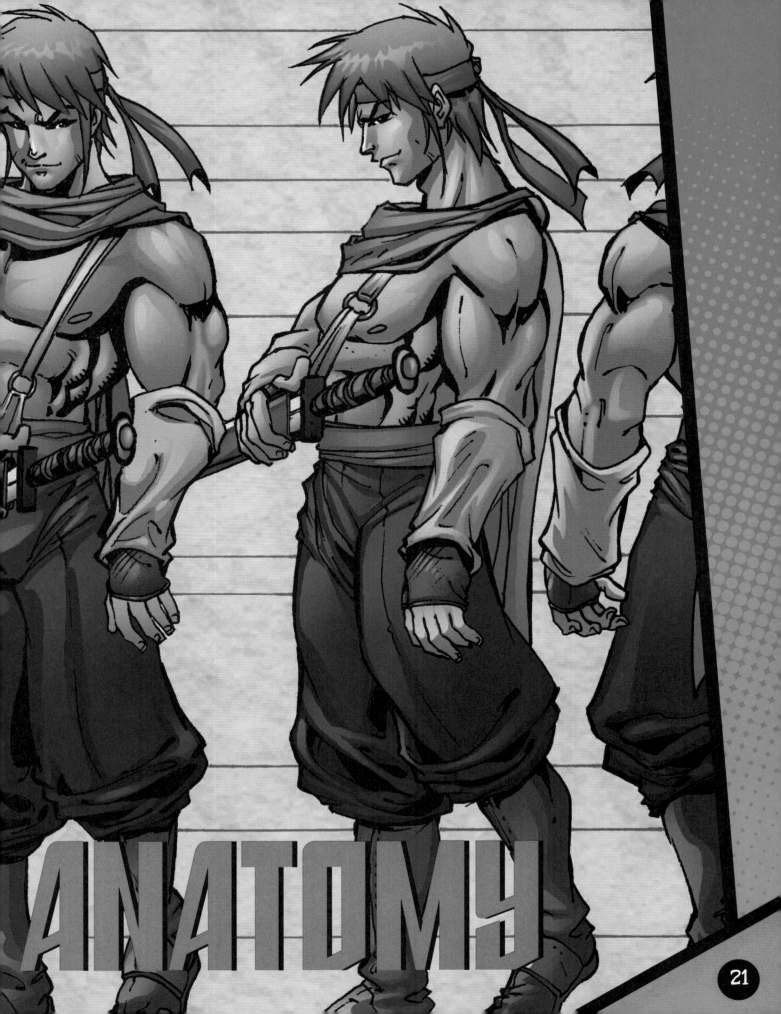

ANATOMY

21

Fusion Muscles: The Men

Male Fusion characters are muscular but are not of the bone-crushing-brute variety. Think of intermediate bodybuilders—before they add those last twenty pounds of muscle that make them gross.

Focus on the major and secondary muscles. But ignore the small muscles that hyperdefine a character. For example, on many standard comic book heroes, the forearms show six or seven clearly defined muscles. On a Fusion character, this would be overkill and would make the character too bulky. Remember: The prime operating word here is sleek!

Simplified Foundation

This basic foundation has all you need to draw the heroic, male figure. Once you have this in place, you can decide how much muscular definition to add.

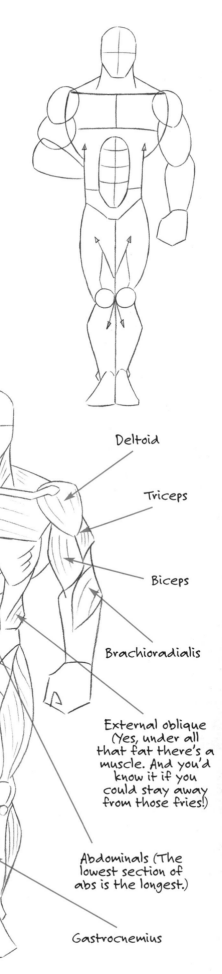

Sternocleidomastoideus (Wow, what a mouthful!)

Trapezius

Pectoralis major

Serratus anterior (These are the muscles covering the rib cage. You have to be very muscular for these to show.)

Pectineus

Vastus externus

Rectus femoris

Vastus internus

Peroneus longus

Deltoid

Triceps

Biceps

Brachioradialis

External oblique (Yes, under all that fat there's a muscle. And you'd know it if you could stay away from those fries!)

Abdominals (The lowest section of abs is the longest.)

Gastrocnemius

Major Comic Book Muscles

Many aspiring artists give up on anatomy, because it seems so complex. And it seems so complex because too many books focus on each muscle with equal emphasis. Listen up: You don't have to know every single one of the over five hundred muscles in the body to have a working familiarity with anatomy. These are the major comic book muscles. These, you need to know—but you don't need to memorize the Latin names. I've listed them just in case you're interested.

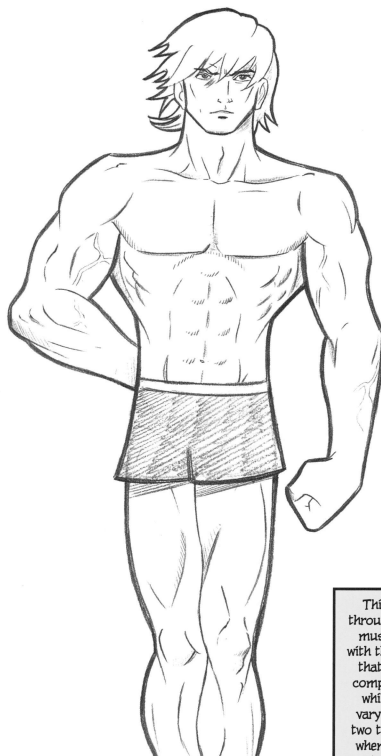

This chart shows how the muscles appear through the skin. And, it's the most important muscle chart because we usually see people with their skin on. If you look closely, you'll see that some of the muscles have softened as compared to the figure on the opposite page, while others remain just as articulated. By varying the intensity of the muscles, you do two things: (1) You give the eye places to rest when every inch of the body is not busy with stressed muscles, and (2) you add visual pacing, varying the look rather than having a one-note representation.

Muscles in Profile

Beginners and even more experienced artists often make a common mistake when drawing the body in the side view: They don't bulk up and define the muscles. It's important to keep the musculature evident, otherwise the character will look oddly flat.

The dotted line represents the curve of the back, hidden by the arm.

This area produces the major, defining curve of the outer thigh.

Giant calf muscles are typical in comic book characters.

The end of the leg bone (fibia) has a natural bulge that creates the ankle.

Major Comic Book Muscles

The deltoid has three parts:
A the outer head,
B the middle head, and
C the inner head.
This is useful, because if you want to add extra definition, you can delineate those three sections.

Sternocleidomastoideus

Pectoralis Major

Serratus Anterior

Deltoid

Triceps

Brachialis

Biceps

Brachioradialis

Abdominals

External Oblique

Ulna
(A bone, not a muscle, the ulna protrudes at the wrist and creates the natural bulge where the arm bones connect to the elbow.)

Vastus Lateralis

Biceps Femoris

Rectus Femoris

Fibula
(A bone, not a muscle, the fibula bulges at its top end, creating a little knob on the outside of the knee.)

Gastrocnemius

Peroneus Longus

Muscles from the Back

The back is extremely wide at the top, and the muscles curve around the shoulder blades, causing them to bunch up in the upper part, near the spine.

Simplified Foundation

Latissimus dorsi (or "lats")

Shoulder blades

Outer leg curves outward.

Line of inner leg is straight.

Calf muscle is high on leg.

Outer ankle bone is lower than inner one.

Basic Comic Book Muscles

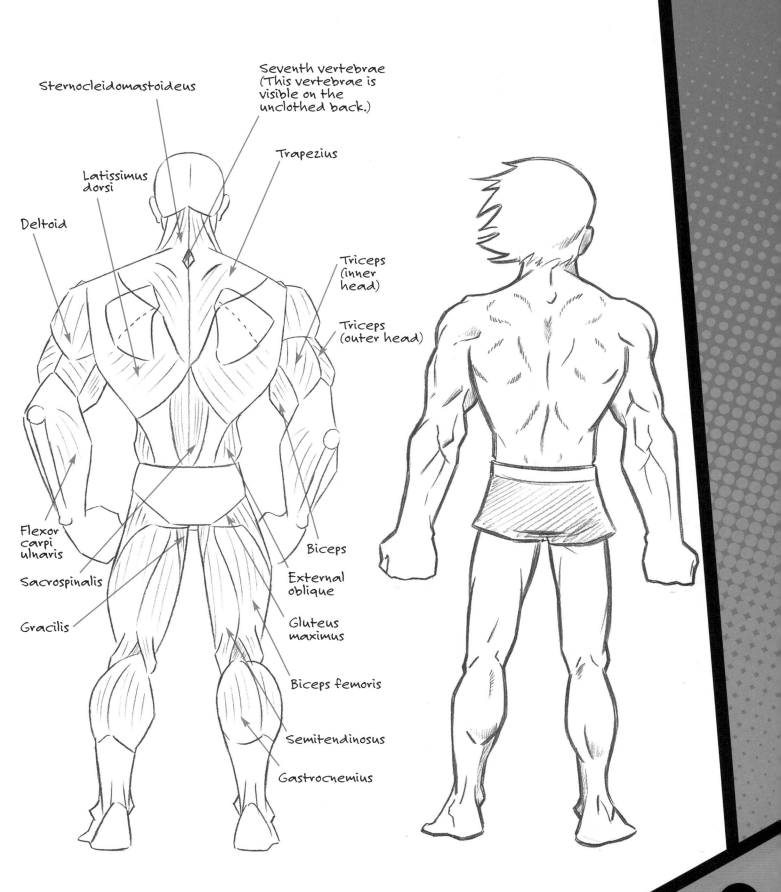

Sternocleidomastoideus

Seventh vertebrae
(This vertebrae is
visible on the
unclothed back.)

Latissimus
dorsi

Trapezius

Deltoid

Triceps
(inner
head)

Triceps
(outer head)

Flexor
carpi
ulnaris

Biceps

Sacrospinalis

External
oblique

Gracilis

Gluteus
maximus

Biceps femoris

Semitendinosus

Gastrocnemius

Fusion Muscles: The Women

When drawing the female figure, concentrate on the overall shape of the body instead of on breaking down each individual muscle group. Don't make her muscles overly defined. Draw pleasing lines that flow smoothly into one another. These flowing lines typically curve around one part of the body, and continue as they curve in the other direction.

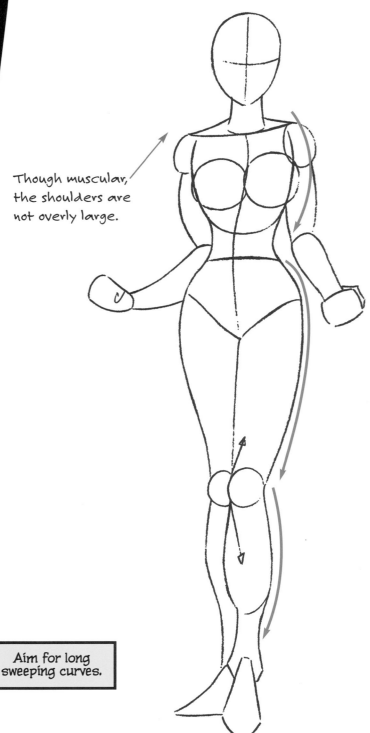

Though muscular, the shoulders are not overly large.

Aim for long sweeping curves.

Basic Comic Book Muscles

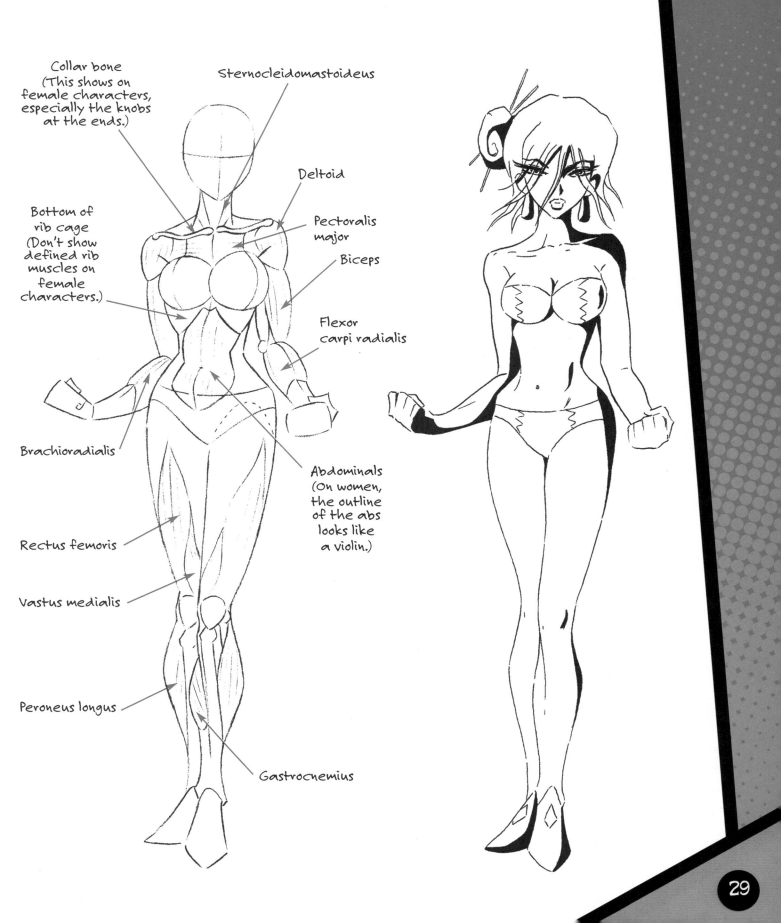

Collar bone
(This shows on
female characters,
especially the knobs
at the ends.)

Sternocleidomastoideus

Deltoid

Bottom of
rib cage
(Don't show
defined rib
muscles on
female
characters.)

Pectoralis
major

Biceps

Flexor
carpi radialis

Brachioradialis

Abdominals
(On women,
the outline
of the abs
looks like
a violin.)

Rectus femoris

Vastus medialis

Peroneus longus

Gastrocnemius

Female Muscles in Profile

Simplified Foundation

Go for long lines instead of bunched, defined muscles. The hip/glute area requires significant mass. So do the thighs. Don't make her too thin.

The curve in the small of the back is exaggerated.

The rib cage tilts up on women.

The hips tilt down on women.

Basic Comic Book Muscles

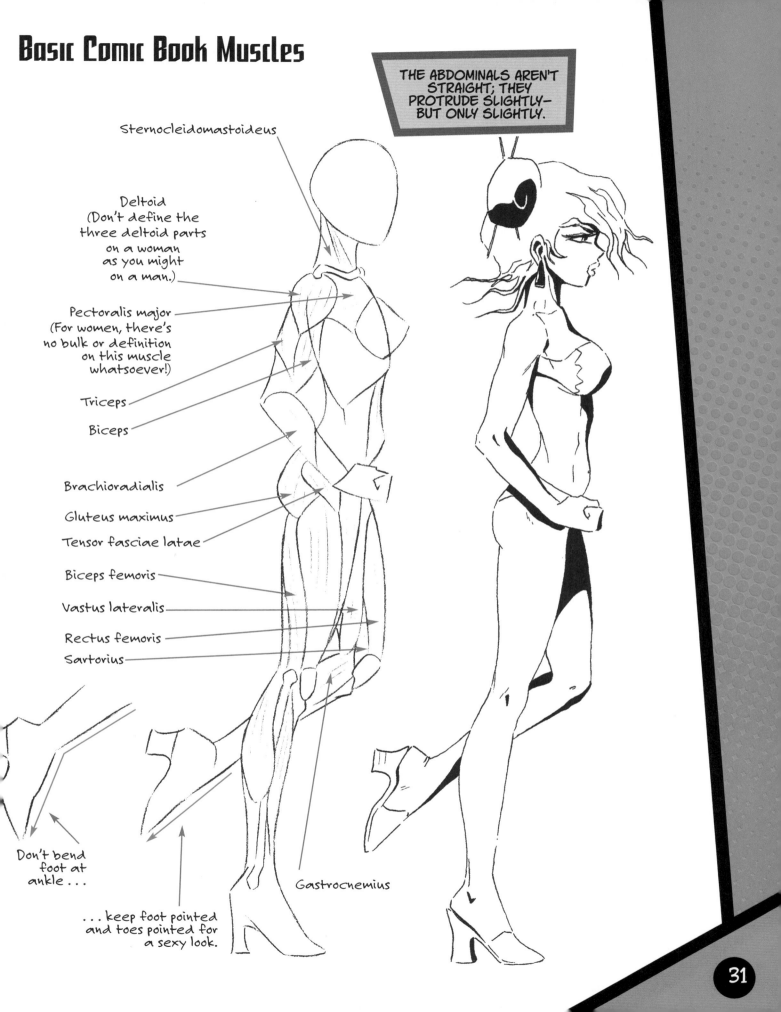

THE ABDOMINALS AREN'T STRAIGHT; THEY PROTRUDE SLIGHTLY— BUT ONLY SLIGHTLY.

Sternocleidomastoideus

Deltoid
(Don't define the three deltoid parts on a woman as you might on a man.)

Pectoralis major
(For women, there's no bulk or definition on this muscle whatsoever!)

Triceps

Biceps

Brachioradialis

Gluteus maximus

Tensor fasciae latae

Biceps femoris

Vastus lateralis

Rectus femoris

Sartorius

Don't bend foot at ankle . . .

. . . keep foot pointed and toes pointed for a sexy look.

Gastrocnemius

Female Muscles from the Back

Note the lack of muscular definition on the back. The shoulder blades are the prominent feature, along with the line of the spine.

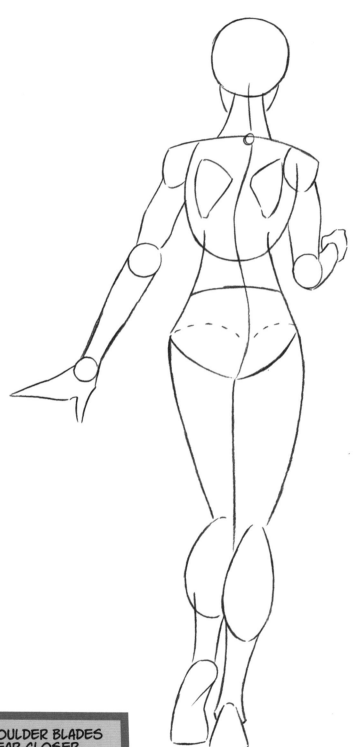

THE SHOULDER BLADES APPEAR CLOSER TOGETHER ON WOMEN THAN THEY DO ON MEN.

Basic Comicbook Muscles

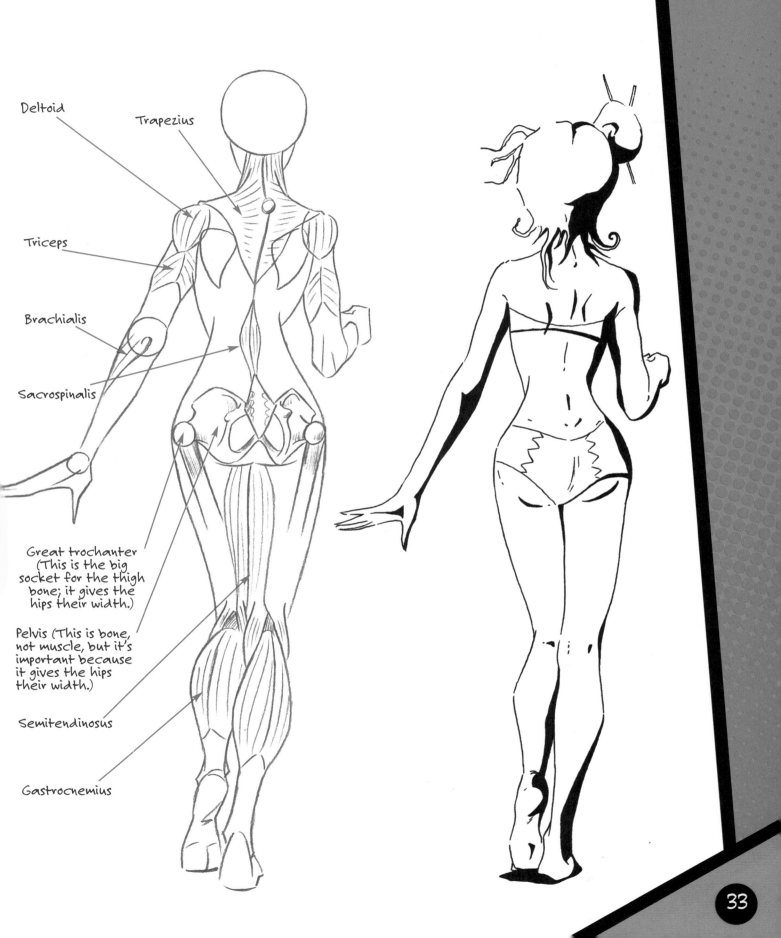

Deltoid

Trapezius

Triceps

Brachialis

Sacrospinalis

Great trochanter
(This is the big
socket for the thigh
bone; it gives the
hips their width.)

Pelvis (This is bone,
not muscle, but it's
important because
it gives the hips
their width.)

Semitendinosus

Gastrocnemius

The Concepts In Use

These sketches put all this anatomy stuff together.

Brachioradialis

Flexor carpi radialis

THE FIST IS DRAWN ALONG TWO ARCS...

...ONE ALONG THE TOP KNUCKLES...

...AND ONE ALONG THE BOTTOM KNUCKLES.

Basic contour of interior leg line

Triceps relaxed

Triceps flexed

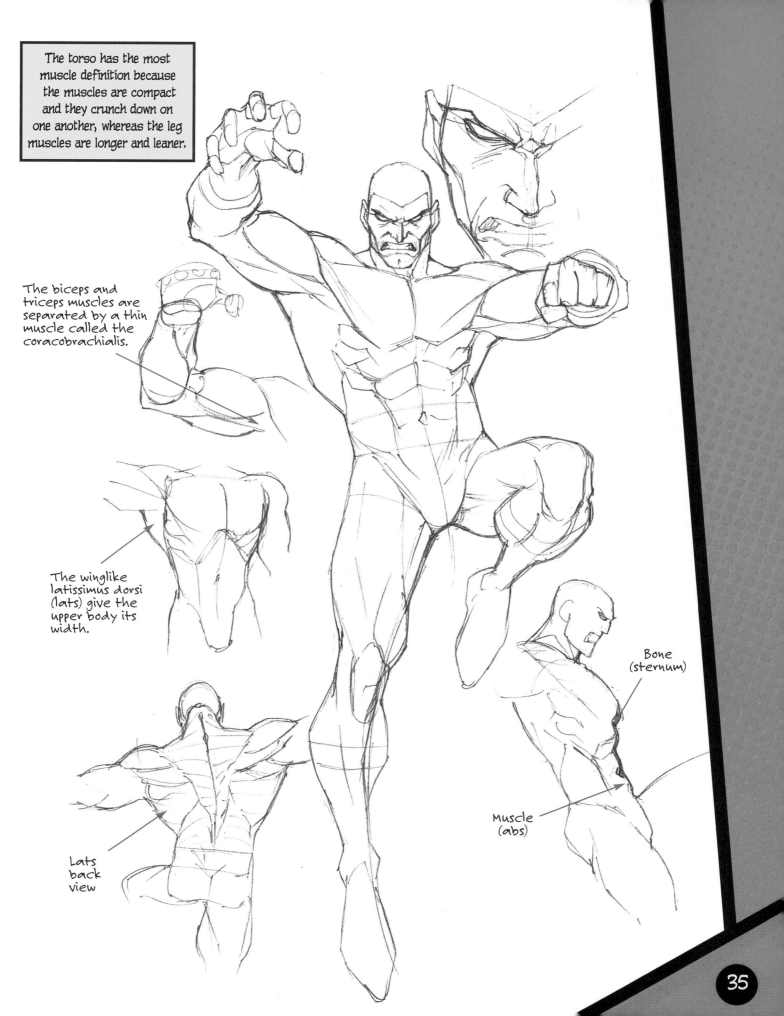

The torso has the most muscle definition because the muscles are compact and they crunch down on one another, whereas the leg muscles are longer and leaner.

The biceps and triceps muscles are separated by a thin muscle called the coracobrachialis.

The winglike latissimus dorsi (lats) give the upper body its width.

Lats back view

Bone (sternum)

Muscle (abs)

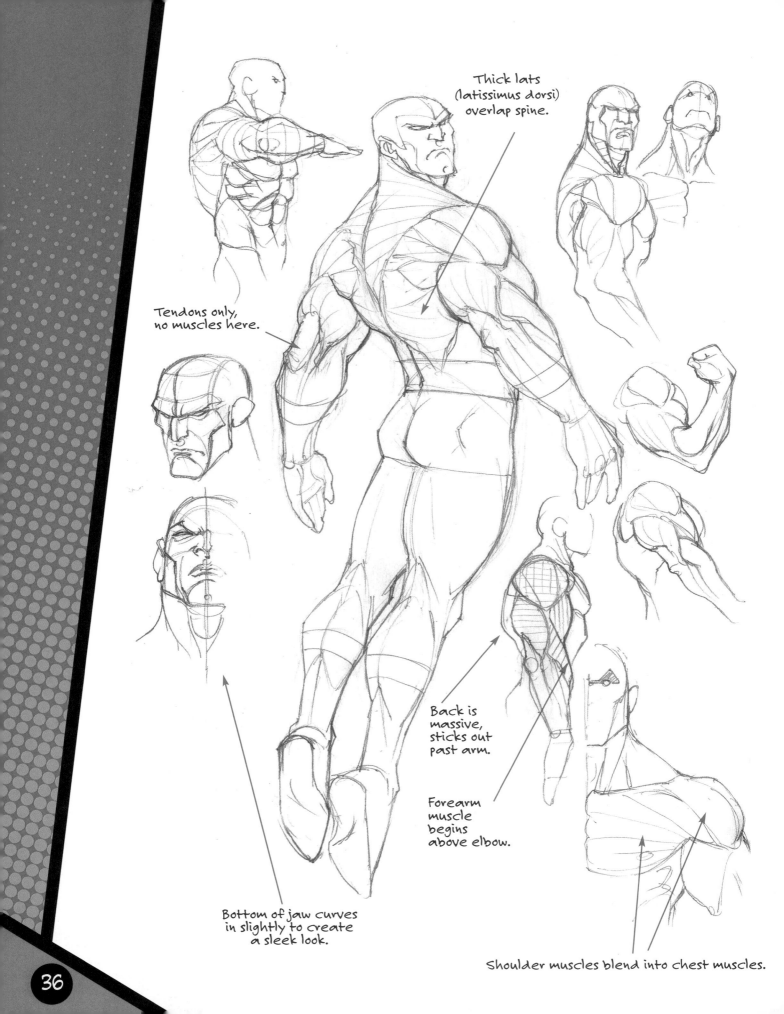

Thick lats
(latissimus dorsi)
overlap spine.

Tendons only,
no muscles here.

Back is
massive,
sticks out
past arm.

Forearm
muscle
begins
above elbow.

Bottom of jaw curves
in slightly to create
a sleek look.

Shoulder muscles blend into chest muscles.

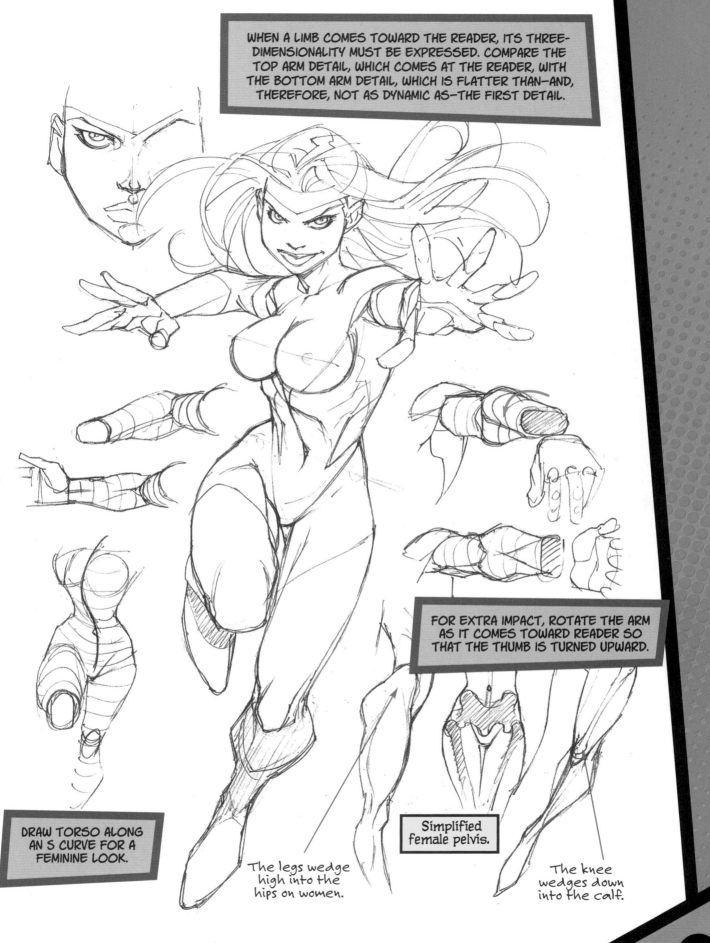

WHEN A LIMB COMES TOWARD THE READER, ITS THREE-DIMENSIONALITY MUST BE EXPRESSED. COMPARE THE TOP ARM DETAIL, WHICH COMES AT THE READER, WITH THE BOTTOM ARM DETAIL, WHICH IS FLATTER THAN—AND, THEREFORE, NOT AS DYNAMIC AS—THE FIRST DETAIL.

FOR EXTRA IMPACT, ROTATE THE ARM AS IT COMES TOWARD READER SO THAT THE THUMB IS TURNED UPWARD.

DRAW TORSO ALONG AN S CURVE FOR A FEMININE LOOK.

The legs wedge high into the hips on women.

Simplified female pelvis.

The knee wedges down into the calf.

37

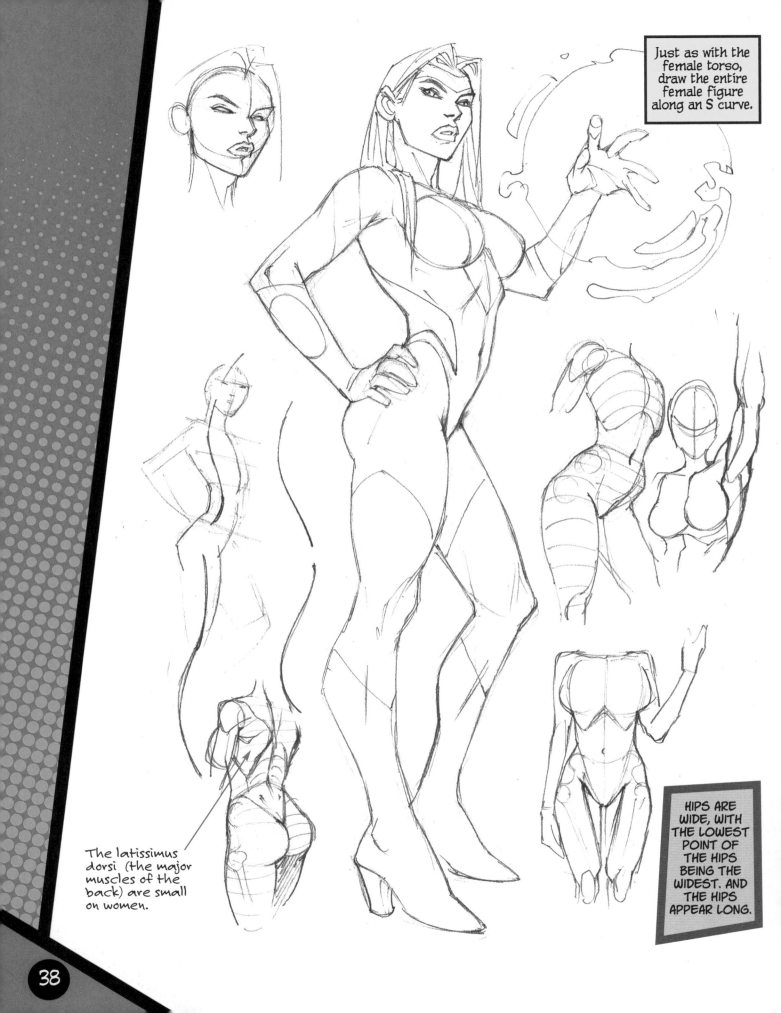

Just as with the female torso, draw the entire female figure along an S curve.

The latissimus dorsi (the major muscles of the back) are small on women.

HIPS ARE WIDE, WITH THE LOWEST POINT OF THE HIPS BEING THE WIDEST. AND THE HIPS APPEAR LONG.

Regular

Nice but bland.

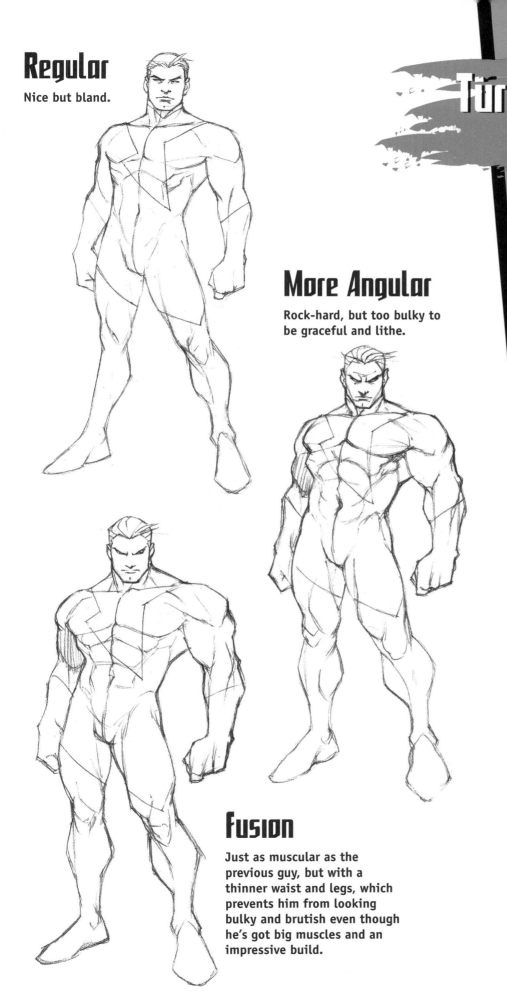

More Angular

Rock-hard, but too bulky to be graceful and lithe.

Fusion

Just as muscular as the previous guy, but with a thinner waist and legs, which prevents him from looking bulky and brutish even though he's got big muscles and an impressive build.

Turning Standard into Fusion

The pose is the same. The character type is the same. But subtle differences make the one on the bottom Fusion.

Standard vs. Fusion Hero

The Fusion hero has an elegant angularity to the outline of his muscles. This results in a heightened feeling of intensity.

Standard

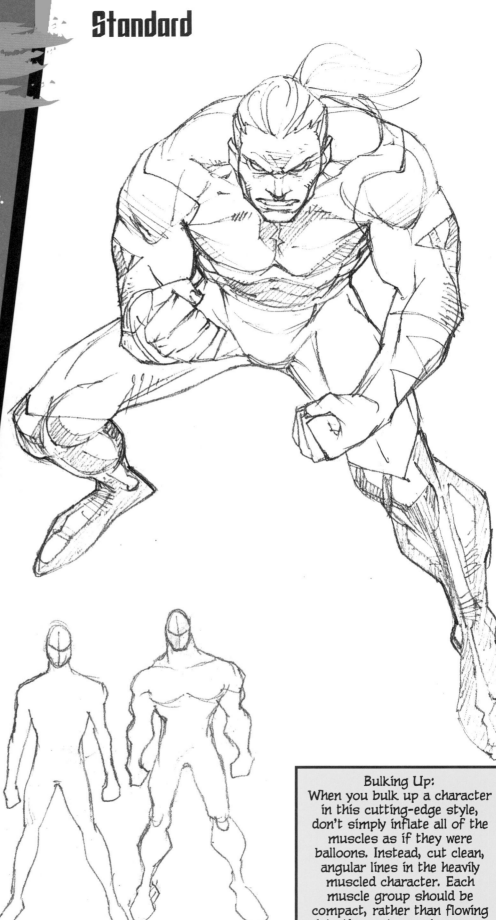

Bulking Up:
When you bulk up a character in this cutting-edge style, don't simply inflate all of the muscles as if they were balloons. Instead, cut clean, angular lines in the heavily muscled character. Each muscle group should be compact, rather than flowing into the next muscle group.

FUSION

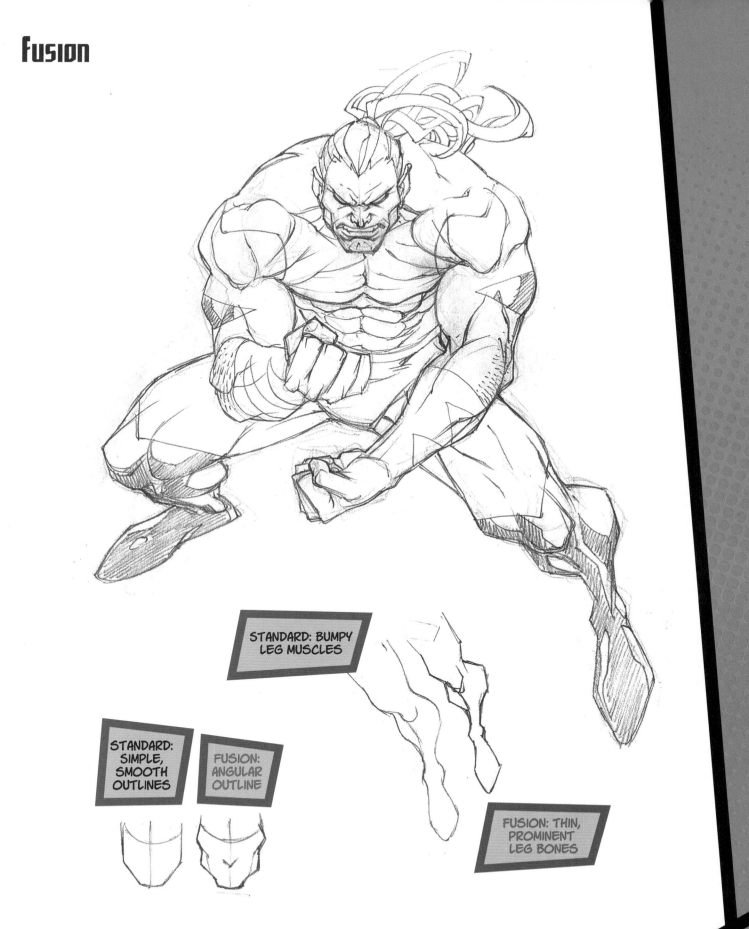

STANDARD: BUMPY LEG MUSCLES

STANDARD: SIMPLE, SMOOTH OUTLINES

FUSION: ANGULAR OUTLINE

FUSION: THIN, PROMINENT LEG BONES

Drawing the Body from all Angles

My advice for the serious aspiring comic book artist is to take a character and practice turning it in different angles. Remember, in comics, the same characters are repeated many times, in many different poses.

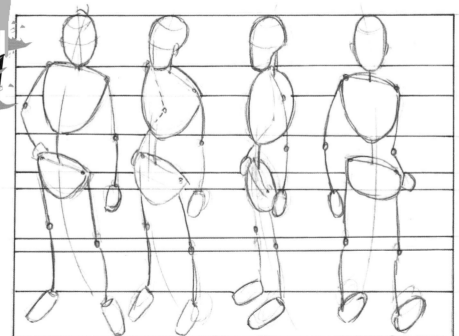

USING BASIC MANNEQUIN-STYLE FIGURES IS A GREAT WAY TO BLOCK OUT A POSE AND A DRAWING. IT HELPS YOU GET THE POSE CORRECT AT AN EARLY STAGE, BEFORE DOING ANY ERASING WOULD MEAN HEARTACHE (OH, HOW WELL I KNOW THAT!). IT ALSO ENABLES YOU TO QUICKLY TURN OUT MANY POSES BEFORE SETTLING ON THE FINAL ONE.

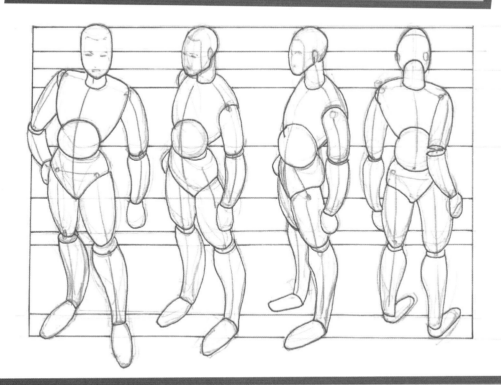

THE VERTICAL LINES SKETCHED DOWN THE MIDDLE OF THE TORSO, ARMS, AND LEGS ACT AS A HELPFUL GUIDE TO KEEP THE LIMBS AND TORSO IN ALIGNMENT. THE MANNEQUIN BODIES ARE BUILT OUT OF INDIVIDUAL PARTS STACKED TOGETHER, AND THERE'S ALWAYS THE DANGER THAT, WHEN FITTING TOGETHER A JUMBLE OF PIECES, THE OVERALL FLOW OF THE POSE COULD BE LOST. A CENTRAL VERTICAL LINE ACTS LIKE A THROUGH-LINE, KEEPING EVERYTHING IN PLACE.

Front 3/4 Side Rear

MALE POSTURE, ESPECIALLY ON A CHARACTER SUCH AS THIS—A SECRET SERVICE AGENT—IS USUALLY QUITE UPRIGHT.

Measure a character's
height from the heel,
not the toes.

Jaw

Sternum

Bottom
of pelvis
is the
halfway
point of
the body

Knee

Ankle

Front **3/4** **Side** **Rear**

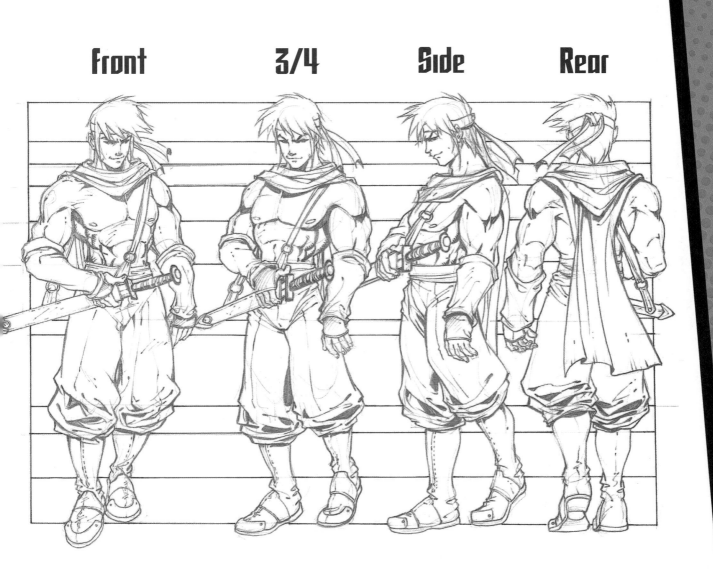

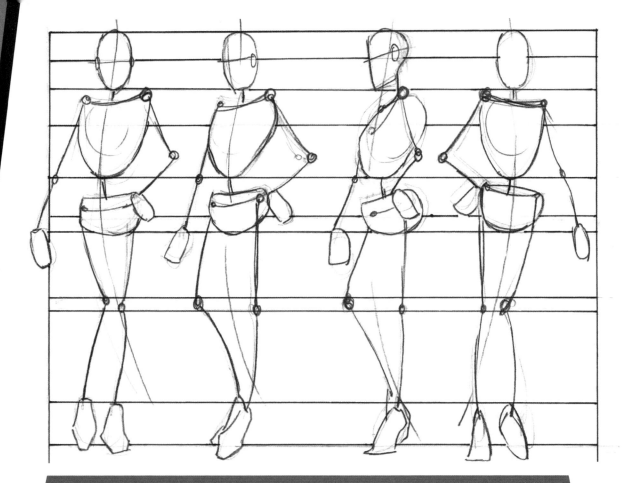

THE TRICK TO KEEPING THE LOOK OF THE BODY CONSISTENT HERE IS TO KEEP THE SLINKY POSTURE IN EACH ANGLE, WITH HIPS TILTING DOWNWARD AND THE CHEST PUSHING UPWARD TO GET A PRONOUNCED OVERALL CURVE TO THE POSTURE.

RAISED SHOULDERS CREATE A SEXY LOOK.

HIPS ARE FAIRLY WIDE.

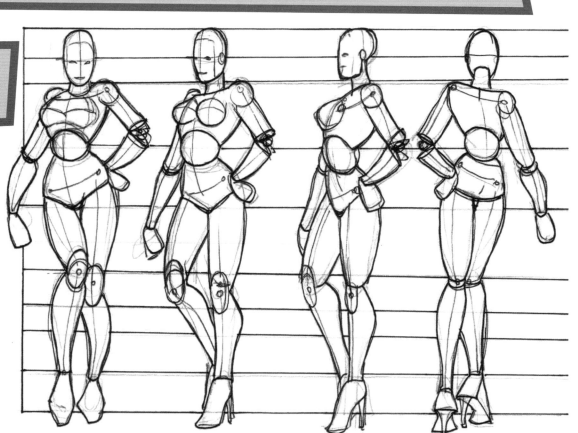

Front **3/4** **Side** **Rear**

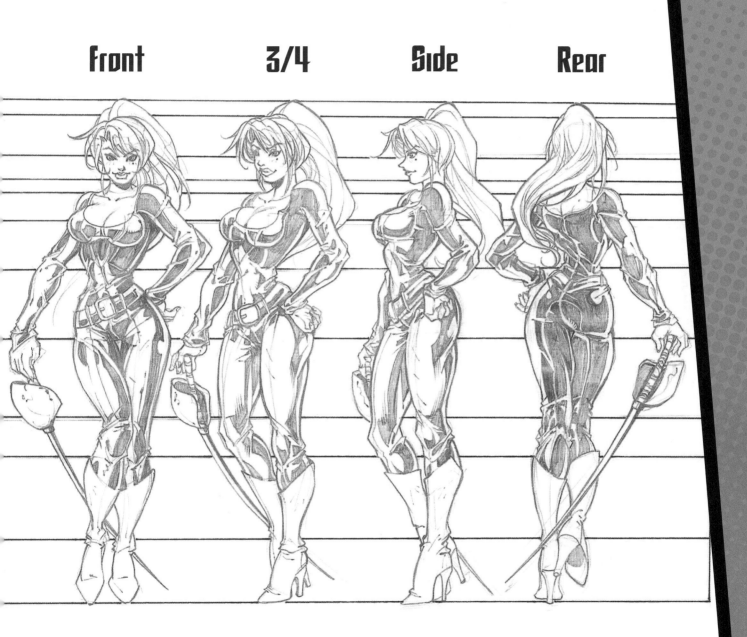

Finessing the Fusion Female Form

You'll notice that in traditional American comics, the women fighters are devastatingly sexy. So are the female villains. However, the "regular" female characters (the ones in supporting roles) are often drawn blandly. These characters appear throughout comics, and they're boring.

But, a new crop of artists is incorporating the Fusion style to make these "everyday" characters as attractive as any over-the-top spandex-clad fighter. While all comics exaggerate women's proportions, manga, on the other hand, caricatures feminine attitude, which manifests itself in almost cutesy poses that, when combined with killer good looks, is a winning combo.

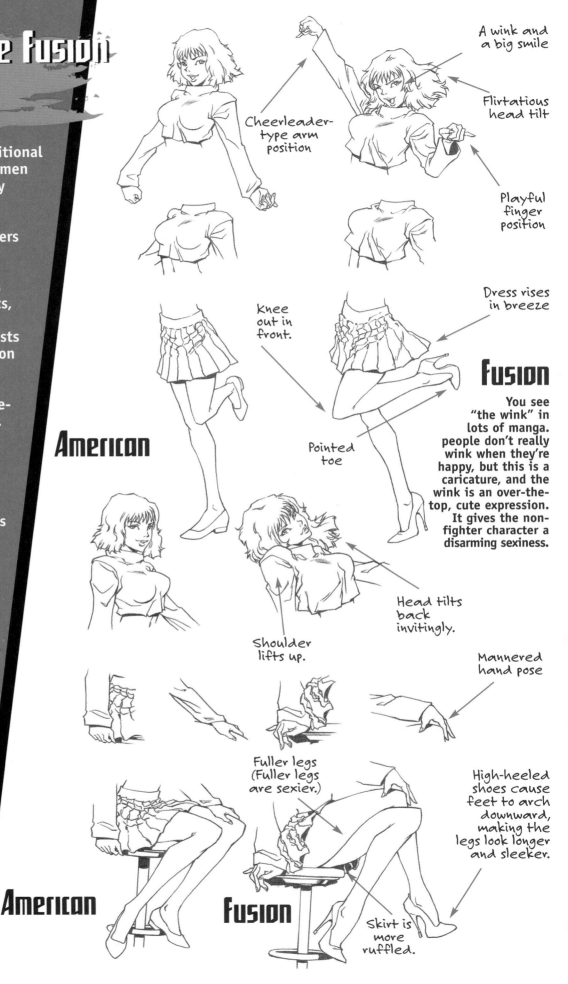

Cheerleader-type arm position

A wink and a big smile

Flirtatious head tilt

Playful finger position

Knee out in front.

Dress rises in breeze

Pointed toe

American

Fusion

You see "the wink" in lots of manga. people don't really wink when they're happy, but this is a caricature, and the wink is an over-the-top, cute expression. It gives the non-fighter character a disarming sexiness.

Shoulder lifts up.

Head tilts back invitingly.

Mannered hand pose

Fuller legs (Fuller legs are sexier.)

High-heeled shoes cause feet to arch downward, making the legs look longer and sleeker.

American

Fusion

Skirt is more ruffled.

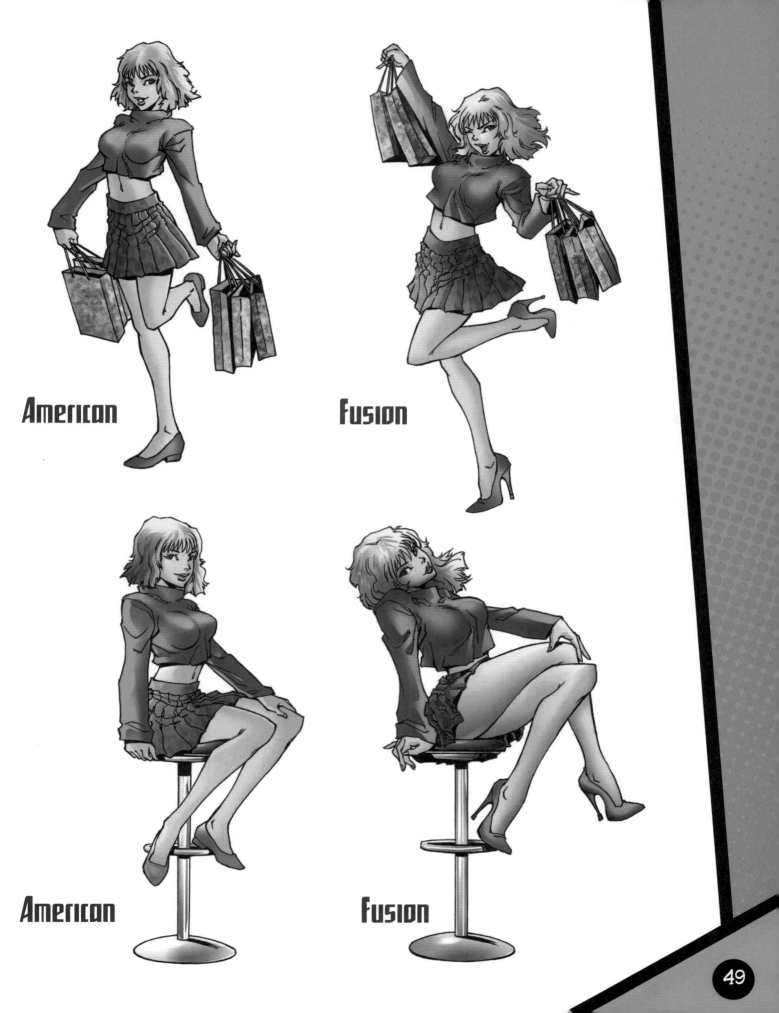

American

Fusion

American

Fusion

49

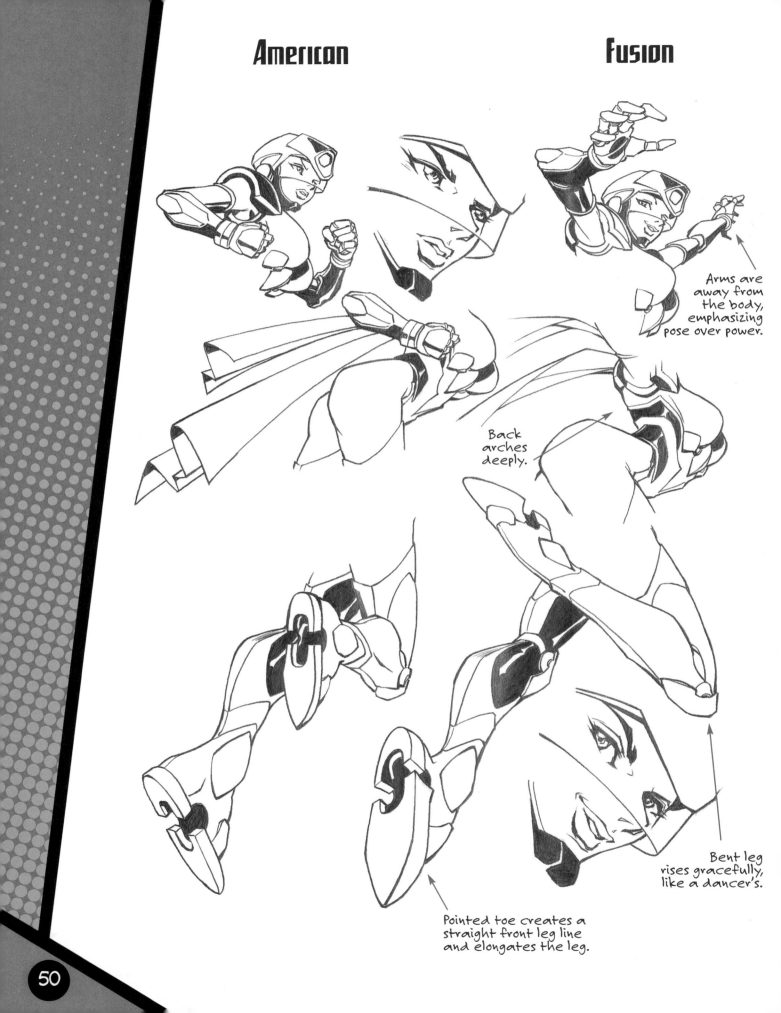

American

Fusion

Arms are away from the body, emphasizing pose over power.

Back arches deeply.

Bent leg rises gracefully, like a dancer's.

Pointed toe creates a straight front leg line and elongates the leg.

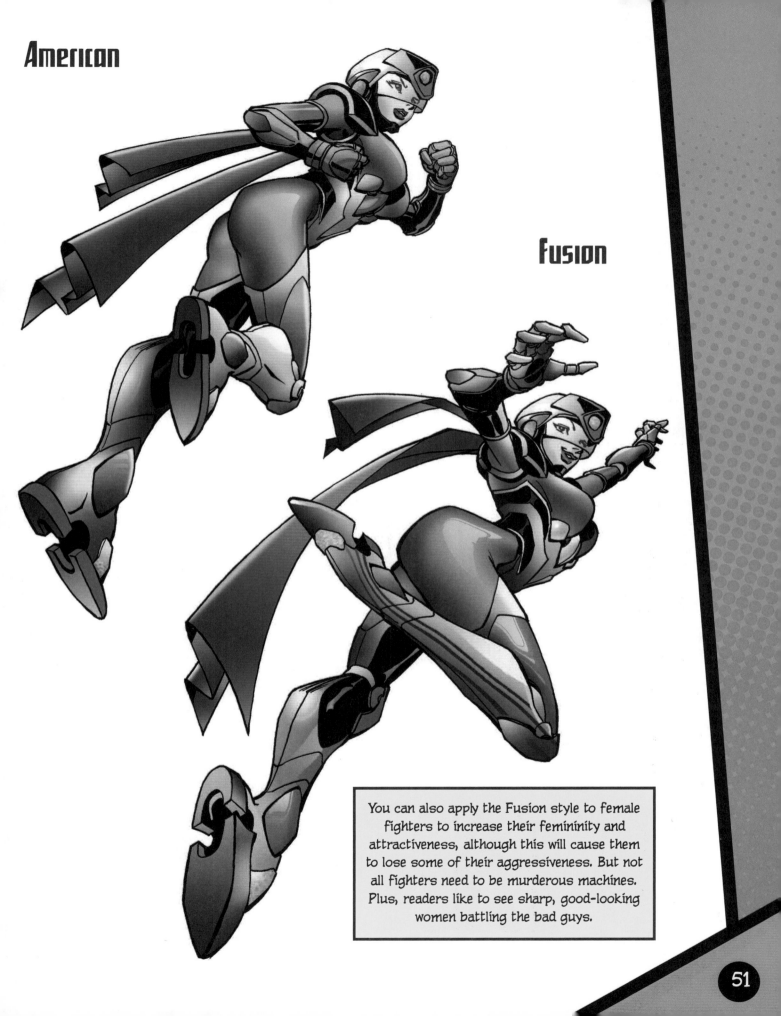

American

Fusion

You can also apply the Fusion style to female fighters to increase their femininity and attractiveness, although this will cause them to lose some of their aggressiveness. But not all fighters need to be murderous machines. Plus, readers like to see sharp, good-looking women battling the bad guys.

Whether you draw a warrior or a winged goddess, the clothes, hairstyle, and accessories make or break the character. It's not enough to just draw a dynamite figure. Your character needs a wardrobe that shouts, "Look at me!" You can draw an edgy figure, but unless the costume is also edgy, you lose. Runway models (both male and female) make a great reference: The avant-garde clothes never make it to the department stores—they're like the cool concept cars you see at auto shows—but in the rarefied world of comic books, outrageously stylish clothes are the only way to go. Remember, you're not drawing your typical girl-next-door or good-natured action hero. This is manga Fusion, the newest style of comics that lives on the razor's edge.

WARDROBE: FROM REALITY TO FANTASY

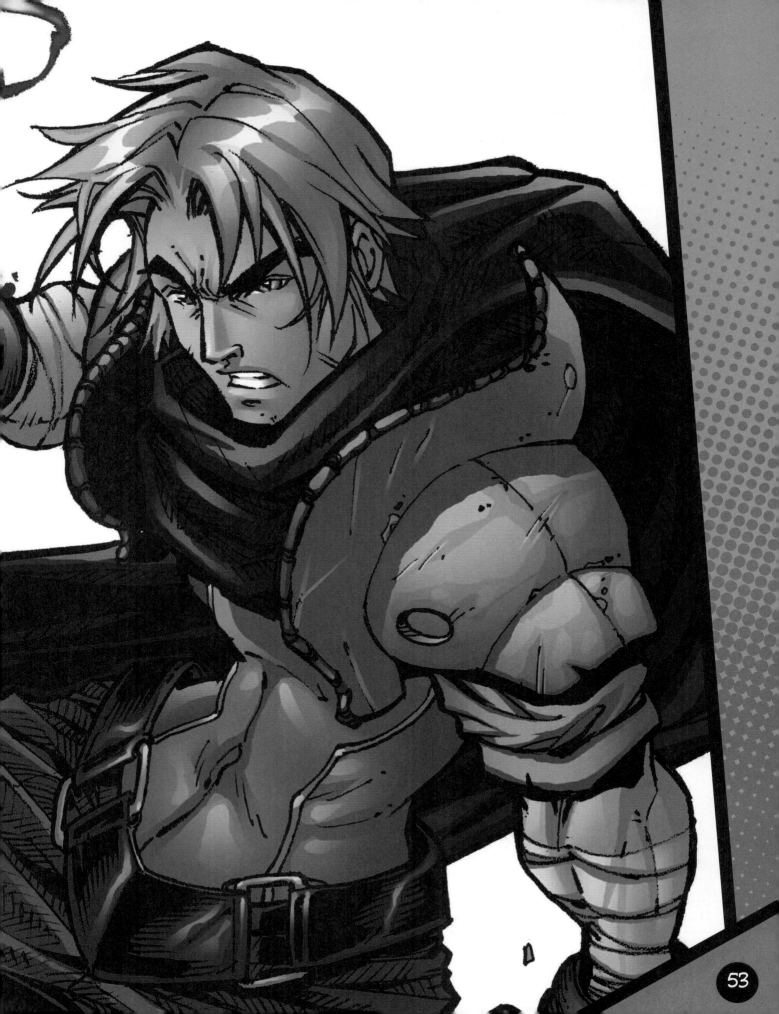

Transforming a Character with Clothes.

We'll start with the women. To illustrate the power of good costuming, we've taken one character and drastically changed her costume—and, therefore, the genre—in three examples. Think she looks any different in each one?

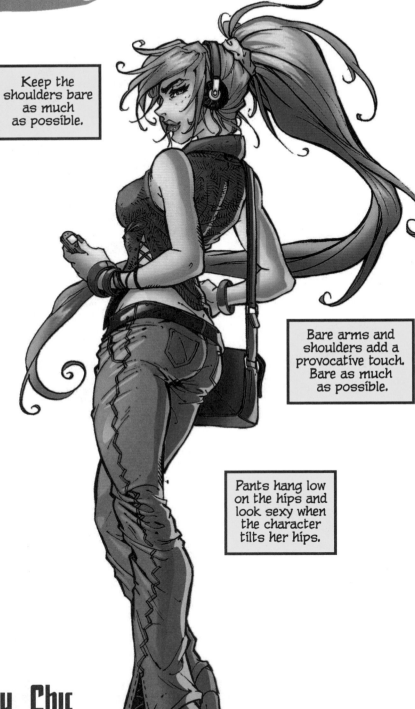

Long, splashy hair is a must! It should look like it's blowing in a soft breeze whether or not the other garments are blowing.

Keep the shoulders bare as much as possible.

Bare arms and shoulders add a provocative touch. Bare as much as possible.

Pants hang low on the hips and look sexy when the character tilts her hips.

High heels elongate the look of the legs.

Everyday Chic

In comics, the typical female city dweller wears clothes that look like they came from a boutique in Tribeca, not from some chain department store. This type of character should never look like she's going on a job interview.

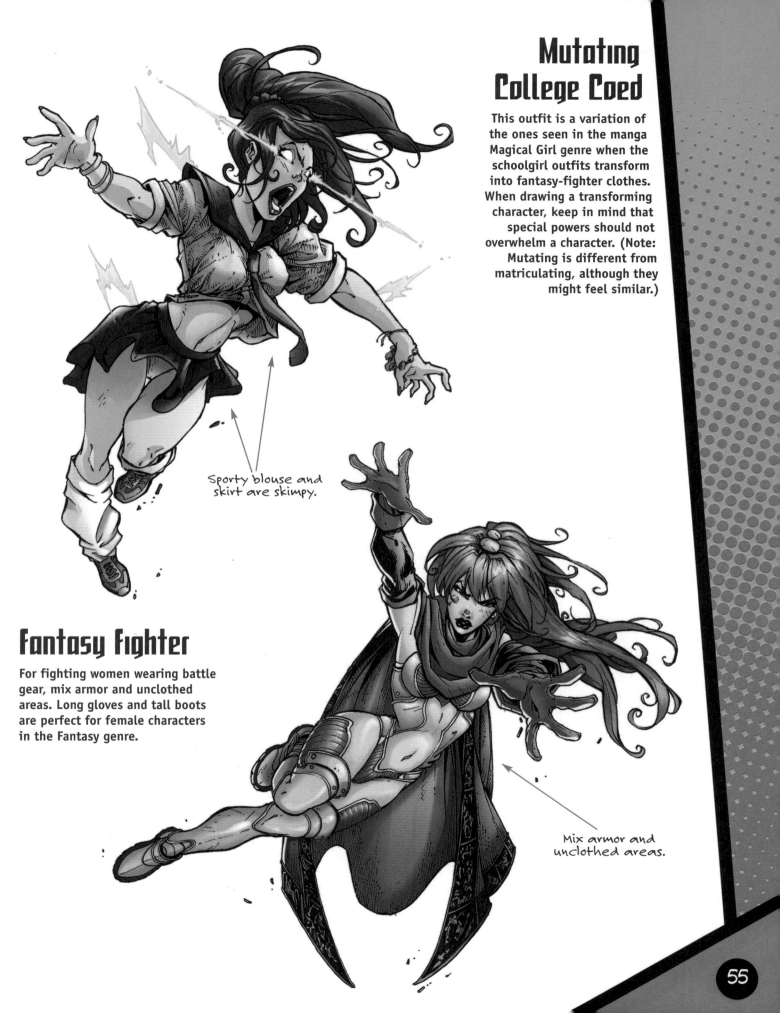

Mutating College Coed

This outfit is a variation of the ones seen in the manga Magical Girl genre when the schoolgirl outfits transform into fantasy-fighter clothes. When drawing a transforming character, keep in mind that special powers should not overwhelm a character. (Note: Mutating is different from matriculating, although they might feel similar.)

Sporty blouse and skirt are skimpy.

Fantasy Fighter

For fighting women wearing battle gear, mix armor and unclothed areas. Long gloves and tall boots are perfect for female characters in the Fantasy genre.

Mix armor and unclothed areas.

A Costume Staple

Many super costumes are based on the French-cut bodysuit. You can add high boots, as well as gloves, stockings, and even some mecha armor. Take a look back at the Fantasy Fighter on the previous page, which makes use of most of these ideas.

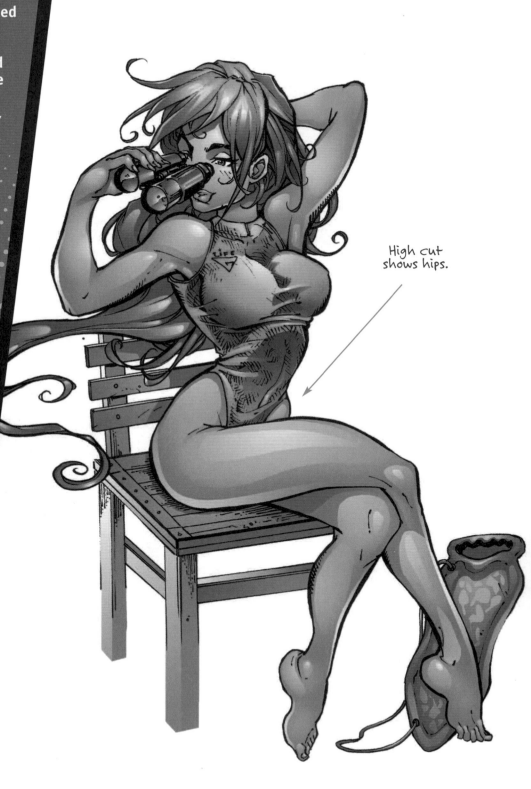

High cut shows hips.

Wings and Horns

Draw wings like a blanket that surrounds her. The horns are curled, like ram's horns (not devil horns, which are cheesy).

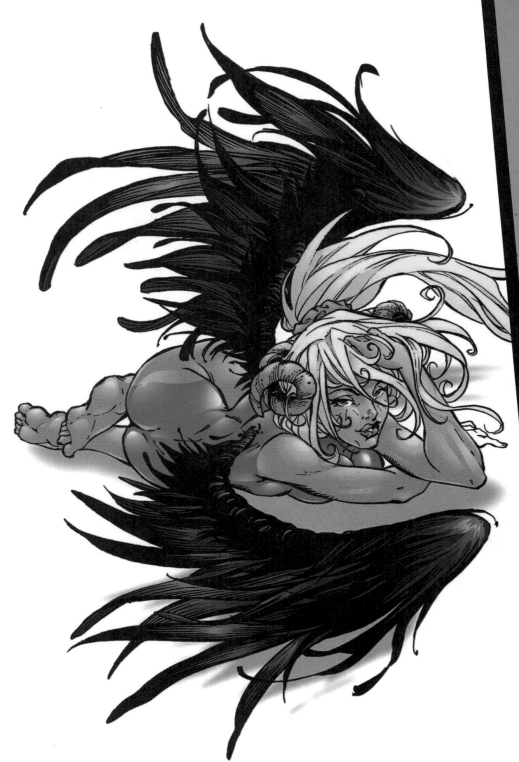

Drama vs. Superpowers

Tight-fitting, spandexlike costumes are more common in traditional comics than in the newer Fusion style. Although no one is willing to toss out the bodysuit costume completely, the current trend is toward *dramatic* characters, rather than *superpowered* ones. And that only makes sense, after all. For example, what's the difference between a character who has super-duper strength and one who is only extremely strong? One can hurl a bus, while the other can only take out three thugs in a nanosecond. The latter is still impressive, but it can also be more dramatic. More is at stake if the character has no superpowers, because he might actually . . . lose!

Costumes don't have to be skintight. Baggy-looking materials give more of a feeling of realism.

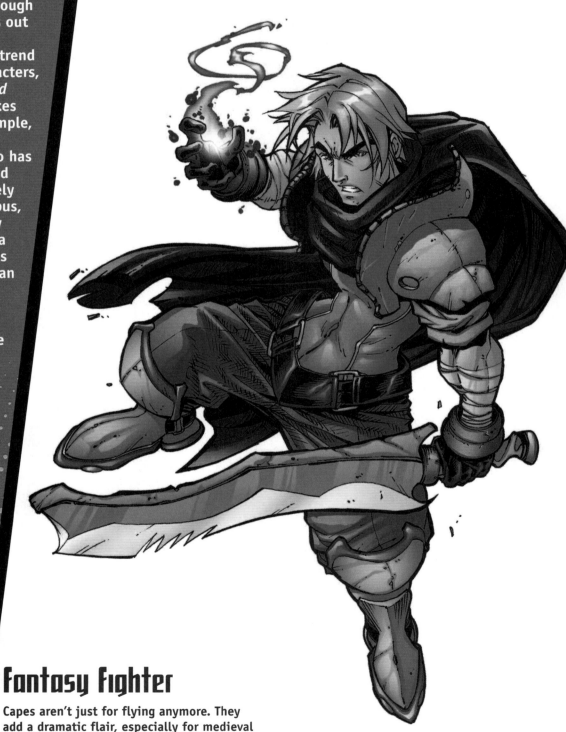

Fantasy Fighter

Capes aren't just for flying anymore. They add a dramatic flair, especially for medieval and sci-fi costumes.

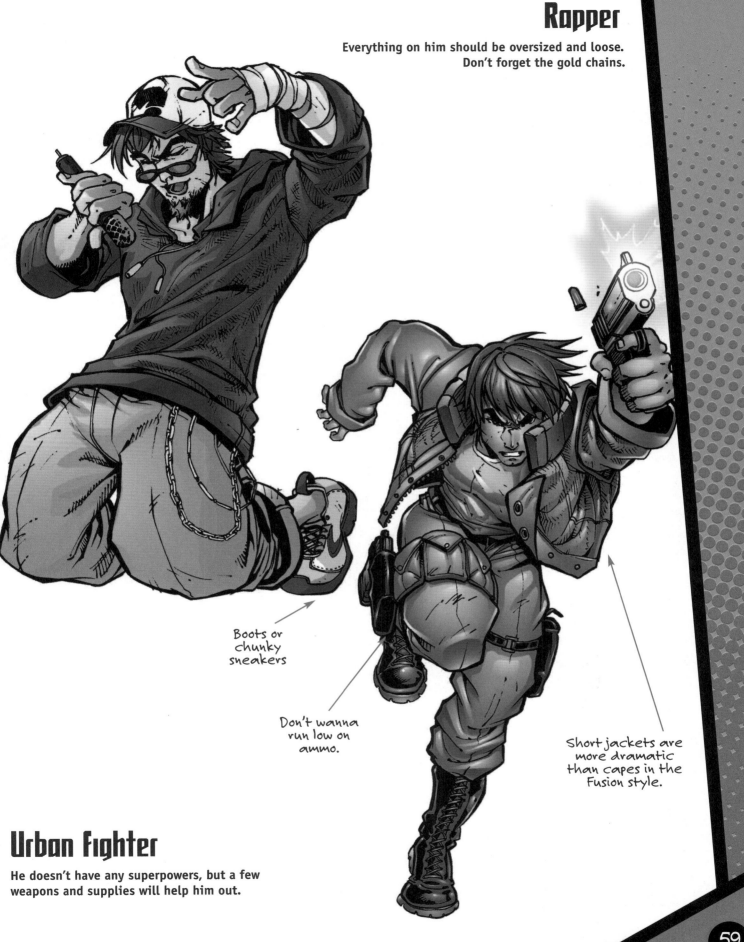

Rapper

Everything on him should be oversized and loose.
Don't forget the gold chains.

Boots or
chunky
sneakers

Don't wanna
run low on
ammo.

Short jackets are
more dramatic
than capes in the
Fusion style.

Urban Fighter

He doesn't have any superpowers, but a few
weapons and supplies will help him out.

There's one variation of the manga Fusion style that aims to bring hardcore action to the mean streets of the city. It's particularly popular with the larger and more successful independent comic book publishers, who tend to lead the way in stylistic trends. The style differs from the look we just covered in that it leans more toward manga than American Fusion-Style comics do, but it is still a combination of the two. These hardcore characters are never superpowered action heroes but, instead, are the gritty rebels living at some time in the not-so-distant future when the country is at war with itself and chaos abounds. It's a tough, violent world.

HARDCORE

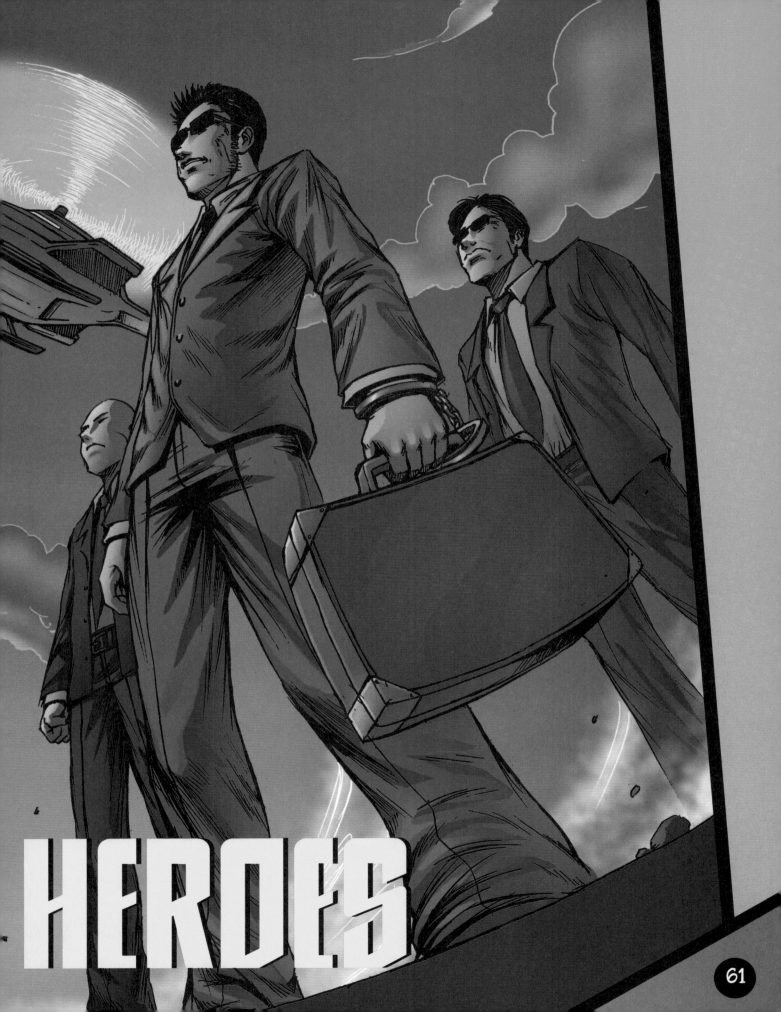

HEROES

Killer on the Edge

Common hardcore characters are the secret police, the double agents, and the trained assassins—all in league, working for the new government. Struggling against them is the resistance, made up of urban warriors fighting to free themselves from the new order imposed by the state. These guys are not about muscles and bulk; they're about attitude and danger. This genre is an Americanized urban look popularized by Sci-Fi manga (such as *Cowboy Be-Bop*) as well as more mature anime (like *Ghost in the Shell*). A hardboiled character is like a killer with a death wish. He doesn't care much for his own life—and a lot less for yours. He's slightly crazy, as you can see from his eyes and his uncomfortable smile. He pulls the trigger first and then looks to see if he shot the right guy. He's paranoid and darkly charismatic. He wears jackets and slacks that are slick yet tacky. But, the real key to the character lies in the facial expression and body language.

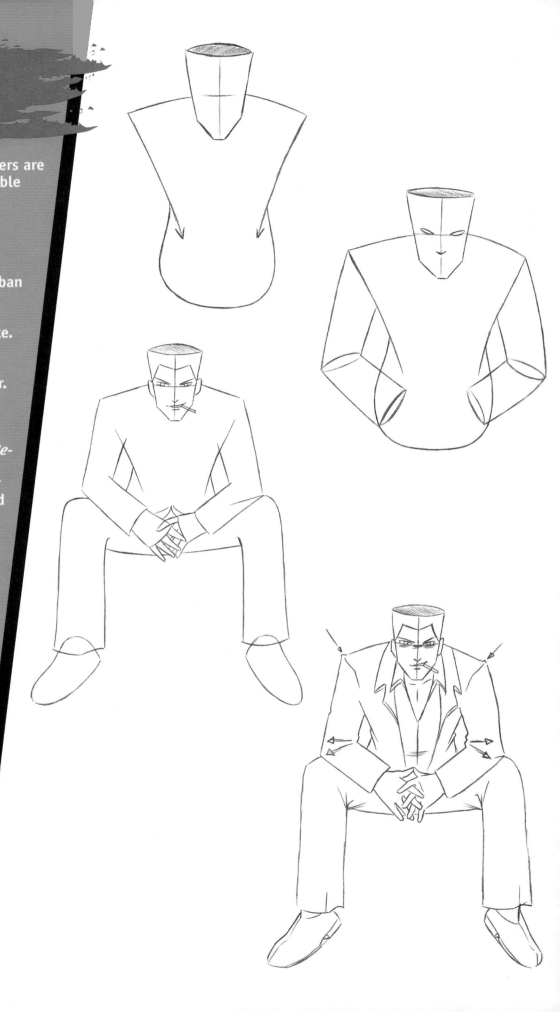

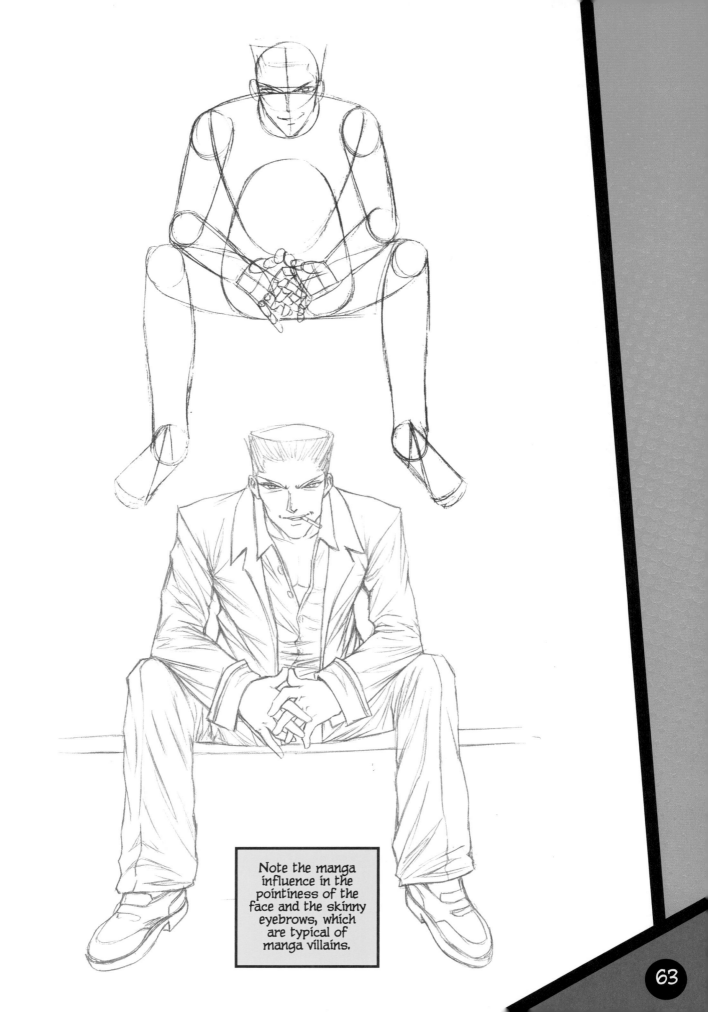

Note the manga influence in the pointiness of the face and the skinny eyebrows, which are typical of manga villains.

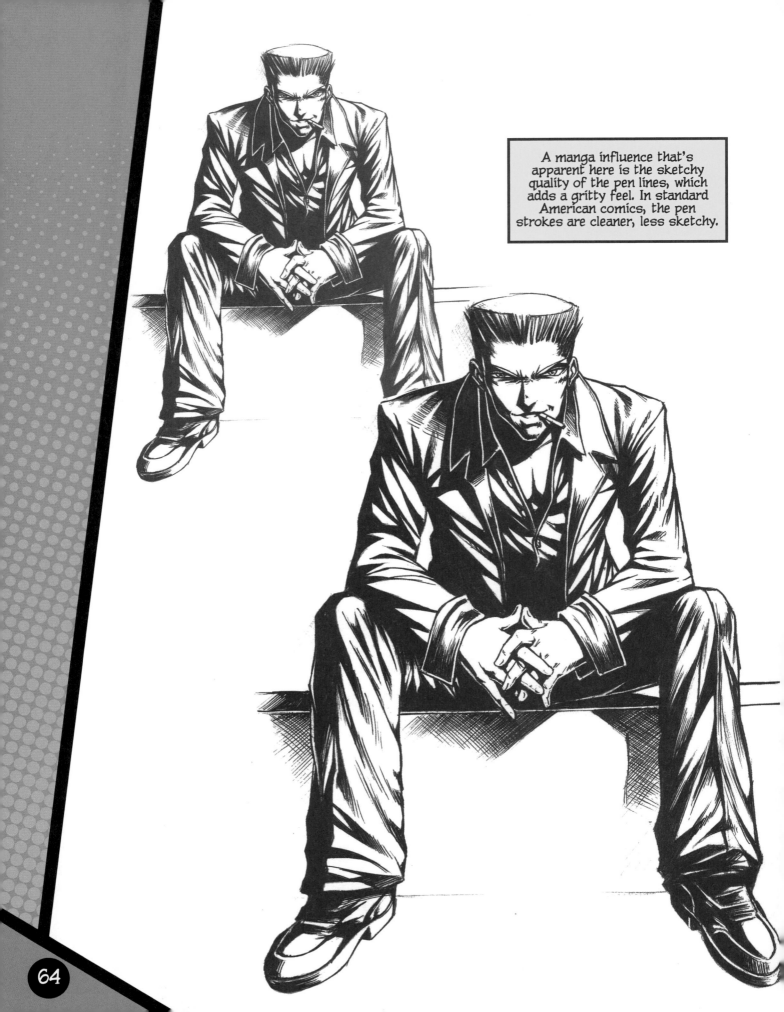

A manga influence that's apparent here is the sketchy quality of the pen lines, which adds a gritty feel. In standard American comics, the pen strokes are cleaner, less sketchy.

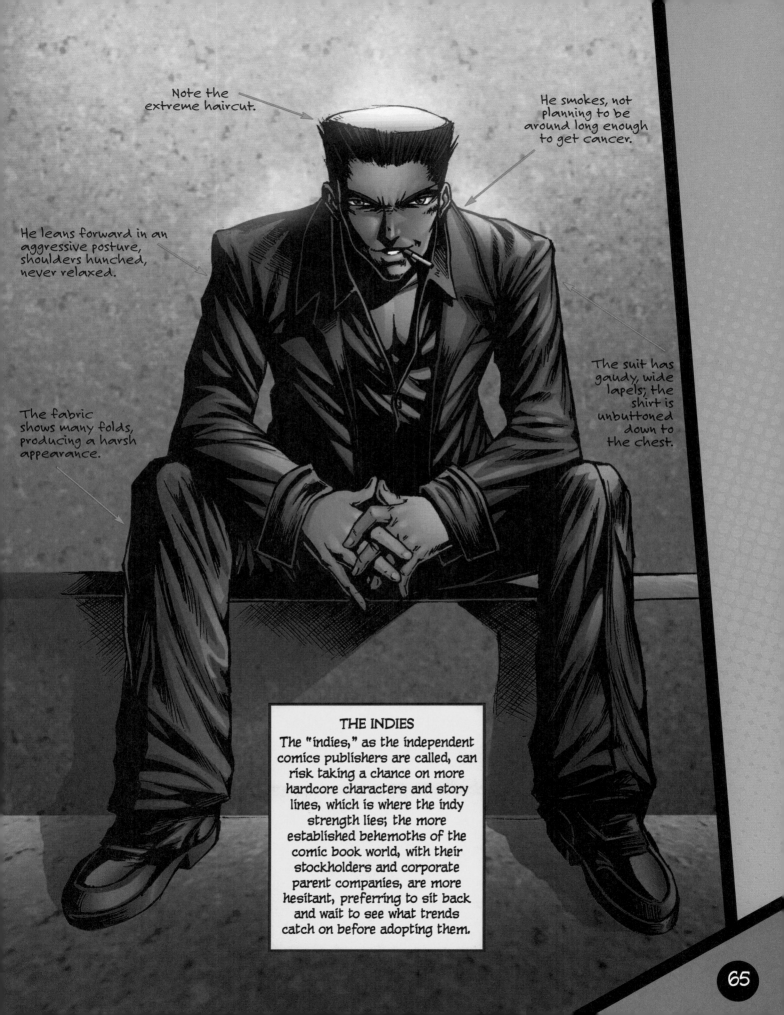

Female Resistance Fighter

This popular Fusion character type shows up in many comics. She has a manga flair, but her role is American: the tough fighter-babe who handles heavy weapons. She's an action character, not a romantic one, although at certain, brief moments in the story, she may let down her guard, wishing things could be different.

She handles the same powerful equipment as a man does.

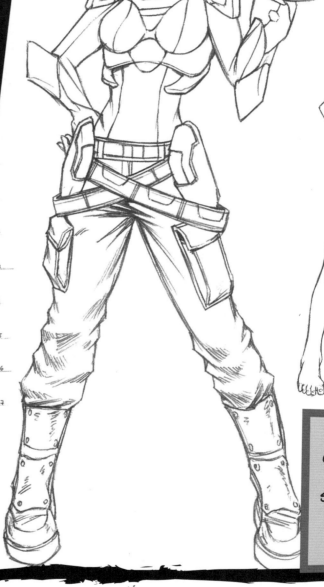

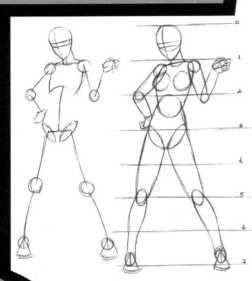

AVERAGE CHARACTER HEIGHT: 7 HEAD LENGTHS TALL.

IN KEEPING WITH THE MANGA INFLUENCE (AS OPPOSED TO AMERICAN-STYLE FIGHTER BABES), SHE'S NOT SUPERMUSCULAR BUT IS A TEENAGE GAL WITH A TOUGH-AS-NAILS PERSONALITY WHO IS FIGHTING FOR A CAUSE.

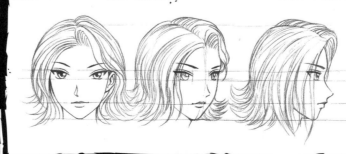

WHEN DRAWING A CHARACTER IN A NEW ANGLE, LINE UP YOUR NEW DRAWING WITH A GOOD SKETCH YOU'VE DONE AT ANOTHER ANGLE. THAT WAY, YOU'LL MAINTAIN THE CORRECT PROPORTIONS.

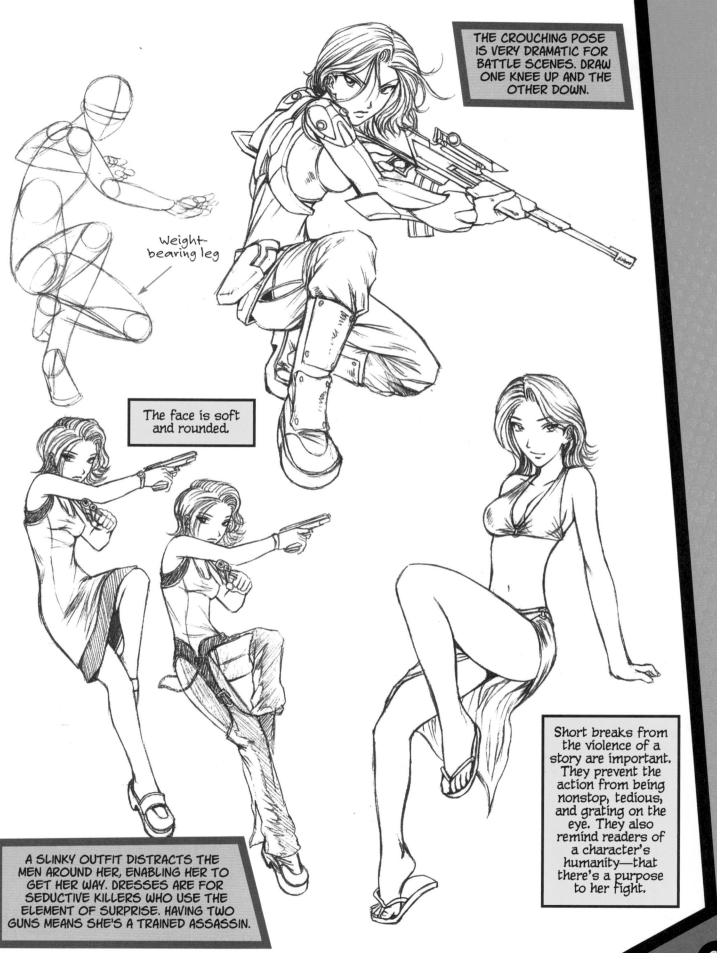

THE CROUCHING POSE IS VERY DRAMATIC FOR BATTLE SCENES. DRAW ONE KNEE UP AND THE OTHER DOWN.

Weight-bearing leg

The face is soft and rounded.

A SLINKY OUTFIT DISTRACTS THE MEN AROUND HER, ENABLING HER TO GET HER WAY. DRESSES ARE FOR SEDUCTIVE KILLERS WHO USE THE ELEMENT OF SURPRISE. HAVING TWO GUNS MEANS SHE'S A TRAINED ASSASSIN.

Short breaks from the violence of a story are important. They prevent the action from being nonstop, tedious, and grating on the eye. They also remind readers of a character's humanity—that there's a purpose to her fight.

Male Resistance Fighter

Like his female counterpart, the male resistance fighter has a manga flair but is still unmistakably American.

Body Armor Details

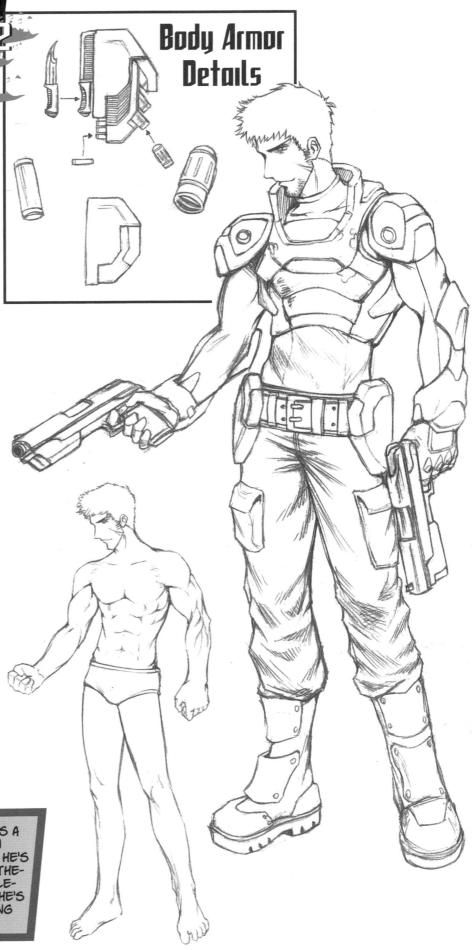

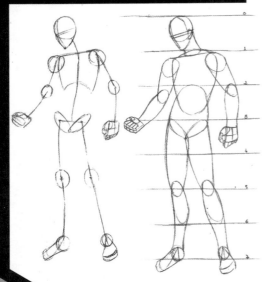

AVERAGE CHARACTER HEIGHT:
7 HEAD LENGTHS TALL

SINCE HE'S A FUSION CHARACTER, HE'S NOT OVER-THE-TOP MUSCLE-BOUND, BUT HE'S NO WEAKLING EITHER.

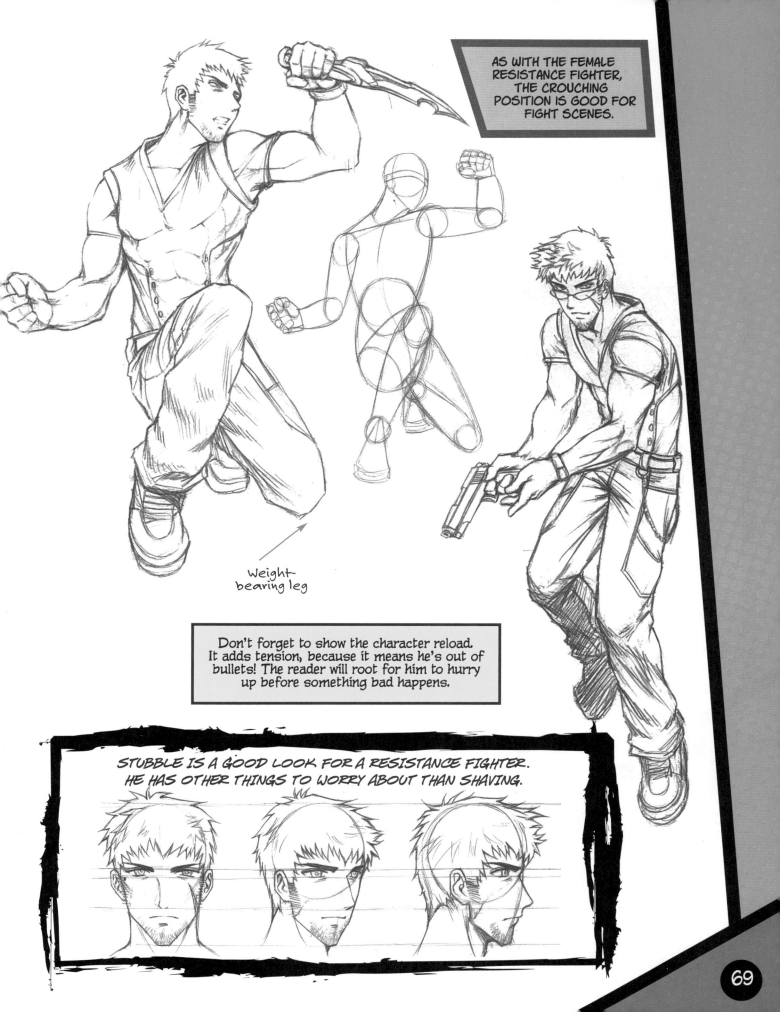

AS WITH THE FEMALE RESISTANCE FIGHTER, THE CROUCHING POSITION IS GOOD FOR FIGHT SCENES.

Weight-bearing leg

Don't forget to show the character reload. It adds tension, because it means he's out of bullets! The reader will root for him to hurry up before something bad happens.

STUBBLE IS A GOOD LOOK FOR A RESISTANCE FIGHTER. HE HAS OTHER THINGS TO WORRY ABOUT THAN SHAVING.

Team Leader

Every team needs a leader—the guy who pulls everyone through when the going gets tough. This type of character should be physically more impressive than the others, gritty and determined.

THE TEAM LEADER IS A NO-NONSENSE CHARACTER WHO BARKS ORDERS.

AVERAGE CHARACTER HEIGHT: 8 HEAD LENGTHS TALL

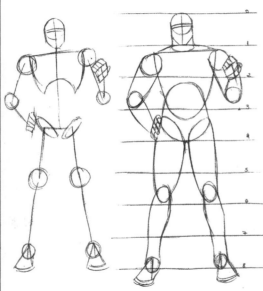

AT 8 HEADS TALL, THE TEAM LEADER IS TALLER THAN THE REST OF THE CHARACTERS AROUND HIM, AND HE'S BIGGER ALL AROUND.

THE THICK NECK INDICATES BULLDOG STRENGTH.

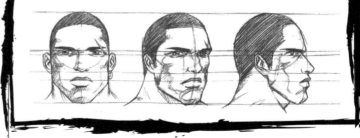

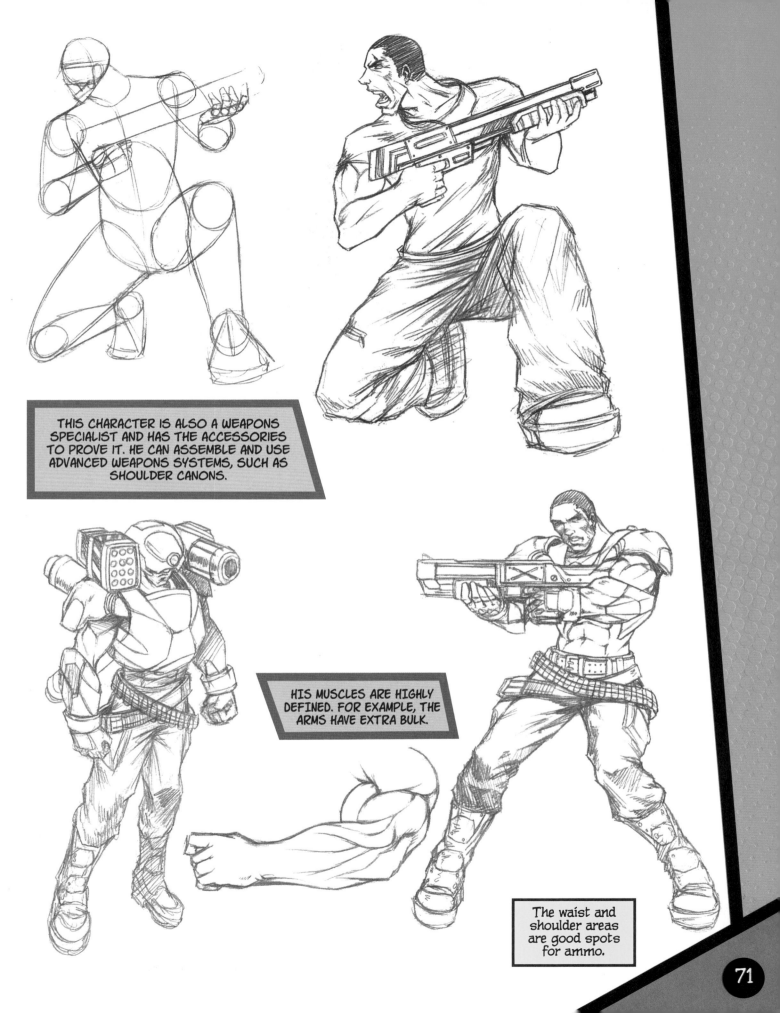

THIS CHARACTER IS ALSO A WEAPONS SPECIALIST AND HAS THE ACCESSORIES TO PROVE IT. HE CAN ASSEMBLE AND USE ADVANCED WEAPONS SYSTEMS, SUCH AS SHOULDER CANONS.

HIS MUSCLES ARE HIGHLY DEFINED. FOR EXAMPLE, THE ARMS HAVE EXTRA BULK.

The waist and shoulder areas are good spots for ammo.

Male Teenage Fighter Pilot

Many independent comic book publishers have used teenage resistance characters to cross over to the Fusion style. The teen Fusion more closely mirrors the manga look, with soft faces and thin frames. Teen fighters make up for a lack of physical impressiveness with a degree of earnestness and single-minded intensity that's very appealing to readers. These fighters are often cast as pilots, the same roles they play in authentic manga. When they're not in their pilot uniforms, they wear the clothes of typical American teenagers in a combination of style and sloppiness—a self-conscious casual look, if you will.

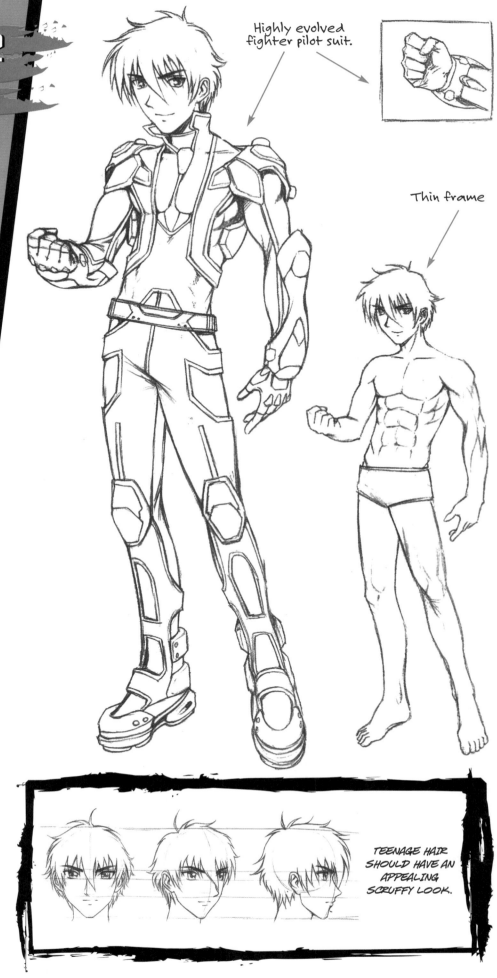

Highly evolved fighter pilot suit.

Thin frame

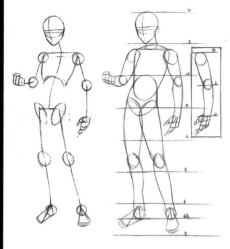

MALE TEENAGE RESISTANCE FIGHTER HEIGHT: 6 TO 6 1/2 HEAD LENGTHS TALL

TEEN CHARACTERS HAVE SMALLER PROPORTIONS THAN ADULTS.

TEENAGE HAIR SHOULD HAVE AN APPEALING SCRUFFY LOOK.

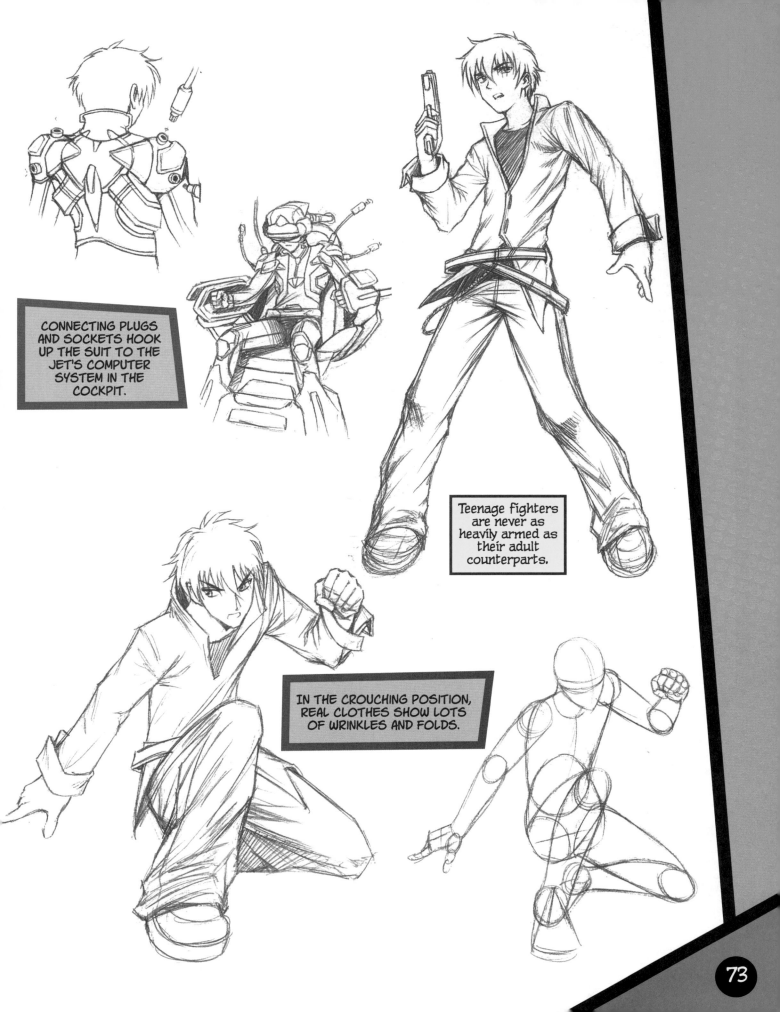

CONNECTING PLUGS AND SOCKETS HOOK UP THE SUIT TO THE JET'S COMPUTER SYSTEM IN THE COCKPIT.

Teenage fighters are never as heavily armed as their adult counterparts.

IN THE CROUCHING POSITION, REAL CLOTHES SHOW LOTS OF WRINKLES AND FOLDS.

Female Teenage Fighter Pilot

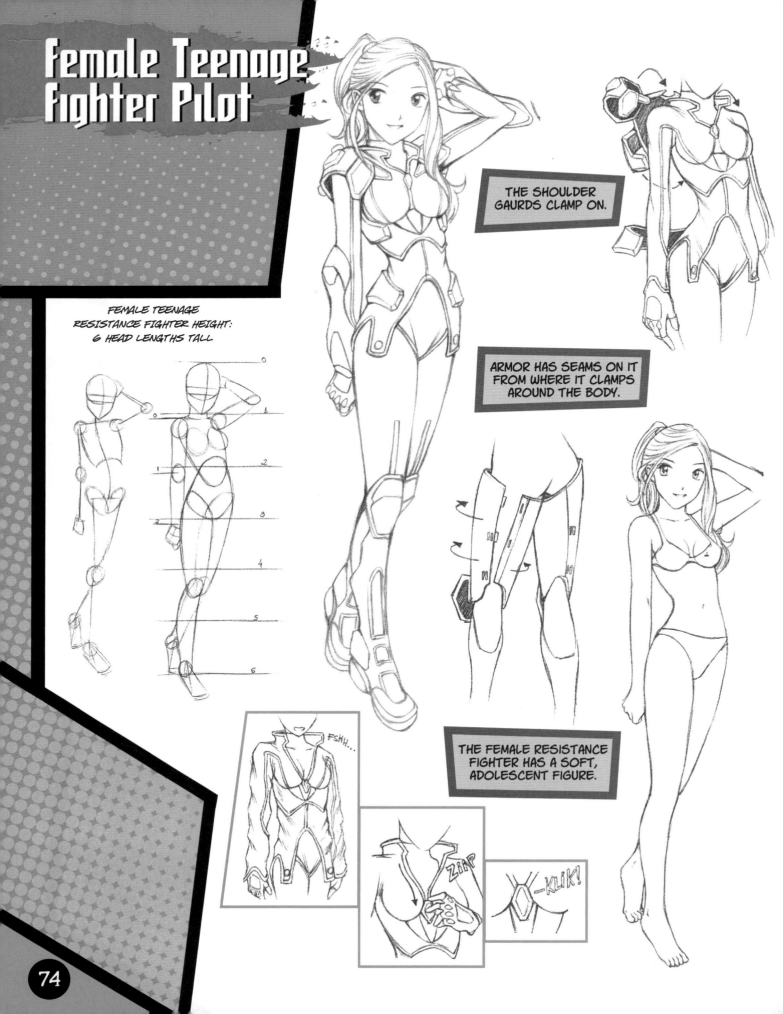

FEMALE TEENAGE
RESISTANCE FIGHTER HEIGHT:
6 HEAD LENGTHS TALL

THE SHOULDER
GAURDS CLAMP ON.

ARMOR HAS SEAMS ON IT
FROM WHERE IT CLAMPS
AROUND THE BODY.

THE FEMALE RESISTANCE
FIGHTER HAS A SOFT,
ADOLESCENT FIGURE.

FSHH...

ZIP

-KLIK!

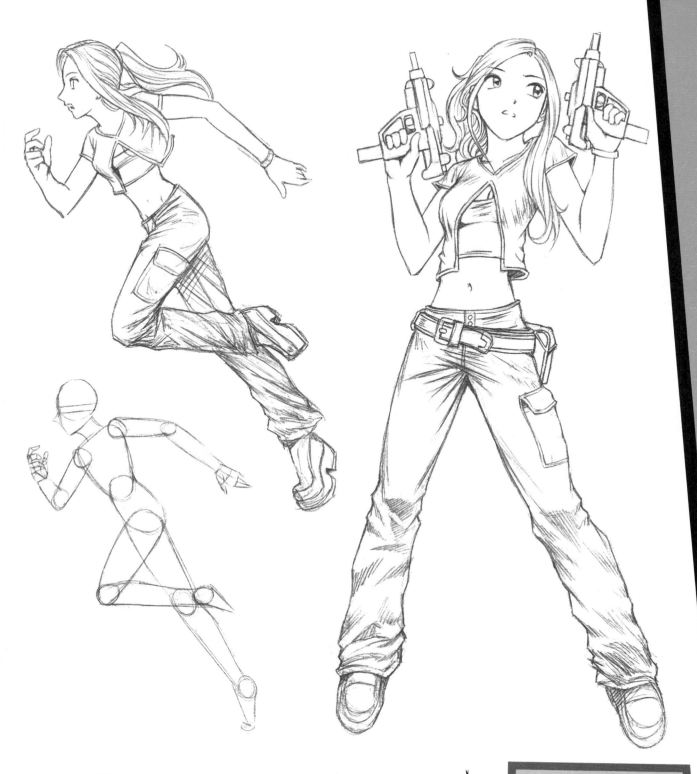

THE HAIR IS ASYMMETRICAL WITH ONE SIDE LONGER THAN THE OTHER, WHICH IS MORE INTERESTING THAN A PERFECTLY EVEN HAIRDO.

NO WALLFLOWER, THIS CHARACTER IS EVERY BIT THE FIGHTER. HER CASUAL OUTFIT INDICATES THAT SHE BECAME A REBEL LEADER QUITE BY ACCIDENT—BECAUSE SOMEONE HAD TO DO IT, AND SHE WAS THE ONLY ONE LEFT STANDING.

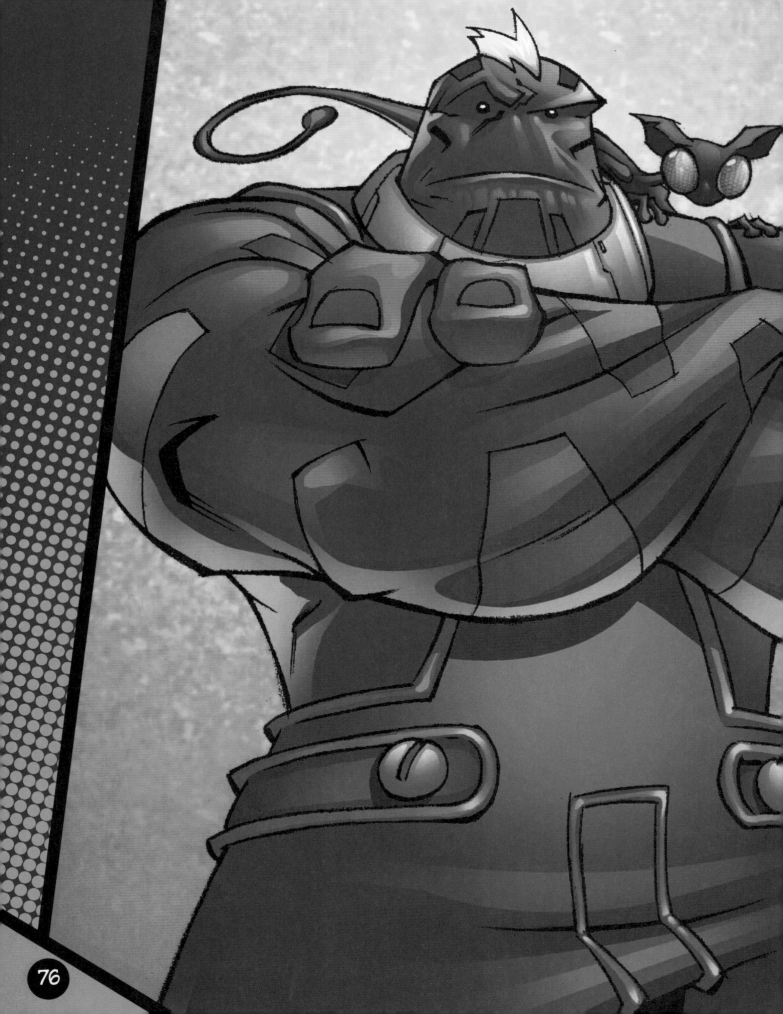

Now let's get to the secrets of drawing costumed action heroes in the Fusion style. Action heroes are colorful characters whose costumes are their flamboyant trademarks. The costumes are indicative of the characters' powers or special skills. These characters are generally more fantasy-based than the figures in the first half of the book; their outfits are never realistic. An action hero would look out of place walking down a city street. The Action-hero style of Fusion has a manga flair, but with a simplified, cartoony appearance that gives it a clean, sleek look. These Fusion characters are generally not so hugely muscular as the typical American comic-book-save-the-world-from-bad-guys heroes. You can't rely on gigantic muscles to awe your readers—they've seen that many times before. You want more. You want to be outstanding. You want your characters to grab the reader. Fusion does that.

ACTION-HERO FUSION

Masks and More

Before I even get to the body, I have to mention masks. Masks are a popular dramatic device. But a word of caution: While full face masks work well on classical, square-jawed comic book characters, they tend to make the sleek faces of Fusion characters look pointy, and you don't want that. For Fusion characters, partial masks are better than ones that cover the entire head.

No Mask

Keep in mind that an unmasked face should be as good as any mask you can think up—if you're going to give a character a mask, you should have a good reason why it would help the story.

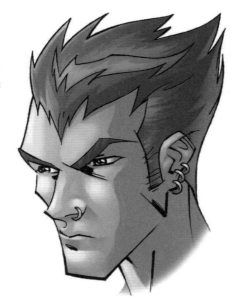

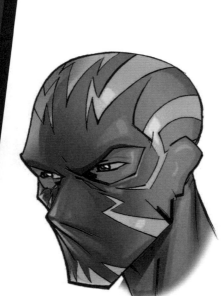

Full Mask

The total face mask focuses the reader's attention on the outline and shape of the face, and the narrowness of the Fusion face makes the character look weaker.

Eye Mask

That's better. He's a masked character, but now the Fusion style shows through. Note the downward-pointed "hook" design at the outer edge of the mask. It runs along the typically sharp cheekbones of Fusion characters. Adding little touches like this keeps an old design fresh.

Goggles and Headpiece

Eyepieces, earpieces, and layered helmets are great for the mecha Sci-Fi genre, which is now incorporated into many Fusion comics.

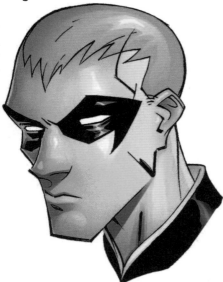

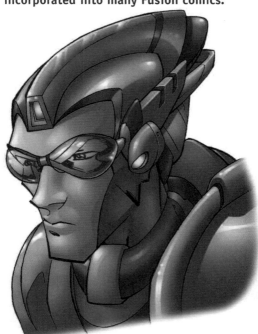

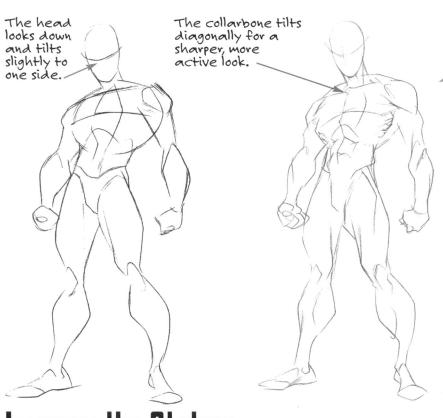

The head looks down and tilts slightly to one side.

The collarbone tilts diagonally for a sharper, more active look.

Body attitude (expressive poses and body language) can spell the difference between an eye-catching character and a plain old vanilla one. This goes beyond drawing action poses. For example, a professional comic book artist can draw an exciting pose for a character who is standing still. What makes the pose dynamic? I'm not telling. Well, okay, you wore me down. Keep reading.

Increase the Stature

To do this draw the figure from a low angle, as if the reader is below the character and the character is looking down at the reader. This creates a commanding look. It pulls the reader in as the character appears to be in a superior position, just like a boss who sits across the desk from you but in a higher chair. The character looks assertive and ready. It's a pose you'll be using a lot in comics.

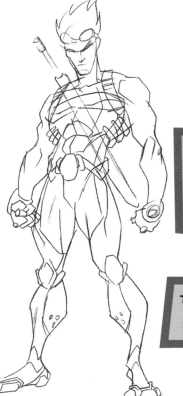

THE ANGULAR BODY, SAMURAI SWORD, AND SPIKED HAIR GIVE HIM A FUSION LOOK.

THE COSTUME FITS AROUND EACH INDIVIDUAL MUSCLE.

Twist the figure

Twisting the body is another great way to create a sense of motion while a character is standing still. It makes the pose look more fluid and energetic. This would ordinarily be a 3/4 rear view of the character. But here, the torso twists so that the figure now looks back (toward the reader). As a result, the chest and hips rotate in opposite directions, which is more active than just standing straight forwardly.

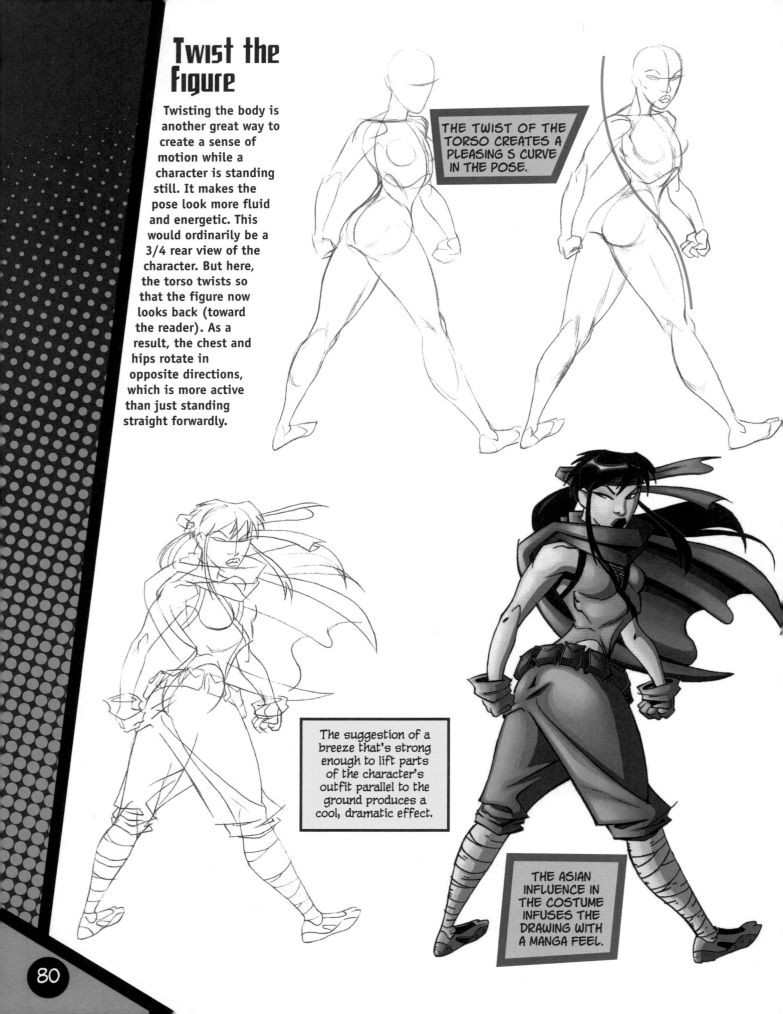

THE TWIST OF THE TORSO CREATES A PLEASING S CURVE IN THE POSE.

The suggestion of a breeze that's strong enough to lift parts of the character's outfit parallel to the ground produces a cool, dramatic effect.

THE ASIAN INFLUENCE IN THE COSTUME INFUSES THE DRAWING WITH A MANGA FEEL.

Shifting Weight

Shifting the bulk of a character's weight off to one side, makes a stationary pose more expressive. Female characters, especially, always look sexier if drawn with their hips shifted to one side. I can't emphasize this technique enough. Make good use of it, and your drawings will immediately have extra pizzazz. But here's the catch. When you shift the hips over, you need to adjust the entire pose to accommodate this. So, notice that the weight-bearing leg is straight (it always is) and directly under the body. This, in turn, pushes the hip on that side up and out. The non-weight-bearing leg is used for balance, it is placed away from the body, and bends slightly at the knee.

SINCE THE WEIGHT-BEARING LEG IS LOCKED, IT SHOVES THE HIP UP AND OUT.

THE WEIGHT-BEARING LEG IS STRAIGHT AND DIRECTLY UNDER THE BODY.

THE NON-WEIGHT-BEARING LEG IS BENT AT THE KNEE, PULLING THE HIP DOWN ON THAT SIDE.

Don't draw skinny thighs! Only women think that guys like anorexic women.

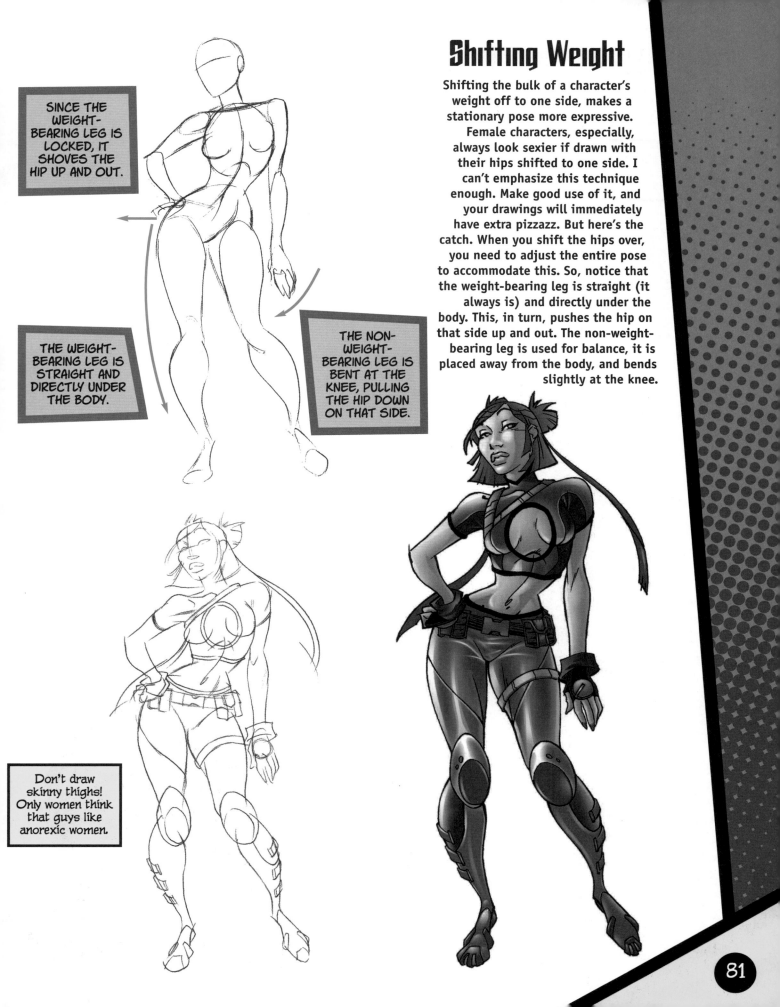

Emphasizing the Power of Giant Characters

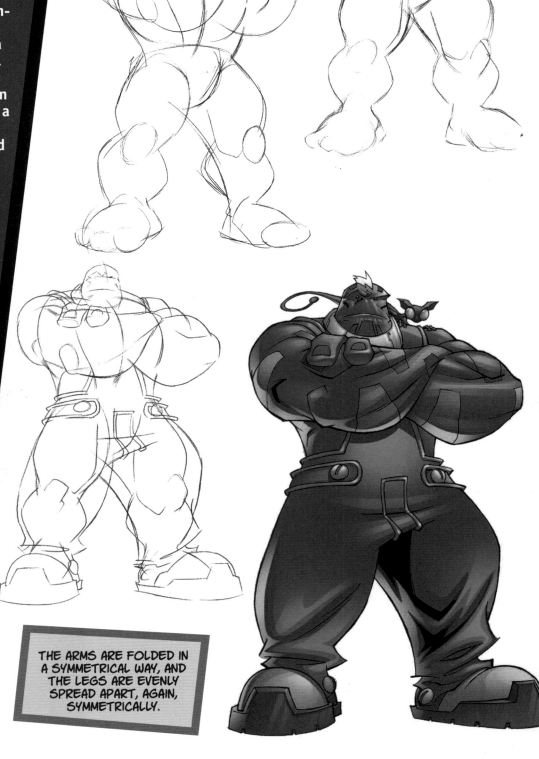

Here's the typical action-hero sidekick: the friendly-but-not-too-swift powerhouse of the team. The standard American-style comic book giant is an overgrown muscleman with a turbo-charged thyroid. He is, in effect, a blown up version of the hero. But in the Fusion style, the hero doesn't make a good giant character. The Fusion hero is too stylish and slick for that. So, the giant has to be invented fresh, from scratch.

The poses of big, lumbering guys are best drawn symmetrically. Symmetry is stable. Asymmetry is dynamic. Usually, you'd go for asymmetry, but you don't want his posture to be dynamic and athletic when, instead, this type of character should look like a brick building.

THE ARMS ARE FOLDED IN A SYMMETRICAL WAY, AND THE LEGS ARE EVENLY SPREAD APART, AGAIN, SYMMETRICALLY.

Fusion and Mecha

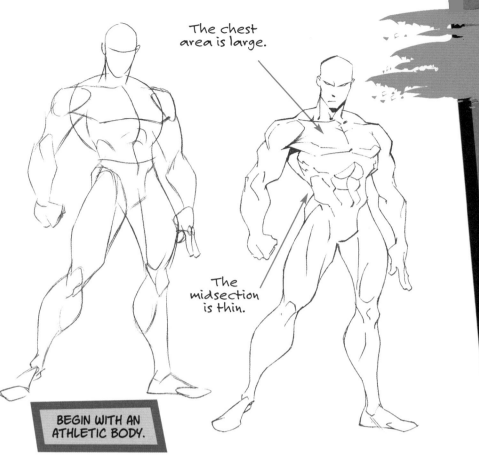

The chest area is large.

The midsection is thin.

BEGIN WITH AN ATHLETIC BODY.

Mecha is an entire genre of its own in authentic manga. And the mecha-clad action fighter has found a way into many Fusion comics. When designing a mecha outfit, vary the sizes of the protective body armor, alternating between large and small section to give the suit a visual rhythm.

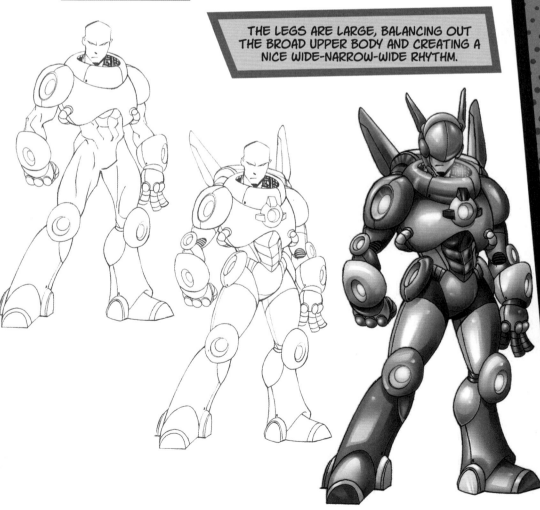

THE LEGS ARE LARGE, BALANCING OUT THE BROAD UPPER BODY AND CREATING A NICE WIDE-NARROW-WIDE RHYTHM.

Getting Power from Perspective

Since action-hero Fusion characters aren't as built up as the as standard American-style heroes, it's even more important to strive for poses with impact. The results can be even more impressive than if the characters were supermuscular. To get more power into a pose, get in the reader's face. Use extreme perspective to distort the image, markedly increasing the size of part of the figure—always the part that's closest to the reader.

But use logic. You wouldn't increase the size of a character's head simply because you want to create greater impact. You've got to pick and choose your perspective-busting images: Focus on fists, hands, weapons, and the like. The dramatic stuff.

Blah

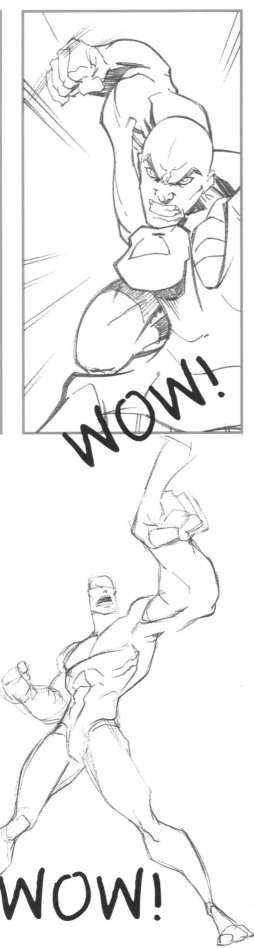

WOW!

Blah

WOW!

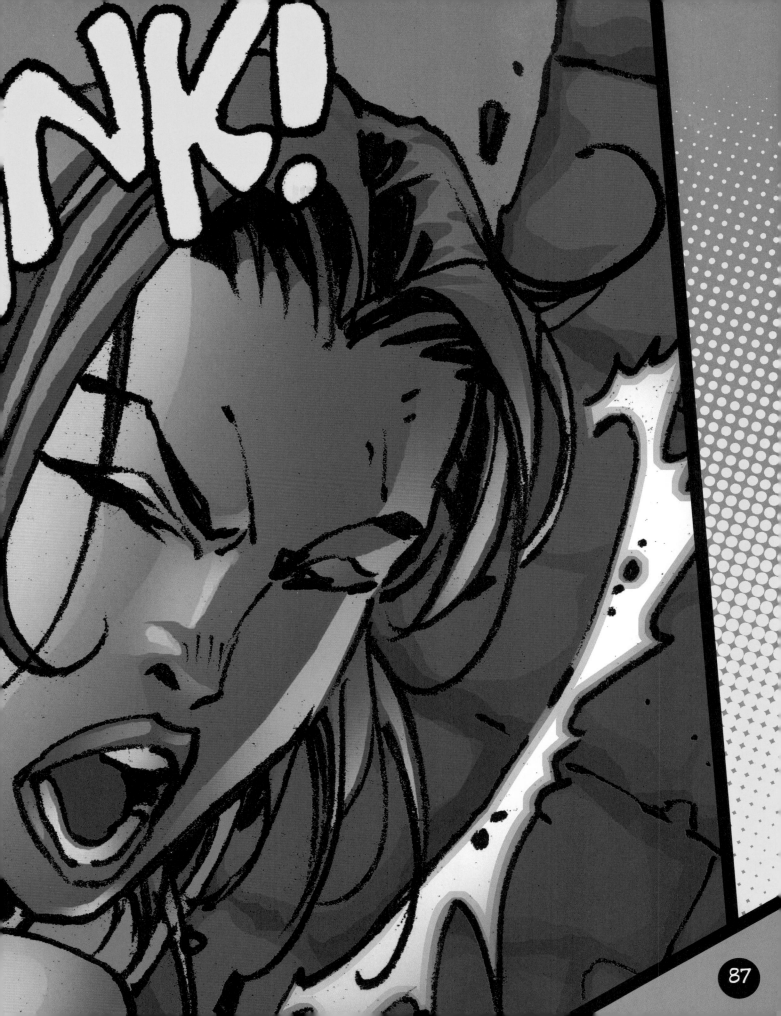

The Wide Shot

When you're establishing a scene, a *down* angle is the best choice because it creates a fly-on-the-wall viewpoint for readers, allowing them to get a broad look at the scene and who's in it. (This is an optimal combination of characters for a Fusion team: the hero, the girl, and the giant—all personalities that complement one another.) To prevent the panel from looking empty and to unify the elements, create a floor pattern. (Note that the pattern is positioned in a diagonal orientation, which is more dynamic than vertical and horizontal lines.)

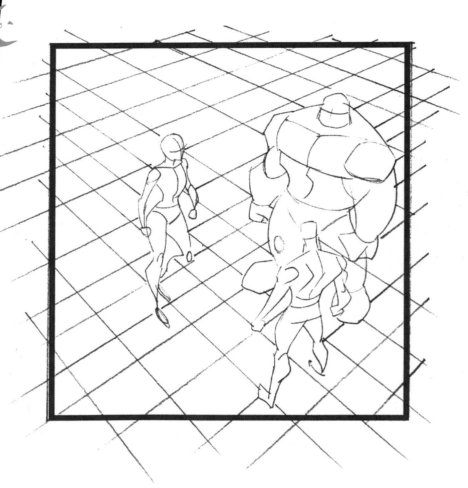

THE CHARACTERS SHOULD BE PLACED SO THAT THEY FORM A LOOSE CIRCLE, WITH THE BACK OF ONE OF THEM FACING THE READER. THIS CREATES A TEAM FEELING AND A SENSE OF DEPTH THAT WOULD BE ABSENT IF THEY WERE ALL FACING THE READER.

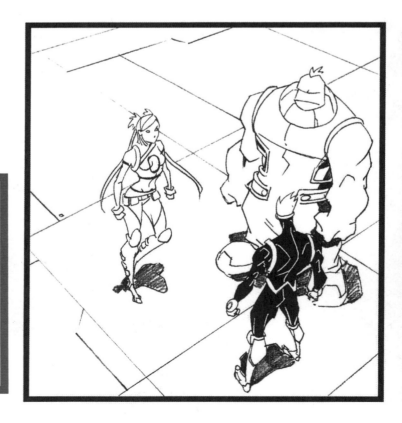

Woman Is Dominant

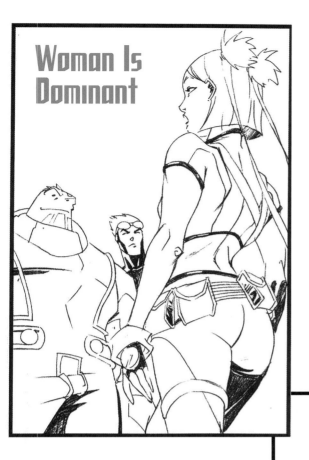

Positioning the Dominant Character

Whether you've got two, three, or twelve characters in a scene, you've got to make one of them stand out above the rest, otherwise the panel will lack focus. Position that dominant figure closer to the reader than the others. To make the composition even better, place the characters so that they overlap one another. That really cements them as a group.

Mutant Is Dominant

Mutant Is Dominant but...

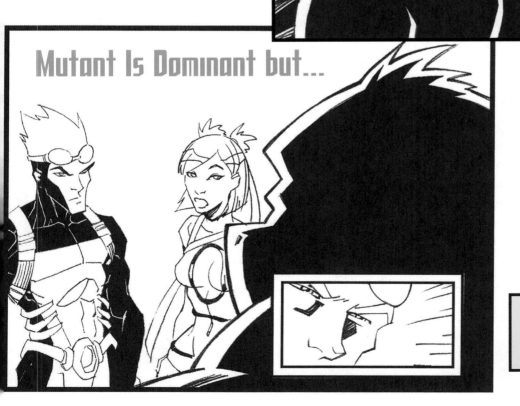

...injecting an insert panel of the hero makes the hero the focus of the panel.

Details and Skinny Panels

Detail Shots

Detail panels are used to show just that—the details. They focus readers on one thing, and break up the monotony of a scene. When you've got a character with matinee-style good looks, you'll want to show them in extreme close-ups more often. Whatever you're showing in a detail shot, it should be important to the story—perhaps a loaded weapon, perhaps a facial reaction—otherwise, readers will scratch their head wondering what all the fuss is about. In addition, the shape of the detail panel should comfortably fit the image it contains. If you're detailing a set of eyes, the panel should be horizontal. If you're concentrating on the outline of the face, the panel should be vertical.

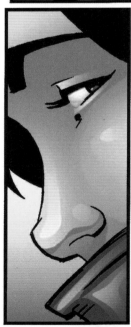

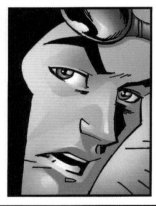

Skinny Panels

Skinny panels are sleek and stylish, which is in keeping with the Fusion look. When you see a comic book page with skinny panels thrown in, it always looks trendier than a page of blocky rectangles.

FUSION CHARACTERS ARE ALWAYS UP AGAINST IT. THEY CAN'T BREAK THROUGH SOLID ROCK WITH SPECIAL POWERS, LIKE LASER EYEBEAMS, AND THAT RAISES THE STAKES WHEN THEY'RE CAPTURED AND TRAPPED IN A CELL WITH NO WAY TO CLIMB OUT (RIGHT). THE TALL VERTICAL PANEL EMPHASIZES THEIR PREDICAMENT.

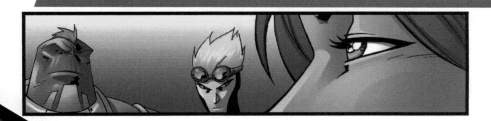

NEUTRAL
THERE'S NO TENSION WHEN THE HORIZON IS LEVEL. THE FIGURE IS CENTERED IN THE SPACE AND THE SPEED LINES TRAVEL BACK TOWARD CENTER OF THE PANEL.

Tilting the Horizon Line

Horizontal lines are peaceful and calm. That's why people like to gaze at the horizon. Serenity is fine for ordinary citizens, but for comic book artists it's B-O-R-I-N-G. Tilting the horizon line adds a sense of unease—of urgency—to a scene. Also, keep the horizon line low on the page; the higher the horizon, the weaker the effect of the tilting.

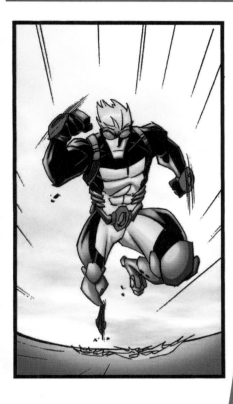

TILTED
THE TILTED HORIZON ACCENTUATES THE ACTION, ESPECIALLY WHEN THE CHARACTER RUSHES TOWARD YOU. THE FIGURE TILTS IN THE SPACE ALONG WITH THE HORIZON LINE, AND THE SPEED LINES ALSO ECHO THAT TILTING.

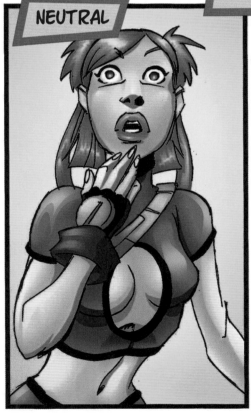

NEUTRAL

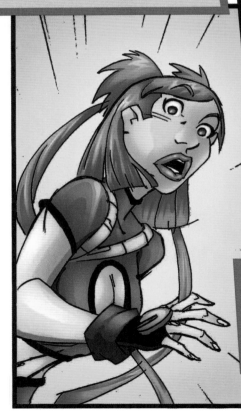

TILTED
TILTING DESTABILIZES THE SCENE, INDICATING A LOSS OF CONTROL, WHICH EMPHASIZES THE EMOTION OF THE CHARACTER.

Fusion Line Quality

The Fusion line is thinner than the typical line of standard American-style comics. The Fusion style can also incorporate light, sketchy lines, which you would never see in typical American style comics but which are more common in manga.

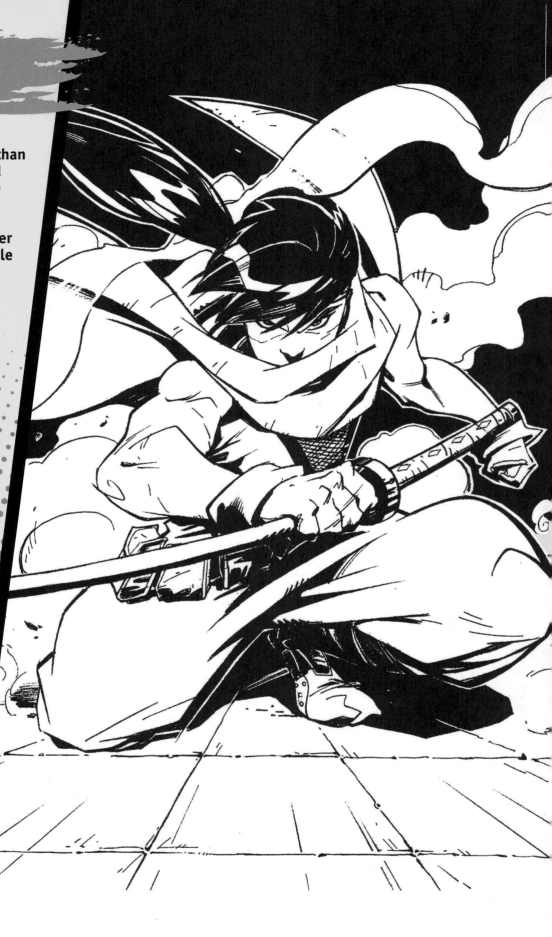

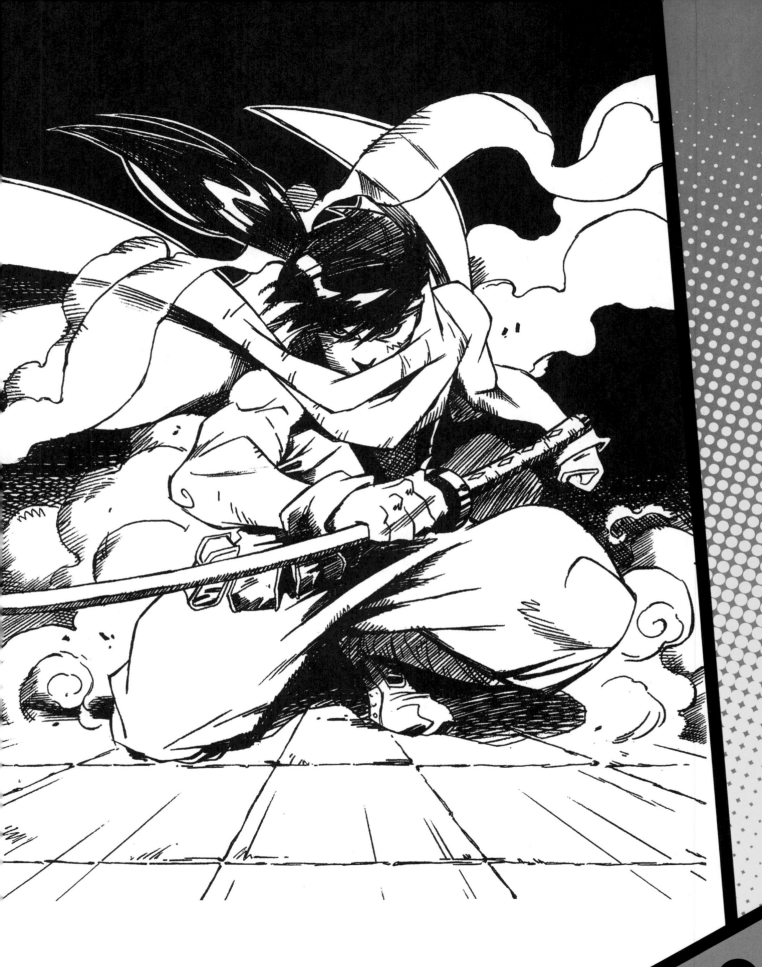

Fusion Shading

Flashy comics become even more dramatic, more brutal, more heroic when a high-contrast approach is taken—when areas of dark shadow are juxtaposed against light areas.

It's part of the comic book penciler's job to indicate where these areas of shadow fall. And while the penciler has to consider the light source, shading is primarily an aesthetic consideration. It needs to look cool just as much as it needs to be logical. Getting this down takes time and practice, like any other aspect of drawing.

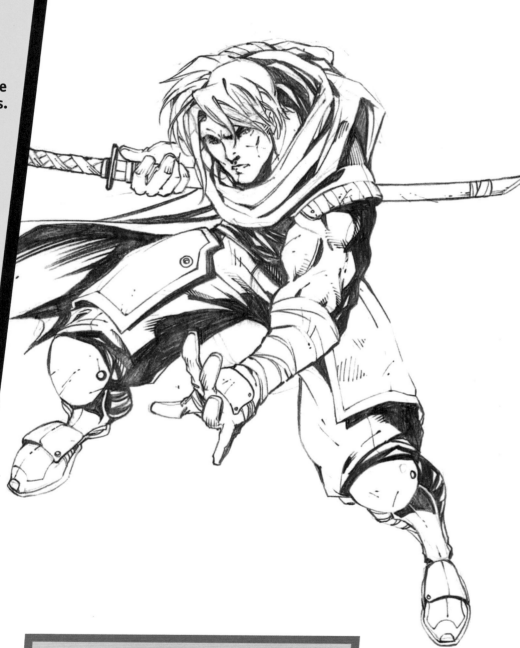

AMERICAN SYTLE
HEAVY SHADING CONVEYS MORE RAW POWER AND INTENSITY THAN LIGHT SHADING. IT CREATES A FEELING OF URGENCY. IT IS PRIMARILY AN AMERICAN INVENTION. JAPANESE ARTISTS LEAVE MOST OF THAT OUT; IN FACT, THEY RARELY EVEN VARY THE THICKNESS OF THEIR INK LINES—SOMETHING AMERICAN ARTISTS CONSIDER A NECESSITY.

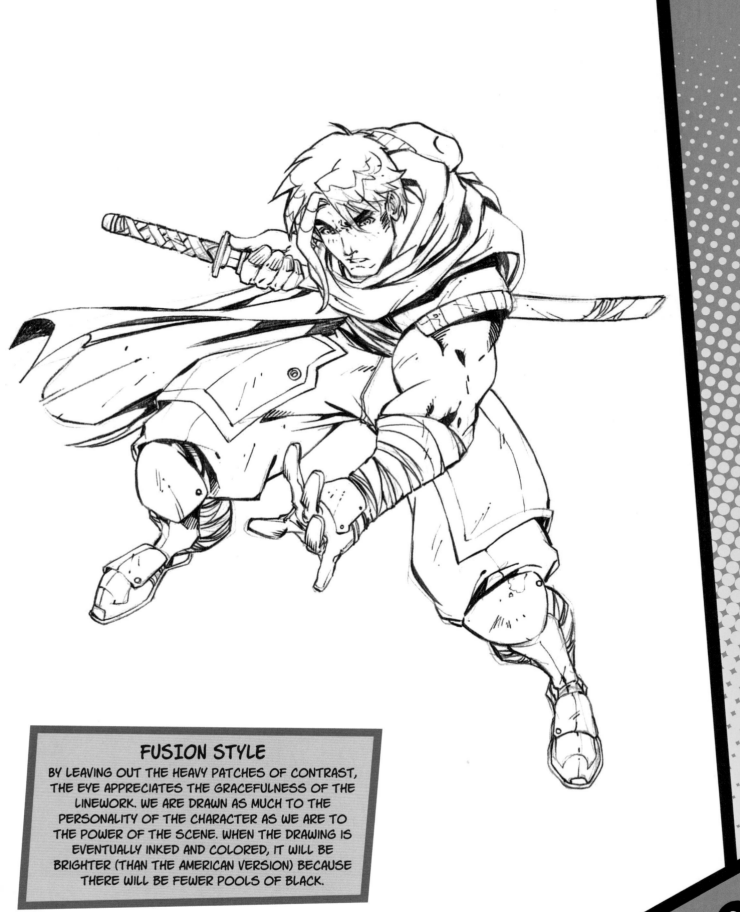

FUSION STYLE

BY LEAVING OUT THE HEAVY PATCHES OF CONTRAST, THE EYE APPRECIATES THE GRACEFULNESS OF THE LINEWORK. WE ARE DRAWN AS MUCH TO THE PERSONALITY OF THE CHARACTER AS WE ARE TO THE POWER OF THE SCENE. WHEN THE DRAWING IS EVENTUALLY INKED AND COLORED, IT WILL BE BRIGHTER (THAN THE AMERICAN VERSION) BECAUSE THERE WILL BE FEWER POOLS OF BLACK.

Light, Shadow and Mood

All comic book art uses light and shadow to create engaging moods. And this works especially well on Fusion characters. You can bathe these characters in pools of blackness and edges of light. Their elegant look, splashed with shadow, gives them a dark glamour that is at once compelling and haunting. To use light and shadow, ask yourself where the light source is for a scene. You need to know the light source, because the shadows have to make sense. If you don't know where the light comes from, you'll be winging it, applying shadows here and there wherever you think they'll look good. But the result will not be logical or look particularly appealing. So, think "light" so that you'll be able to draw "dark."

Various Light Sources and Resulting Shadows

Cool looks result from multiple light sources. Two, even three, light sources in different spots around a character, create appealing moody effects. The light sources don't all have to be of equal strength. Often, a weaker, secondary light source provides just the accent needed.

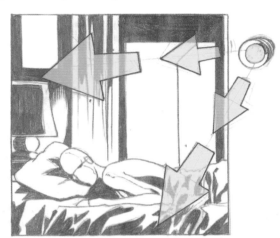

UNSEEN LIGHT SOURCE
YOU DON'T HAVE TO ACTUALLY SEE THE LIGHT SOURCE TO SEE ITS EFFECTS. EXAMPLES OF THIS COULD BE LIGHT FROM A WINDOW OR FROM AN OVERHEAD FIXTURE IN ANOTHER ROOM.

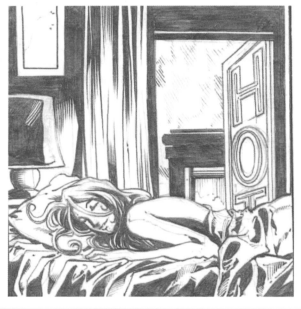

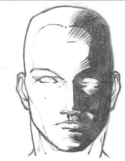

Light source from left.

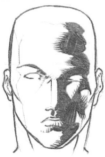

Major light source from left and minor light source from right.

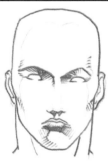

Overhead light source.

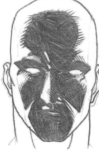

Minor light sources from left and right.

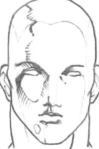

Major light source from right and minor light source from left.

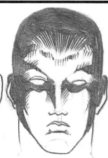

Light source from below.

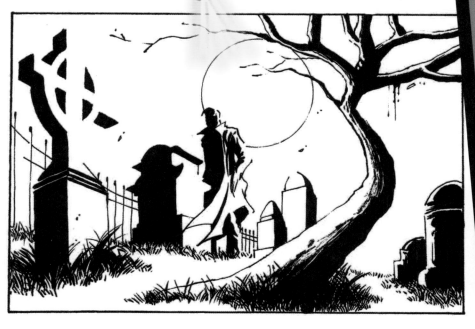

The Moon as a Light Source

Moonlight causes hard shadows, with no soft gradations. The cemetery on a moonlit night is a great location for shadows. Any figures and objects, plus the foreground and background, are all hit by the same one light source and, therefore, cast shadows in the same direction.

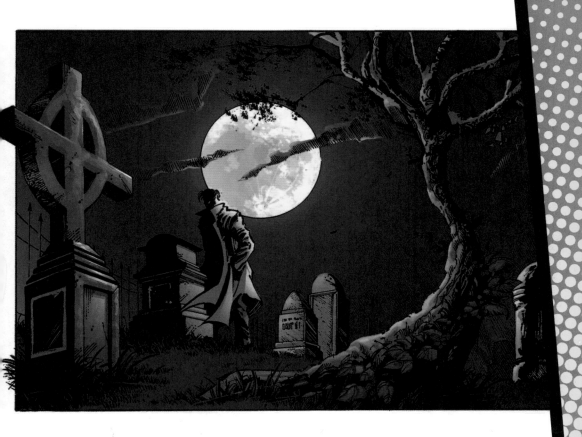

Edge Lighting

Edge lighting is a popular device and one of the most effective types of light for highlighting the curves of female characters. In edge (or rim) lighting, the major light source hits the figure on one side while, simultaneously, a minor light source hits the figure from the opposite side. This results in the formation of a thin sliver of shadow that falls on the figure between the two light sources (but closer to the minor light source). This narrow shadow travels in a serpentine manner along the contours of the body, accentuating every curve.

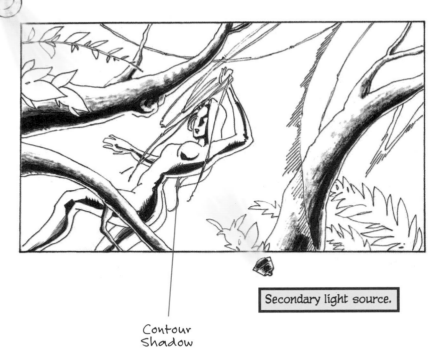

-Main light source.

Contour Shadow

Secondary light source.

98

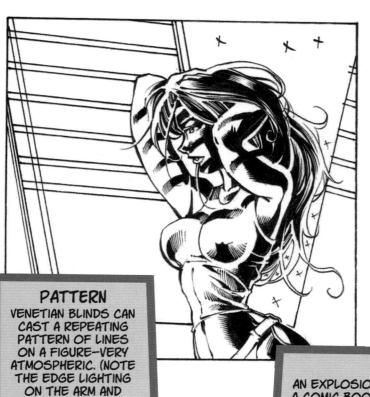

PATTERN

VENETIAN BLINDS CAN CAST A REPEATING PATTERN OF LINES ON A FIGURE—VERY ATMOSPHERIC. (NOTE THE EDGE LIGHTING ON THE ARM AND SHOULDER.)

EXPLOSIONS

AN EXPLOSION IS A VIOLENT, SUDDEN BURST THAT FLOODS A COMIC BOOK PANEL. SINCE IT IS ALSO A LIGHT SOURCE, IT CAN CAUSE AN INTENSE SHADOW TO FALL ON A CHARACTER. IF THE EXPLOSION IS BEHIND THE FIGURE, THE SHADOW FALLS ON THE FRONT OF THE FIGURE.

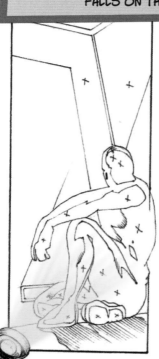

REVERSE EDGE LIGHTING

THE FIGURE IS BATHED IN BLACK WITH A SLIVER OF LIGHT RUNNING DOWN THE CONTOUR OF THE FIGURE. THIS IS A THICK, BROODING, NOIR LOOK.

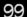

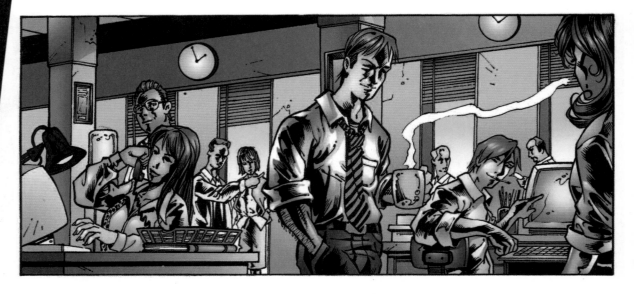

WINDOW LIGHT

NOT ALL INTERIOR LIGHTING IS OVERHEAD FLUORESCENT LIGHTING. IF THAT WERE THE CASE, EVERYONE IN AN OFFICE BUILDING WOULD BE WALKING AROUND WITH SPOOKY SHADOWS ON THEIR FACES. FLUORESCENT LIGHTING IS NOT ACTUALLY VERY STRONG, WHICH IS WHY IT'S SO DREARY. A STRONGER LIGHT COMES THROUGH OFFICE WINDOWS. IN THIS EXAMPLE, THERE ARE TWO BASIC LIGHT SOURCES: (1) THE LARGE WINDOWS RUNNING ALONG THE BACK OF THE ENTIRE SCENE, AND (2) A SECONDARY, UNSEEN LIGHT THAT'S OFF-PANEL TO THE LEFT AND COULD BE EITHER MORE WINDOWS OR LIGHT THAT HAS TRAVELED FROM THE VISIBLE WINDOWS, BOUNCED OFF A WALL SOMEWHERE TO THE LEFT OF THE PANEL, AND HIT THE PEOPLE IN THE SCENE. THIS WOULD BE *BOUNCE LIGHT*, WHICH CAN PROVIDE A SECONDARY SOURCE OF LIGHT WHEN THERE'S ONLY ONE LIGHT SOURCE IN A ROOM.

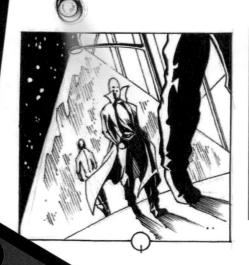

EVENING STREET LIGHT

THE LONELY MIDNIGHT STREETS OF THE CITY ARE EVOCATIVE OF AN EDWARD HOPPER PAINTING. THERE'S NO BOUNCE LIGHT, ONLY THE LONELINESS OF THE SOLITARY STREET LAMP OVERHEAD.

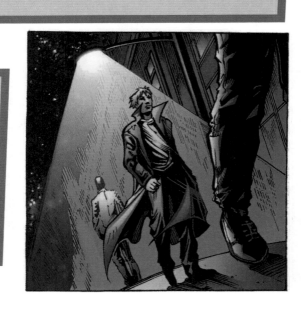

Sound Effect Lettering

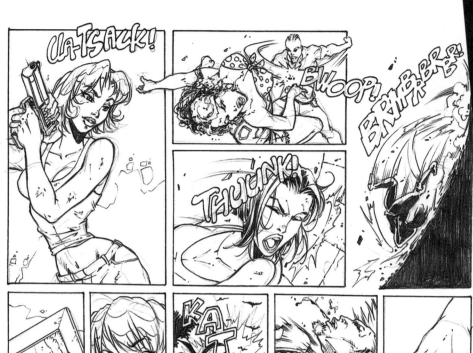

Comics wouldn't be comics without sound effects. Authentic-style manga boasts huge sound effects that literally swamp a page with block letters. So, too, does Fusion, although it doesn't quite have the abandon of authentic Japanese manga. Most sound effects are made up words/sounds. After all, who knows exactly what a crowbar smashing into a plasma-covered robot sounds like? "KA-PONG!" maybe? Or perhaps "GRRYNNXX!" Since I don't know and you don't know, then no one else does either! So, just come up with something that sounds like action. Here are some fun examples of sound effects and lettering styles.

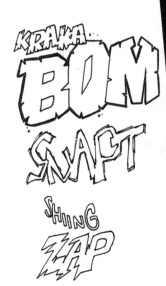

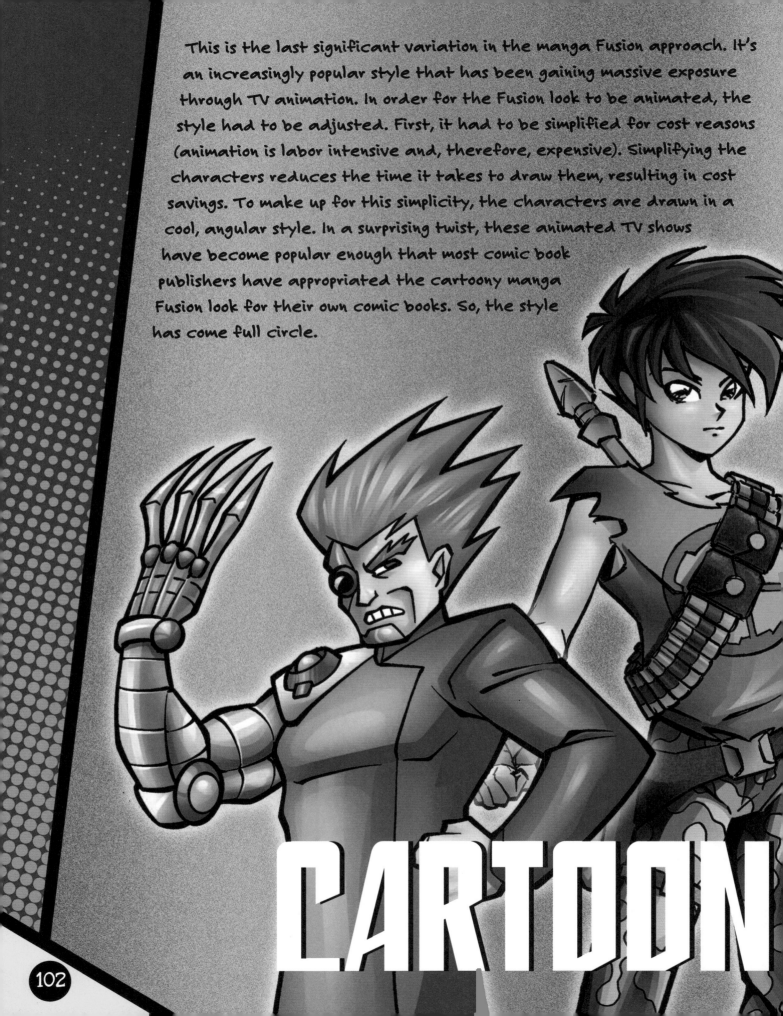

This is the last significant variation in the manga Fusion approach. It's an increasingly popular style that has been gaining massive exposure through TV animation. In order for the Fusion look to be animated, the style had to be adjusted. First, it had to be simplified for cost reasons (animation is labor intensive and, therefore, expensive). Simplifying the characters reduces the time it takes to draw them, resulting in cost savings. To make up for this simplicity, the characters are drawn in a cool, angular style. In a surprising twist, these animated TV shows have become popular enough that most comic book publishers have appropriated the cartoony manga Fusion look for their own comic books. So, the style has come full circle.

CARTOON

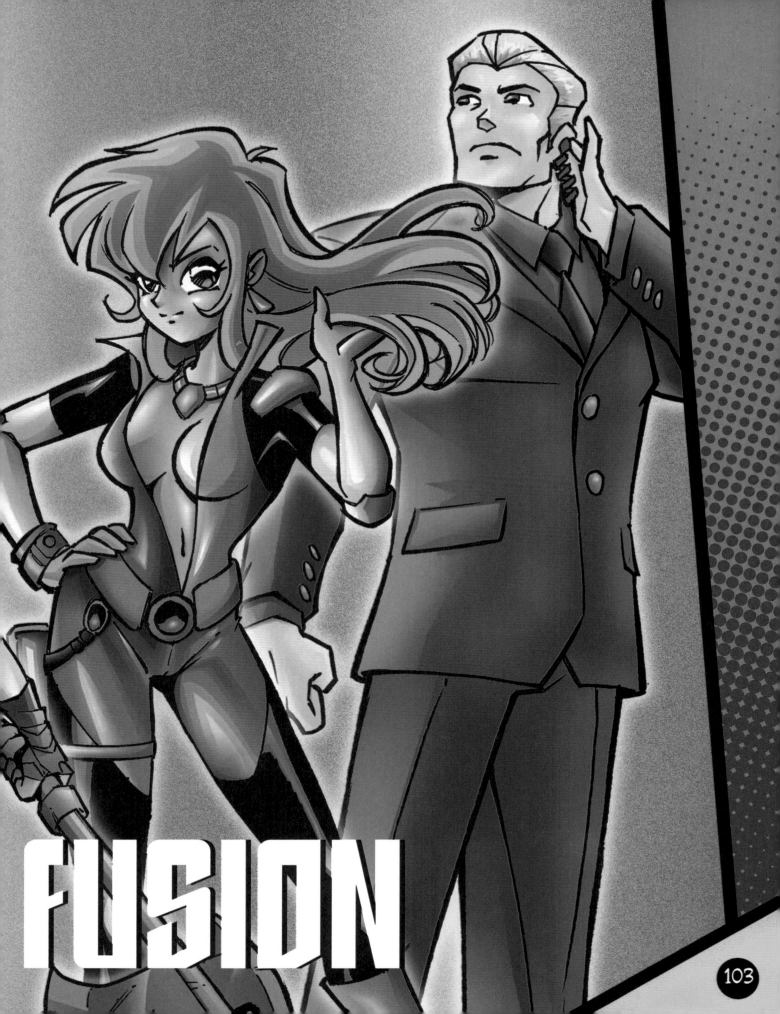

FUSION

The Basics

Fusion characters look more mature, physically, than their manga counterparts. Manga characters typically have round, young faces; the Fusion hero's head is a bit more square and, therefore, more masculine. Standard manga eyes are huge, whereas Cartoon Fusion eyes are smaller (but still have the famous manga eye shines). True manga hairstyles are a bit more extreme and manga bodies are less muscular than their Fusion counterparts. Cartoon Fusion often features metallic shines on costumes, which is something you see a lot in American comics (for example, the shine on the evil scientist's metal arm).

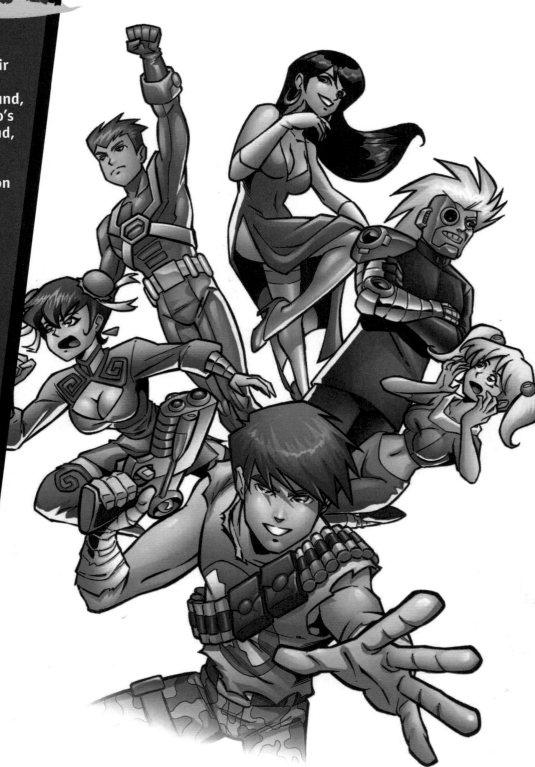

The eyes fall about halfway down the head.

In American-style comics, the space between the two tear ducts equals the width of the nose, but in Cartoon Fusion, the nose is a bit smaller. If that sounds too specific and hard to remember, just remember this: Always keep the nose small.

The mouth is level with the point where the jaw begins to angle in toward the chin.

The distance between the eyeballs equals the distance between the ends of the mouth.

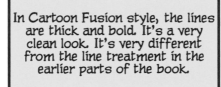

In Cartoon Fusion style, the lines are thick and bold. It's a very clean look. It's very different from the line treatment in the earlier parts of the book.

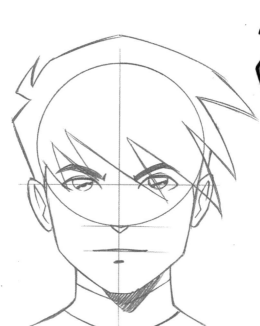

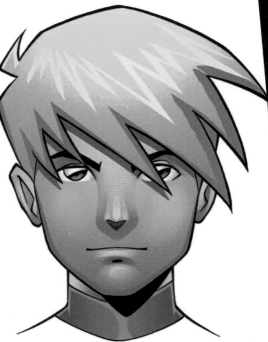

The Face Up Close

The young Cartoon Fusion hero has a chiseled face. The hair is still spiked, which gives him that manga flair, but it's not as over-the-top as on most manga characters. The nose is indicated by a small touch of shading, reminiscent of the manga nose. The eyeballs have shines, like manga, but the overall style of the eye is American (not tall and huge as in manga). The mouth is wider than the typical manga mouth.

Profile

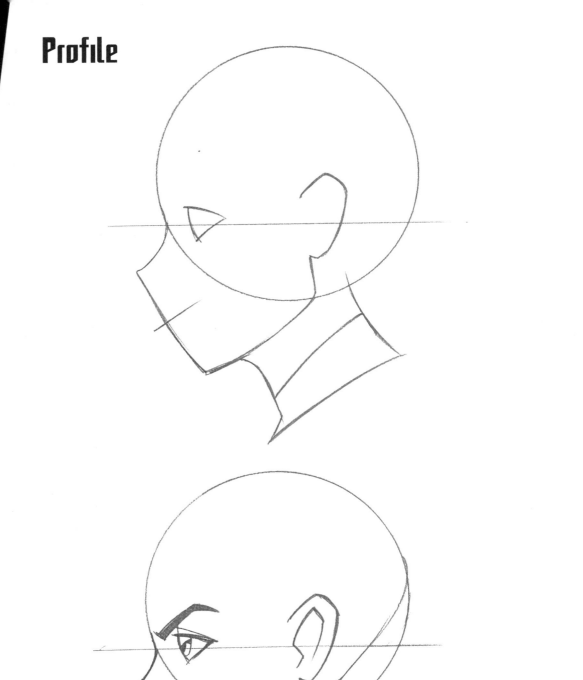

keep the angle
of the jaw sharp
below the ear.

TO START THE PROFILE, DRAW A DIAGONAL LINE FROM
THE TIP OF THE NOSE TO THE TIP OF THE CHIIN; THEN
CARVE OUT THE FEATURES ALONG THAT LINE.

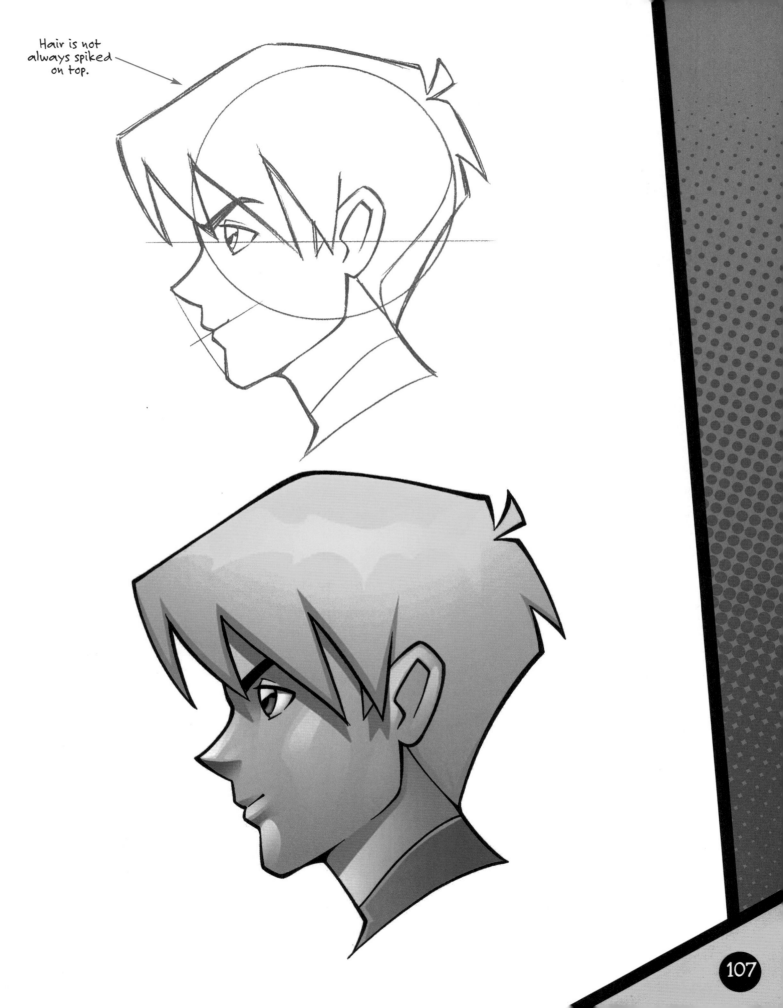

Hair is not always spiked on top.

The top of the head is large.

Create large, full lips (as opposed to authentic manga lips, which are always small).

Just as with male characters, show the angle of the jaw on female characters.

The bottom of the head (the jaw section) is small by comparison.

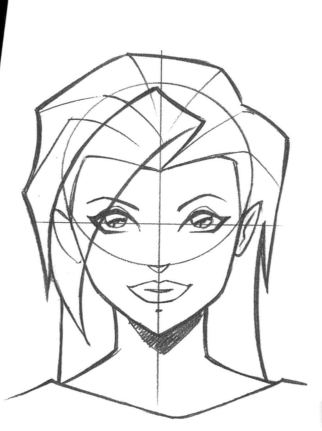

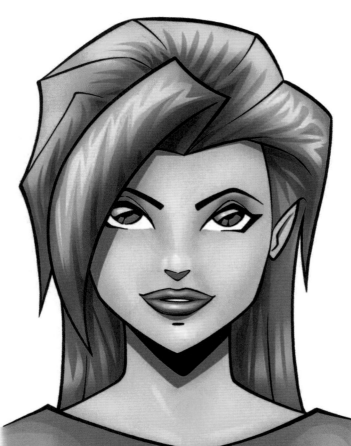

Profile

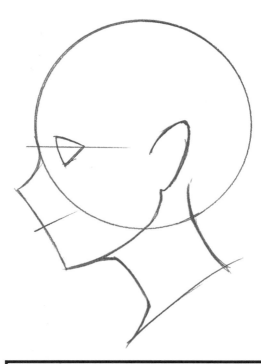

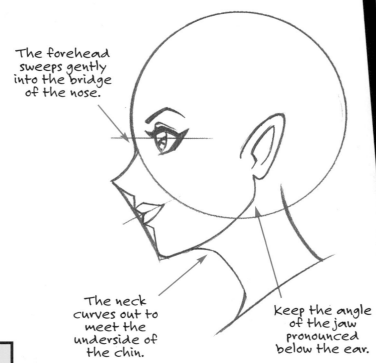

The forehead sweeps gently into the bridge of the nose.

The neck curves out to meet the underside of the chin.

Keep the angle of the jaw pronounced below the ear.

Just as with male characters, to create the profile, draw a diagonal guideline from the tip of the nose to the tip of the chin and then chisel out features within that area.

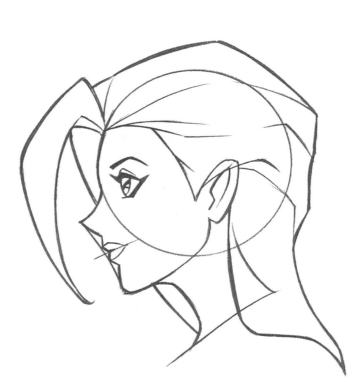

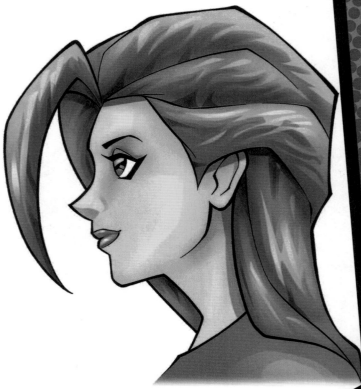

Cartoon Fusion Expressions

Cartoon Fusion expressions are a combination of the American and manga styles simplified for animation purposes. The mouth shows an economy of movement, as in manga, but the teeth play a larger role in the expressions, which is more American. The manga influence is shown in the cartoon-style humorous expressions. You don't have to follow these expressions precisely. There are many ways to draw any given expression. However, to draw the new cartoon-style Fusion, you need to find a way to bring a manga flair to it.

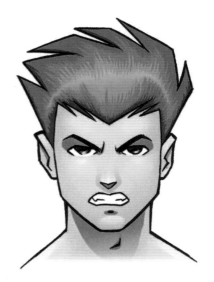

ANGRY

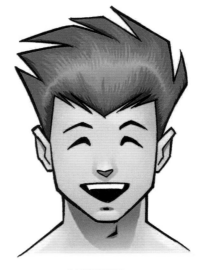

LAUGHING

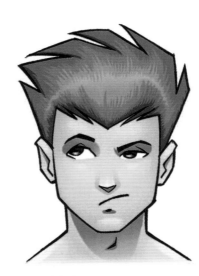

DISAPPOINTED

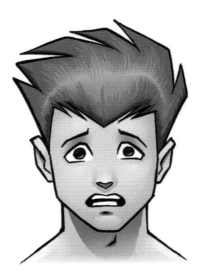

WORRIED

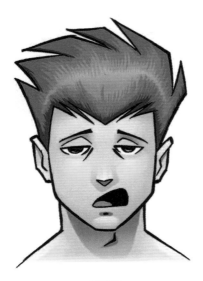

TIRED

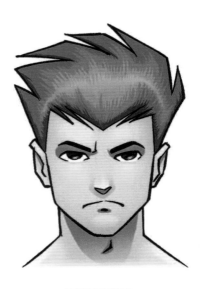

DETERMINED

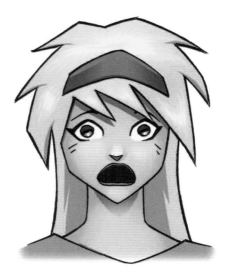

SURPRISED

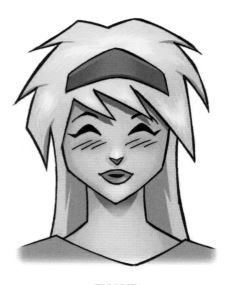

PLEASED

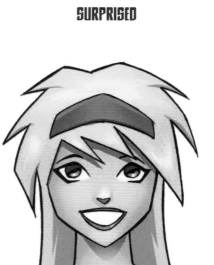

HAPPY

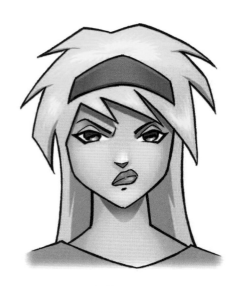

ANNOYED

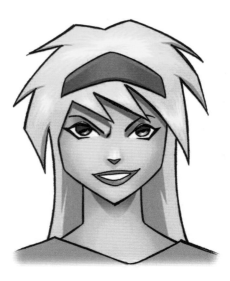

PLAYFUL

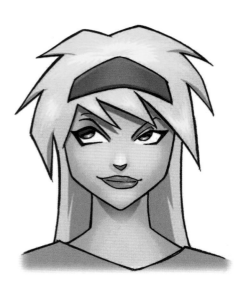

MISCHIEVOUS

The Cartoon Fusion Hero

The salient difference between the authentic manga hero and the Cartoon Fusion counterpart is age. Manga has a long history of teenage, or even preteen, heroes, whereas American comics feature teen characters as sideline or spin-off characters. Cartoon Fusion heroes are young as well, just not so young as those in manga. Think of them as high school juniors and seniors. They also retain the fighting style of American comics, with the muscular clashes and special effects.

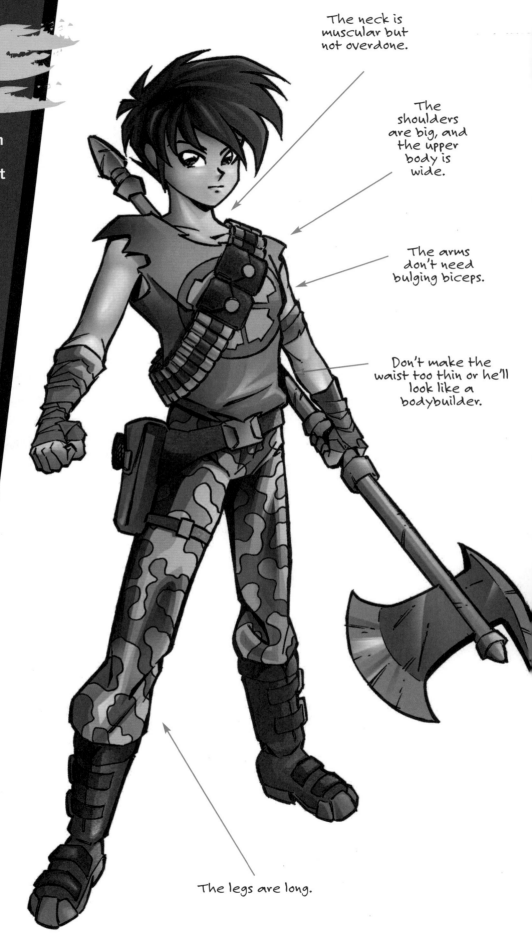

The neck is muscular but not overdone.

The shoulders are big, and the upper body is wide.

The arms don't need bulging biceps.

Don't make the waist too thin or he'll look like a bodybuilder.

The legs are long.

The Cartoon Fusion Heroine

The shoulders are wide.

When it comes to female characters, authentic manga is famous for putting Kewpie-doll faces onto buxom bodies, which makes for a rather uncomfortable combination. The Cartoon Fusion heroine's face, however, is consistent with her maturity. The Cartoon Fusion woman is also more filled out and curvy than her manga counterpart. This makes for a more seductive, dangerous character. Heroines in comics are not shy. They know how to fight. And they will fight, if pushed. There was a backlash against women being too meek in comics, and now the trend has gone even further in the opposite direction so that the women are more assertive than the men, challenging anyone who dares to question their resolve. They fight using martial arts moves.

The legs are not overly muscular.

The ankles are thin (even in boots).

The shoes have high heels to make the legs look longer and push up the calf muscles, making the legs shapelier.

Supporting Characters

INCLUDE CONTROLS ON THE HANDHELD MONITOR SO THAT WHOEVER IS HOLDING IT CAN TRY TO ADJUST THE TUNING IF THE IMAGE BEGINS TO FADE.

Mission Commander

Cartoon Fusion characters are often part of a group, headed by a mysterious leader who conveys their battle plans. The leader is drawn with straight lines so that he looks flat, which is a typical style for manga characters who don't have huge eyes and pointy chins. He sometimes appears as a projected hologram. He can also appear on a handheld monitor. Then he can zap out as fast as he appears. If any group members want to ask questions or opt out of a dangerous assignment, it's too late. The orders have been given and it's over-and-out. Blink!

SHOW THE COMMANDER IN A CLOSE-UP. A FULL SHOT WILL MAKE HIM LOOK SMALL AND WEAK.

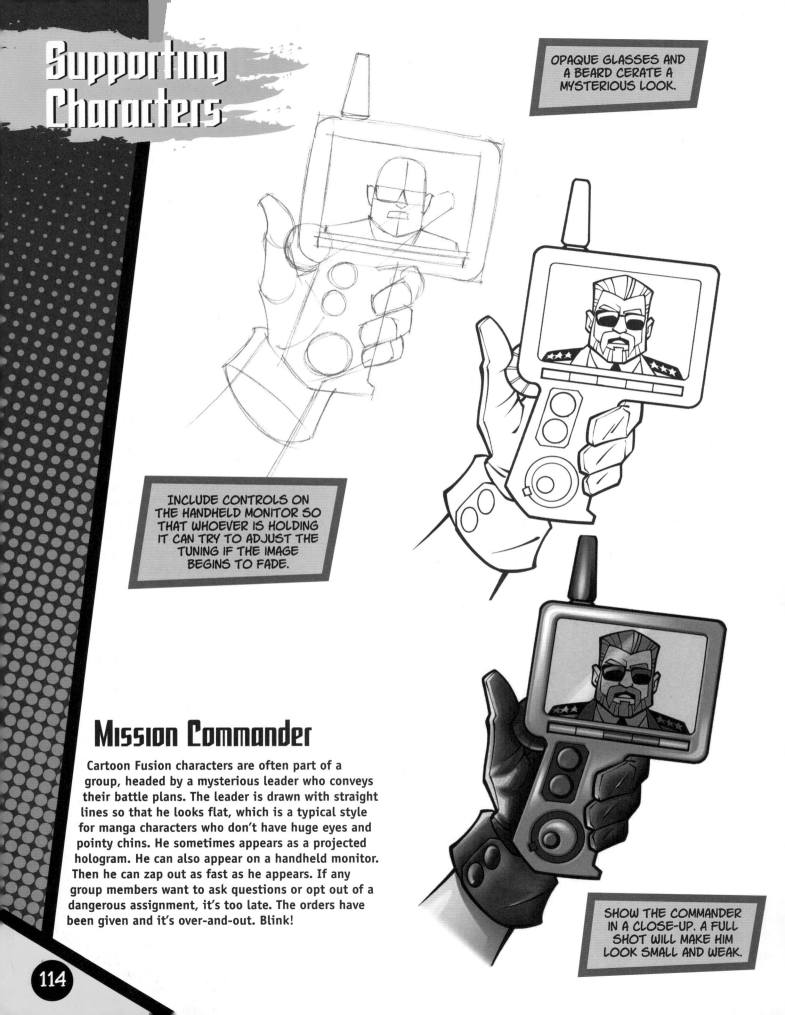

Crazy Scientist

Scientists in lab coats are a staple of manga. So, it's no surprise that they're part of the Cartoon Fusion style. It's a law in comics that if you study science for too long, you're going to end up wanting to rule the world. Why somebody doesn't try to get these guys to pursue, say, the violin instead remains a mystery. But once your scientist passes that point at which all he craves is world domination, it's too late.

THE HAIR IS WILD, LIKE EINSTEIN'S HAIR IN A PANIC.

A CYBORG HEADPIECE, SUCH AS AN INFRARED EYEPIECE IS A NICE TOUCH.

DON'T FORGET THE LAB COAT.

THERE'S OFTEN A MECHANICAL LIMB. THESE SCIENTISTS HAVE OFTEN BEEN SERIOUSLY, ALMOST MORTALLY, INJURED DOING EXPERIMENTS AND HAVE INVENTED REPLACEMENT PARTS TO MAKE THEMSELVES STRONGER—AND MORE DANGEROUS.

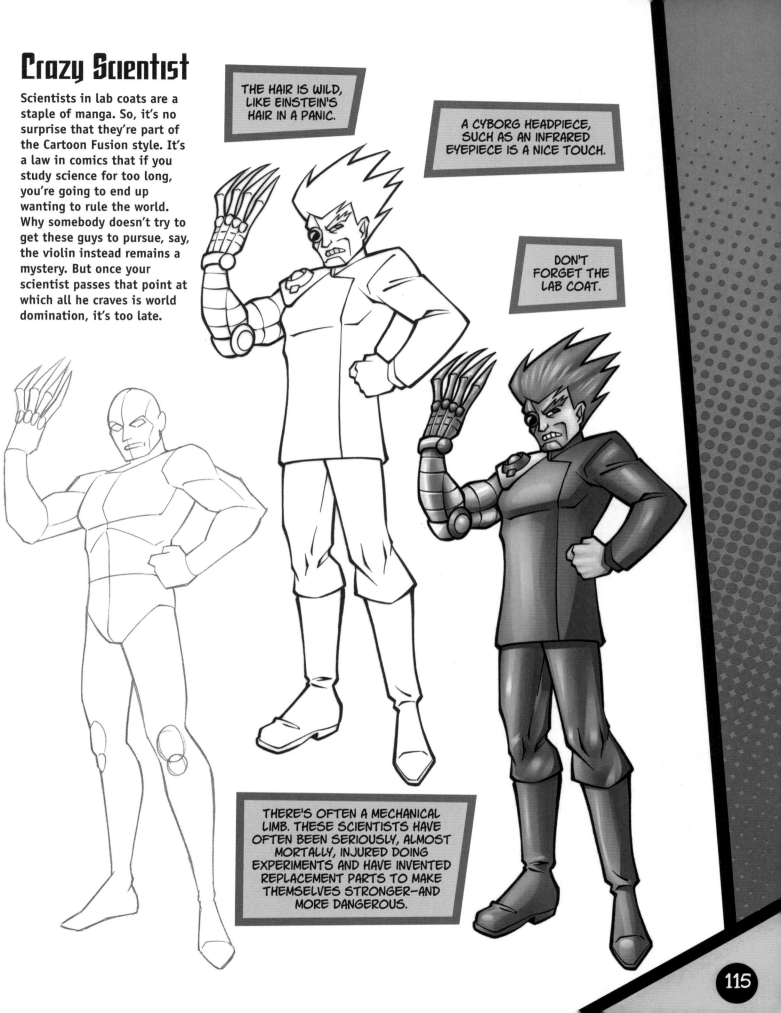

Hands

The Cartoon Fusion hand is very linear, for stylistic reasons. For example, on the male characters the fingertips are square, which is different from either American comics or manga. The look has less detail on the palm and a cleaner overall shape.

Hand pad

Heel of thumb

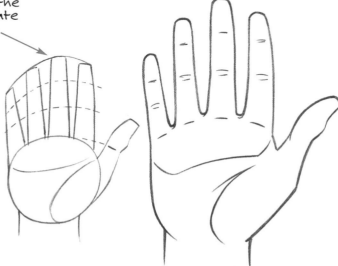

The tips of the fingers create an arch.

The wrist curves where it attaches to the hand, which achieves a three-dimensional look.

The knuckles fall in the middle of the base of each finger.

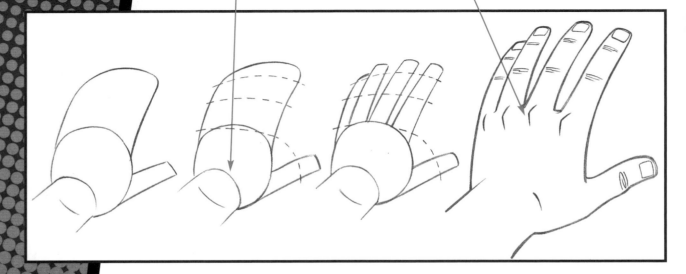

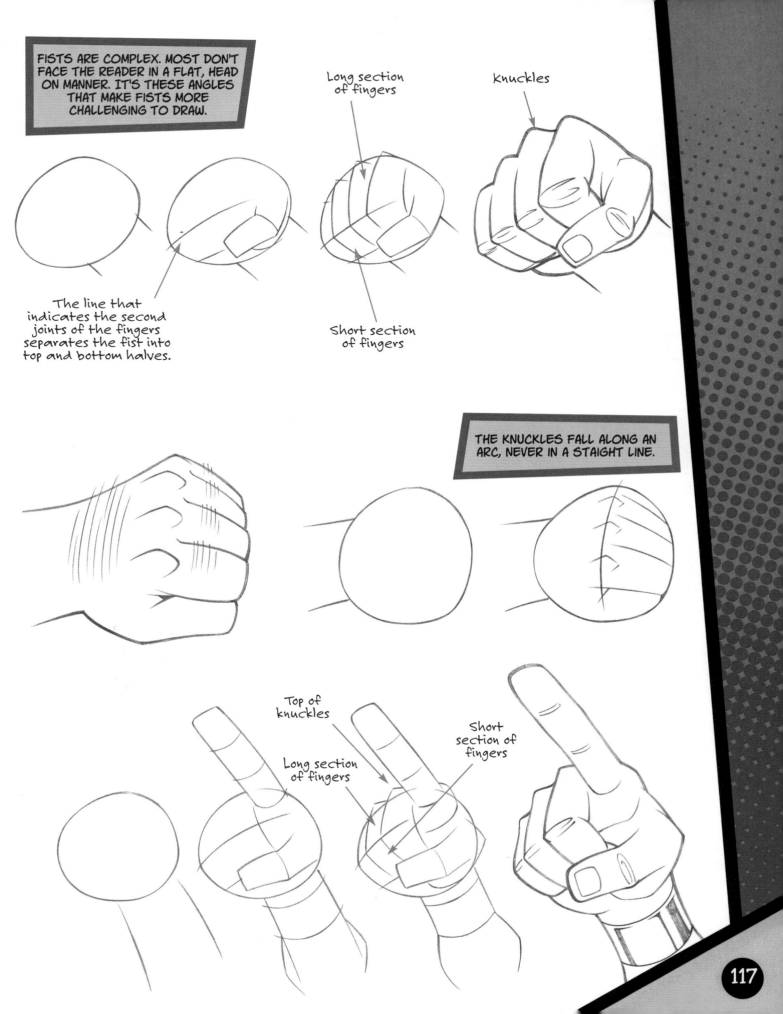

FISTS ARE COMPLEX. MOST DON'T FACE THE READER IN A FLAT, HEAD ON MANNER. IT'S THESE ANGLES THAT MAKE FISTS MORE CHALLENGING TO DRAW.

Long section of fingers

Knuckles

The line that indicates the second joints of the fingers separates the fist into top and bottom halves.

Short section of fingers

THE KNUCKLES FALL ALONG AN ARC, NEVER IN A STAIGHT LINE.

Top of knuckles

Short section of fingers

Long section of fingers

117

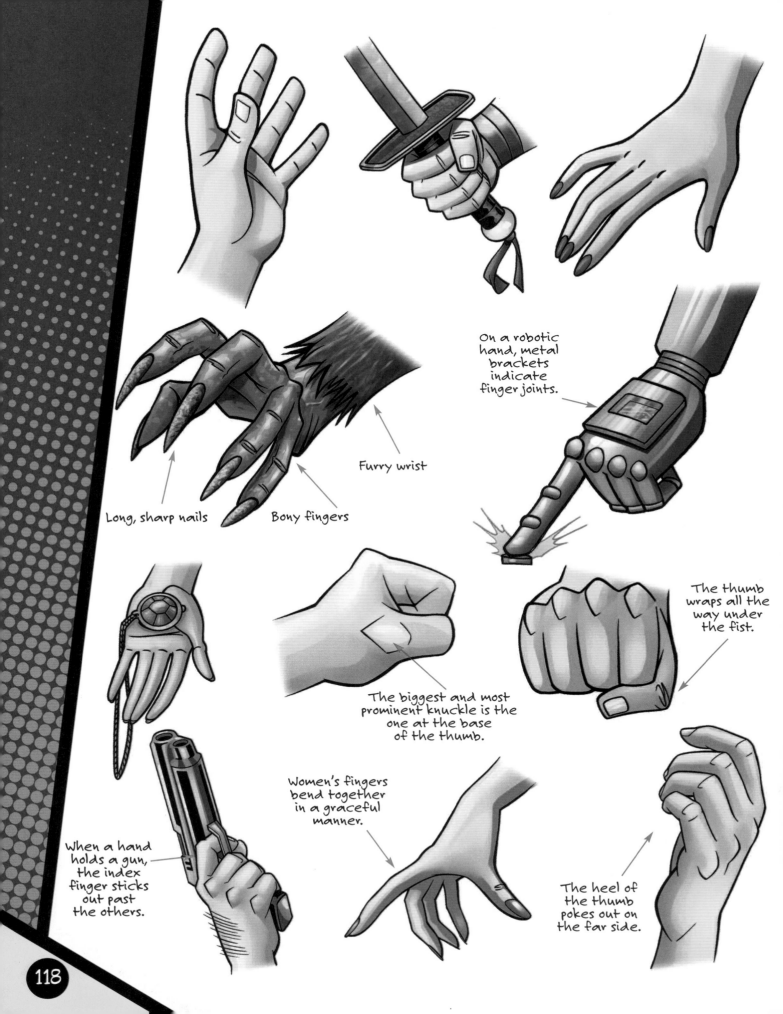

On a robotic hand, metal brackets indicate finger joints.

Furry wrist

Long, sharp nails

Bony fingers

The thumb wraps all the way under the fist.

The biggest and most prominent knuckle is the one at the base of the thumb.

Women's fingers bend together in a graceful manner.

When a hand holds a gun, the index finger sticks out past the others.

The heel of the thumb pokes out on the far side.

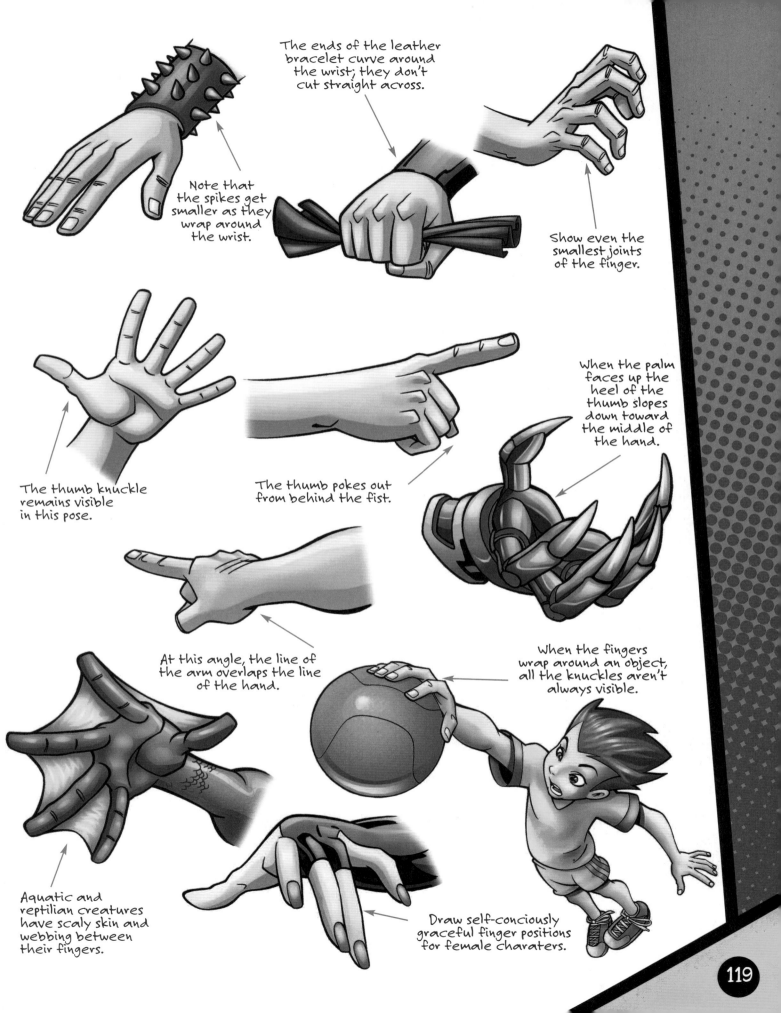

The ends of the leather bracelet curve around the wrist; they don't cut straight across.

Note that the spikes get smaller as they wrap around the wrist.

Show even the smallest joints of the finger.

The thumb knuckle remains visible in this pose.

The thumb pokes out from behind the fist.

When the palm faces up the heel of the thumb slopes down toward the middle of the hand.

At this angle, the line of the arm overlaps the line of the hand.

When the fingers wrap around an object, all the knuckles aren't always visible.

Aquatic and reptilian creatures have scaly skin and webbing between their fingers.

Draw self-conciously graceful finger positions for female charaters.

The Two Basic Comic Book Ages

Does growing older simply mean getting more wrinkles? Yes, there are more facial lines; however, the Cartoon Fusion approach is a simplified and clean look. Excessive wrinkles would detract from it. Instead, the overall structure of the face goes through subtle, age-related changes.

In addition, there are only two basic ages in comics: young and old. Where is the line between them? Any character who would be able to name the five hottest rock bands currently on the radio is young. Classic American action-style comics feature many thirty- and even fortysomething heroes. But the cartoon Fusion style relies exclusively on younger heroes. The older characters are villains or are in supporting roles.

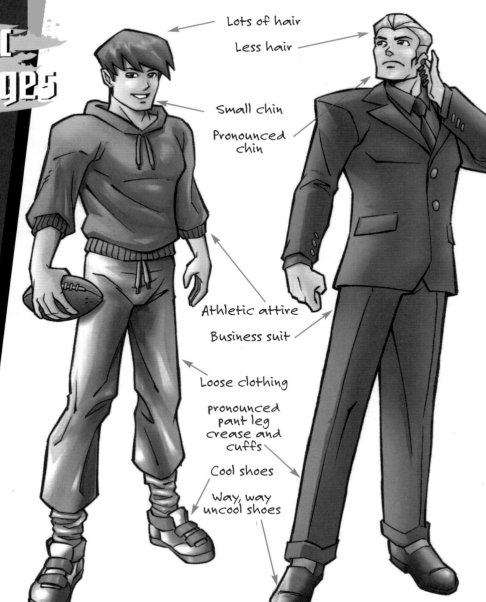

Lots of hair

Less hair

Small chin

Pronounced chin

Athletic attire

Business suit

Loose clothing

pronounced pant leg crease and cuffs

Cool shoes

Way, way uncool shoes

Twentysomething

THE YOUTHFUL, ADULT FACE.

Fortysomething

THE CHEEKBONES AND CHIN BECOME MORE PRONOUNCED. THE HAIRLINE RECEDES.

Fiftysomething

THE FACE CONTINUES TO THIN OUT, RESULTING IN A MORE ANGULAR LOOK. DUE TO THE RECEDING HAIRLINE, THE FOREHEAD BECOMES MORE PRONOUNCED. FACIAL CREASES GAIN PROMINENCE.

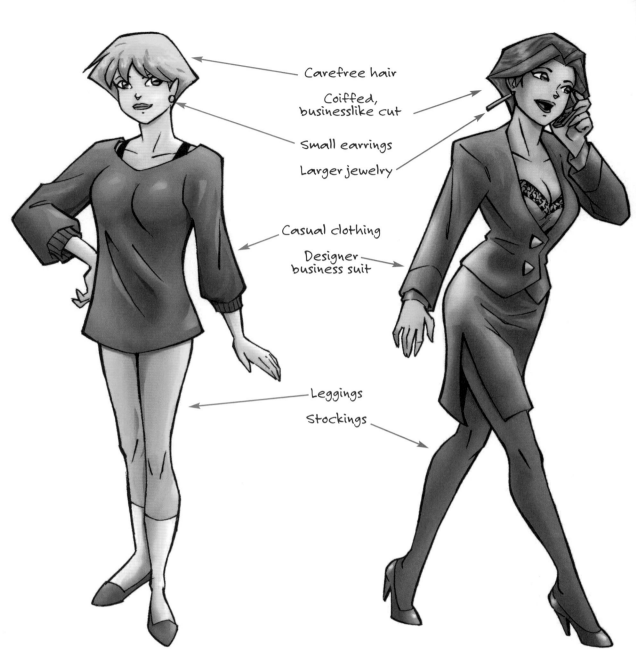

Carefree hair

Coiffed,
businesslike cut

Small earrings

Larger jewelry

Casual clothing

Designer
business suit

Leggings

Stockings

Twentysomething

PRETTY
ALL OVER.

Fortysomething

THE FACE BECOMES WIDER
BUT ALSO MORE ANGULAR.

Fiftysomething

THE FACE STILL BECOMES
WIDER AND MORE ANGULAR, BUT
THE LIPS GET THINNER. AND
NOTE THE SLIGHTLY FORWARD-
LEANING ANGLE TO THE NECK.

Amazing Silhouettes

Due to their angular, flat and stylized look, Cartoon Fusion characters cut sharp silhouettes. Silhouettes are used liberally throughout all types of comics, and manga Fusion is no exception. Silhouettes are used for a variety of reasons: for a change of pace, to draw attention to a character, to create contrast between characters in the foreground and those in the background, or to create a thicker mood. And sometimes, they're used for the most obvious of reasons: just because they look good.

An effective silhouette needs to have, above all, two elements: (1) a dramatic pose, and (2) clarity. It's not always as easy as you might think. A pose may look fine when not shown in silhouette, but as a silhouette, it may not work. Let this be a warning to you: An excellent picture does not necessarily make an excellent silhouette. Let's see why.

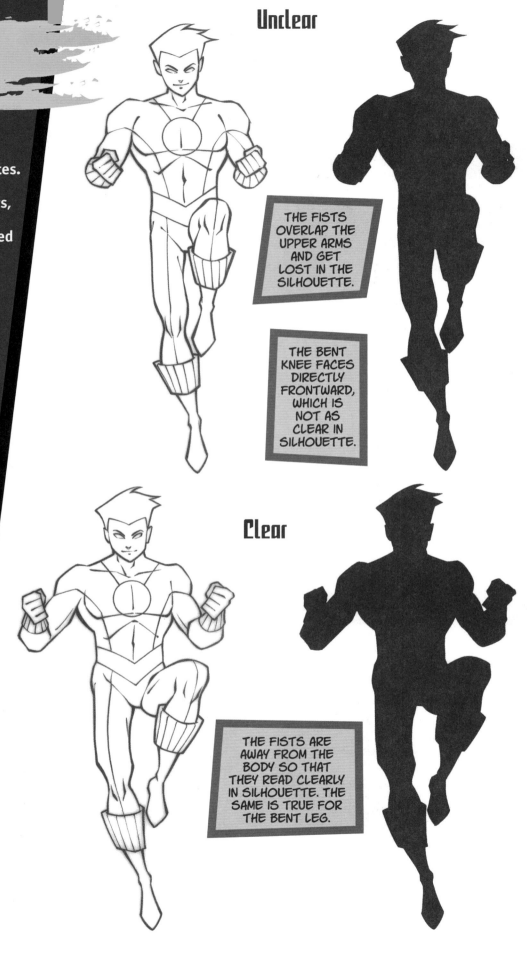

Unclear

THE FISTS OVERLAP THE UPPER ARMS AND GET LOST IN THE SILHOUETTE.

THE BENT KNEE FACES DIRECTLY FRONTWARD, WHICH IS NOT AS CLEAR IN SILHOUETTE.

Clear

THE FISTS ARE AWAY FROM THE BODY SO THAT THEY READ CLEARLY IN SILHOUETTE. THE SAME IS TRUE FOR THE BENT LEG.

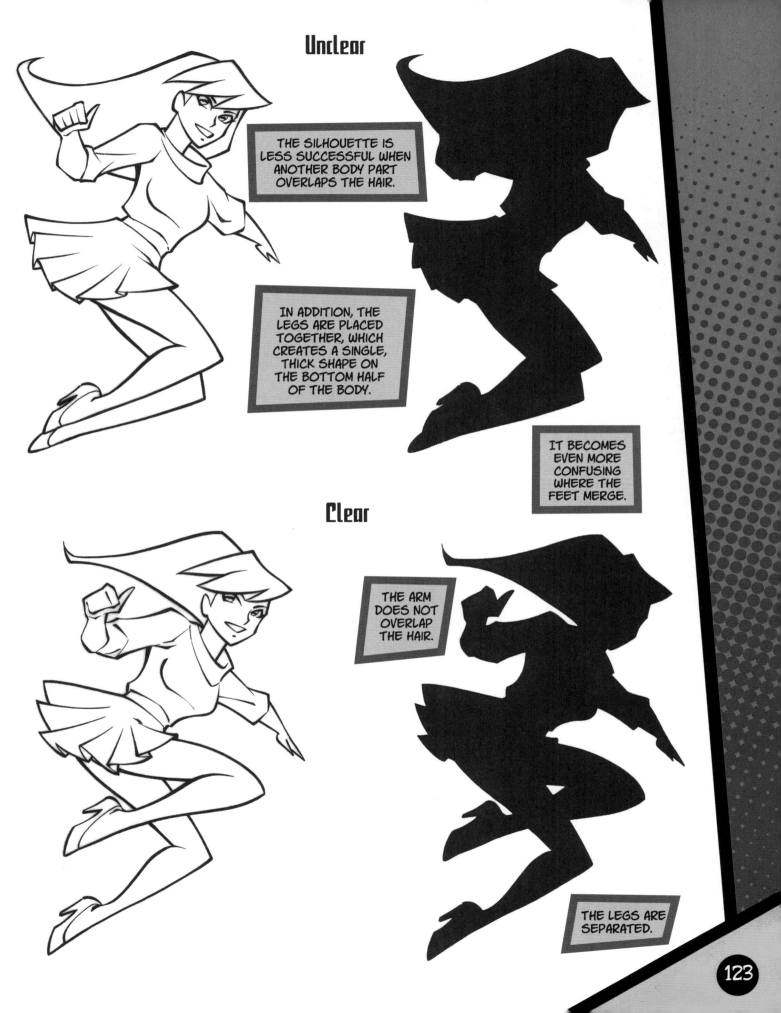

Unclear

THE SILHOUETTE IS LESS SUCCESSFUL WHEN ANOTHER BODY PART OVERLAPS THE HAIR.

IN ADDITION, THE LEGS ARE PLACED TOGETHER, WHICH CREATES A SINGLE, THICK SHAPE ON THE BOTTOM HALF OF THE BODY.

IT BECOMES EVEN MORE CONFUSING WHERE THE FEET MERGE.

Clear

THE ARM DOES NOT OVERLAP THE HAIR.

THE LEGS ARE SEPARATED.

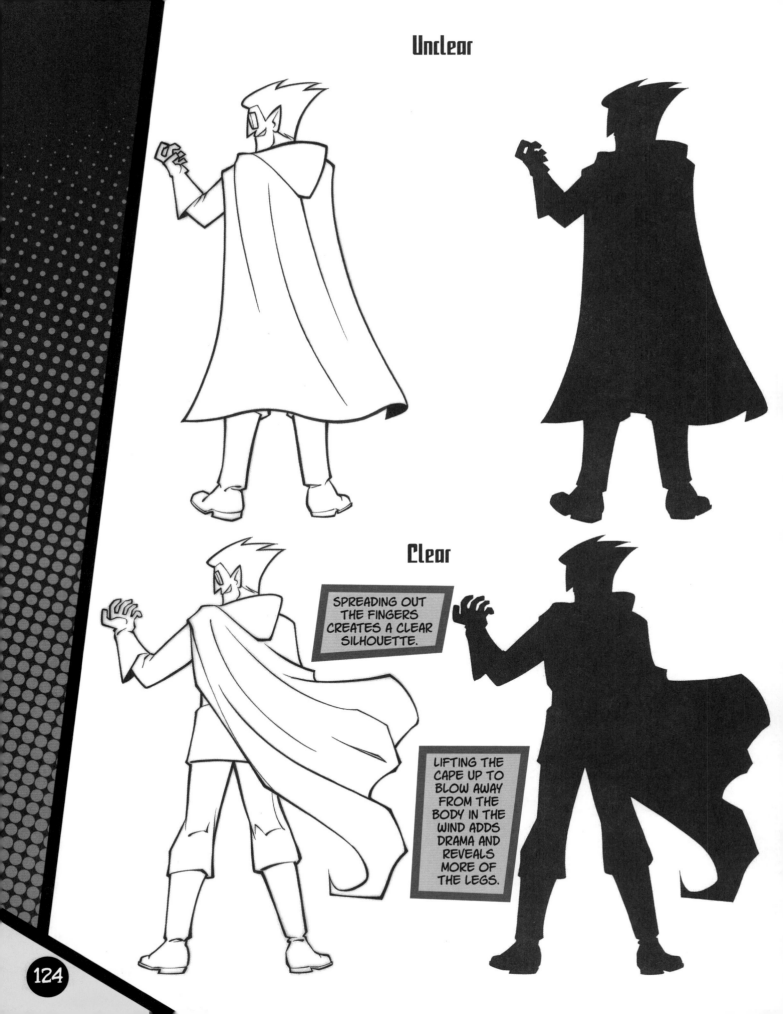

Unclear

Clear

SPREADING OUT THE FINGERS CREATES A CLEAR SILHOUETTE.

LIFTING THE CAPE UP TO BLOW AWAY FROM THE BODY IN THE WIND ADDS DRAMA AND REVEALS MORE OF THE LEGS.

Unclear

THE ARM HOLDING THE SWORD LOOKS TOO SHORT (EVEN THOUGH IT LOOKS OKAY WHEN NOT IN SILHOUETTE).

THE SWORD HANDLE LOOKS LIKE IT'S GOING DIRECTLY INTO THE CHARACTER'S FOREHEAD.

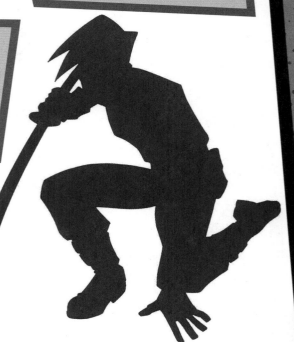

ANOTHER TYPICAL SILHOUETTE MISTAKE: THE CHARACTER'S ARM IS PLACED IN FRONT OF HIS LEG. IN SILHOUETTE, THIS OVERLAP MAKES IT LOOK AS IF A HAND IS GROWING OUT OF HIS KNEE.

Clear

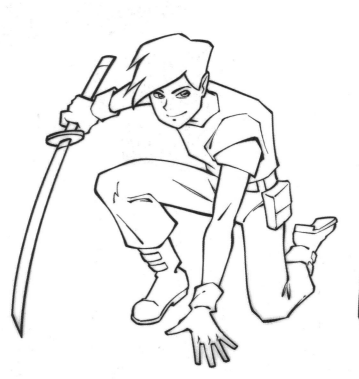

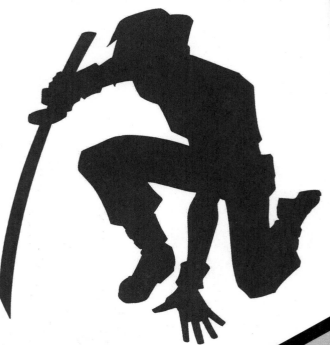

For animation-style characters, action is the key, and fight scenes are the most spectacular way of showing it. Unlike the highly rendered linework of print-style comics, animation-style characters are too graphically flat to capture and hold the reader's attention—unless there is movement. But, once these characters are launched into action, their poses are just as powerful as anything else. This is because the stylish simplicity of the character design highlights the line of action, unfettered by overworked lines and shading.

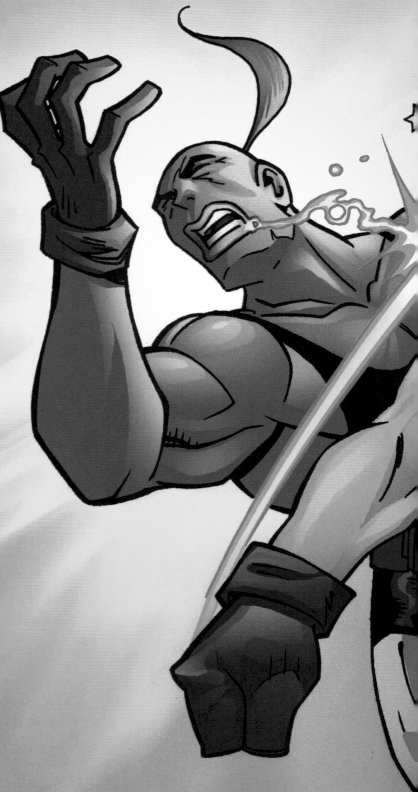

DRAWING

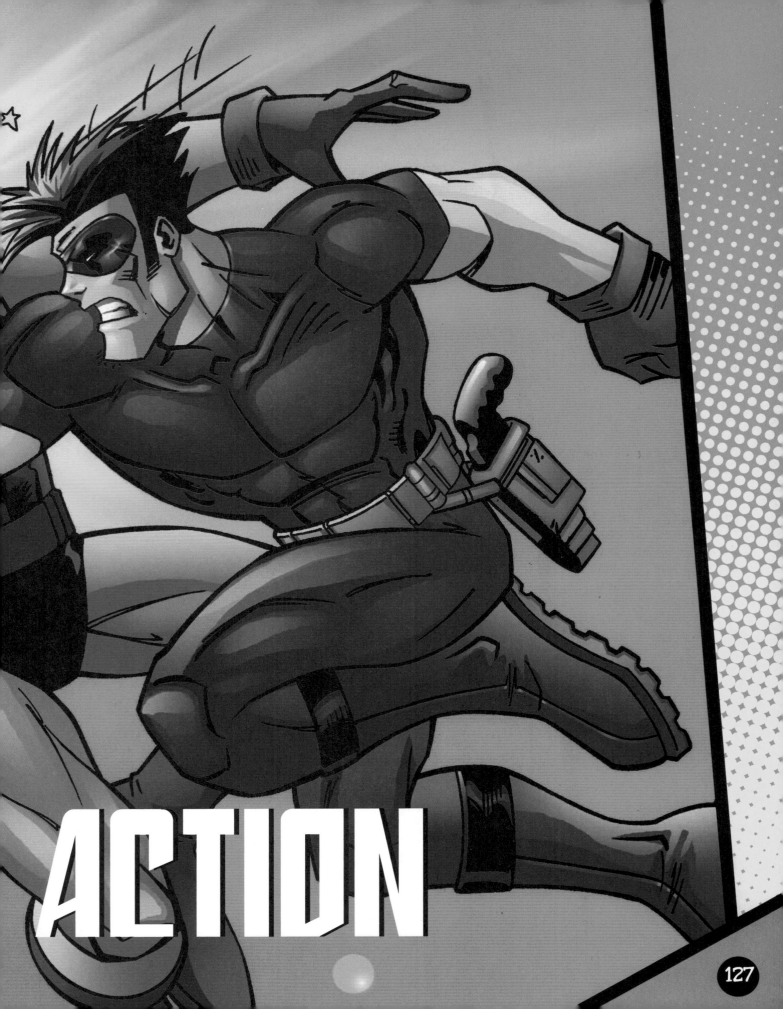

ACTION

The Line of Action

You'll like the concept of the *line of action*. It ties everything together, is simple to use, and boy, does it make a difference in your drawings. You'll wonder how you ever drew an action pose without it.

The line of action is a guideline that you sketch first—before drawing any part of the figure—to show the main thrust of the motion in the pose. When you draw a character with lots of detail, you can sometimes get away with not using the line of action because the rendering is so dramatic. But when you have a stylized, simplified look (as is the case with the Cartoon Fusion style), there simply isn't enough detail to counter a stiff pose. In fact, the line of action becomes even more important to counterbalance the flat, graphic look of the style.

The Punch

More than any other action in comics, the punch needs a one-direction thrust. You need to make all the energy in the pose look as if it's going in one direction. That's where the line of action comes in. Don't labor over it; just quickly sketch a line that indicates the overall flow of the pose. Keep it simple.

PUTTING ONE ARM BACK AND ONE ARM FORWARD MAKES FOR THE MOST DRAMATIC PUNCHING POSE.

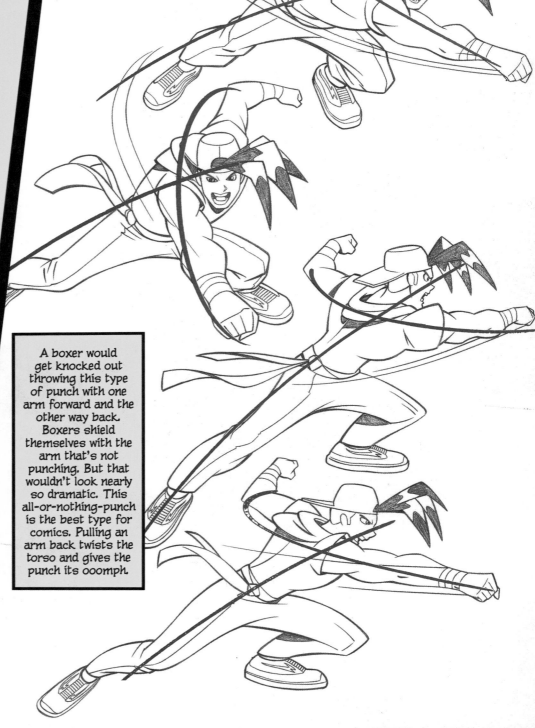

A boxer would get knocked out throwing this type of punch with one arm forward and the other way back. Boxers shield themselves with the arm that's not punching. But that wouldn't look nearly so dramatic. This all-or-nothing-punch is the best type for comics. Pulling an arm back twists the torso and gives the punch its ooomph.

The line of action isn't limited only to punches. Take a look at these other poses.

Graceful Run

Attractive women point their toes when they run.

Reeling Back

In this pose, the line of action dictates, first and foremost, the way the torso moves. The arms are not part of the torso, so they're not part of the line of action. When the body reels back like this, the arms trail the body.

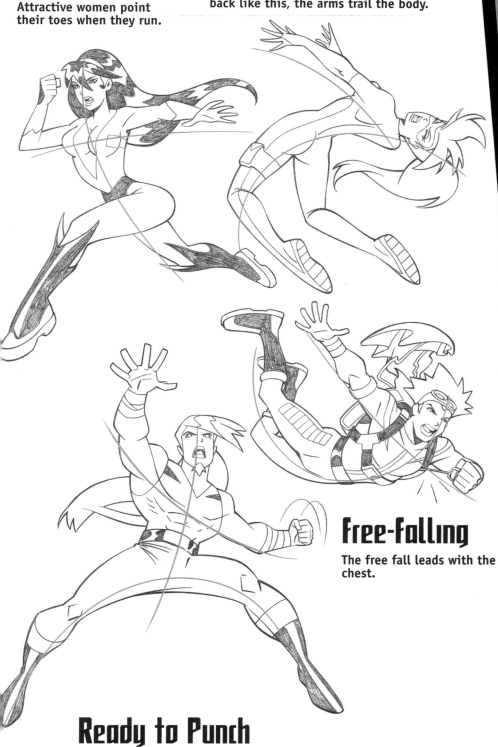

Free-Falling

The free fall leads with the chest.

Ready to Punch

The fist that's ready to punch hangs low, for a dramatic look. Spreading the feet wide adds stability for throwing a haymaker.

Making Contact: Fight Scenes

In authentic manga, fight scenes don't have the giant, cataclysmic, scene-ending punches of American-style comics. In manga, there's more emphasis on characters racing toward one another in clashes. Fusion tilts to the American style.

We've seen how to throw a punch, but things change when you add a second character. The character being punched is responsible for making the punch look effective. That's right, it is the "punchee," for lack of a better term, who gives the punch its power. Think about it. When a boxer throws a punch that doesn't faze his opponent, you think either the guy who got punched is the tougher of the two, or the punch wasn't really that hard. But, if the person who gets punched flies across the ring and lands face down on the mat, then you're impressed with the puncher's power. As I said, it's all in the way the victim reacts. Still, you need to make the punch look powerful *and graceful*, because when combined with an extreme reaction from the victim, it creates a dazzling fight scene.

Kick in the Face

Women do more kicking in comics than men, because it's not considered as masculine. The kick should go straight out, with the leg locked for maximum extension. Notice that her body leans into the pose, never away, which looks weak. Show the moment just after the kick makes contact—never the point of contact (this does not hold true for authentic manga).

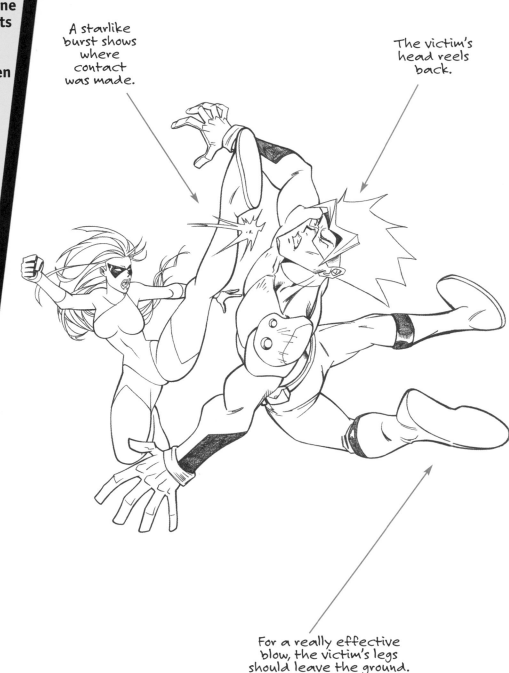

A starlike burst shows where contact was made.

The victim's head reels back.

For a really effective blow, the victim's legs should leave the ground.

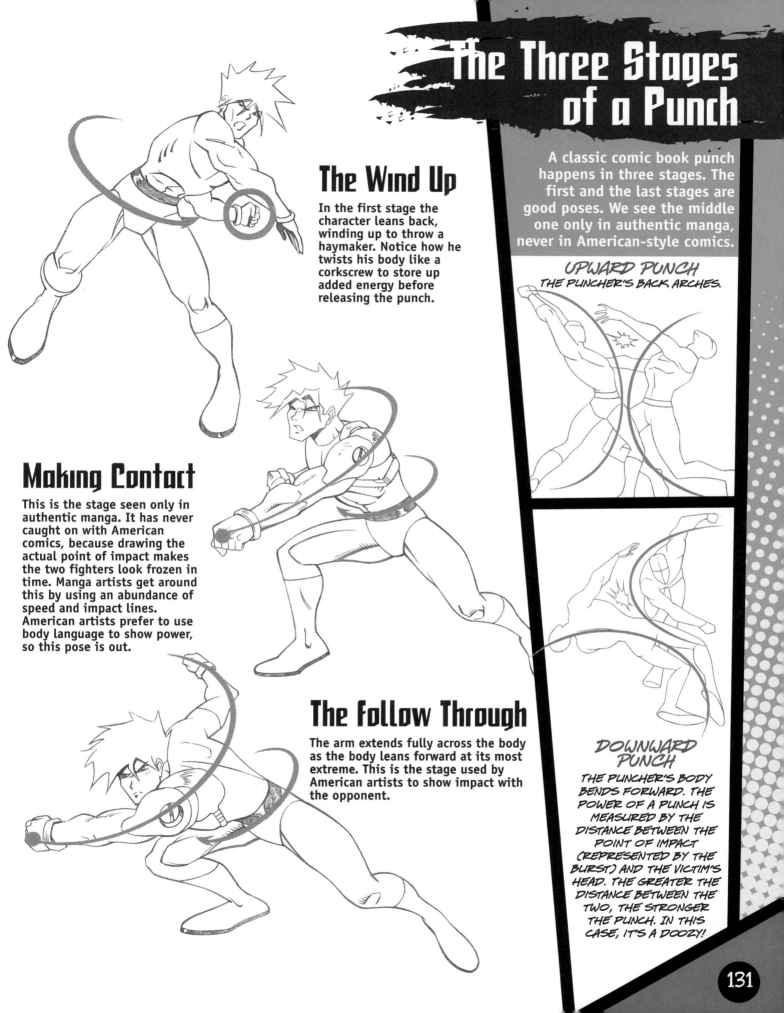

The Three Stages of a Punch

A classic comic book punch happens in three stages. The first and the last stages are good poses. We see the middle one only in authentic manga, never in American-style comics.

UPWARD PUNCH
THE PUNCHER'S BACK ARCHES.

DOWNWARD PUNCH

THE PUNCHER'S BODY BENDS FORWARD. THE POWER OF A PUNCH IS MEASURED BY THE DISTANCE BETWEEN THE POINT OF IMPACT (REPRESENTED BY THE BURST) AND THE VICTIM'S HEAD. THE GREATER THE DISTANCE BETWEEN THE TWO, THE STRONGER THE PUNCH. IN THIS CASE, IT'S A DOOZY!

The Wind Up

In the first stage the character leans back, winding up to throw a haymaker. Notice how he twists his body like a corkscrew to store up added energy before releasing the punch.

Making Contact

This is the stage seen only in authentic manga. It has never caught on with American comics, because drawing the actual point of impact makes the two fighters look frozen in time. Manga artists get around this by using an abundance of speed and impact lines. American artists prefer to use body language to show power, so this pose is out.

The Follow Through

The arm extends fully across the body as the body leans forward at its most extreme. This is the stage used by American artists to show impact with the opponent.

131

Finding the Right Distance

There's another, crucial aspect of drawing fight scenes: the distance between the two fighters. Too close, and the action looks cramped. Too far, and the action lacks impact.

Too Close

The fighter receiving the blow is almost entirely obscured by the puncher.

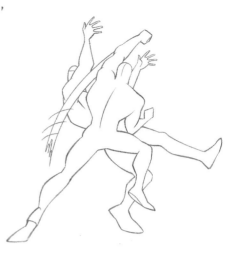

Too Far

These two fighters are too far apart. Despite the fact that one is reeling back, the punch loses all impact.

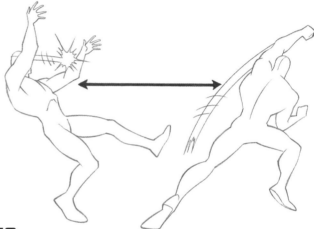

Correct Distance

While the figures overlap to some degree, there is enough space between them for the action to read clearly. The effect is that you can almost feel the impact of the blow.

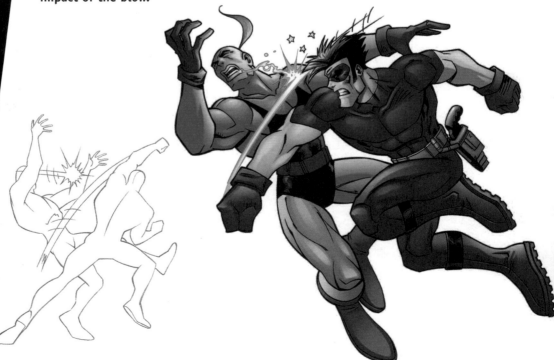

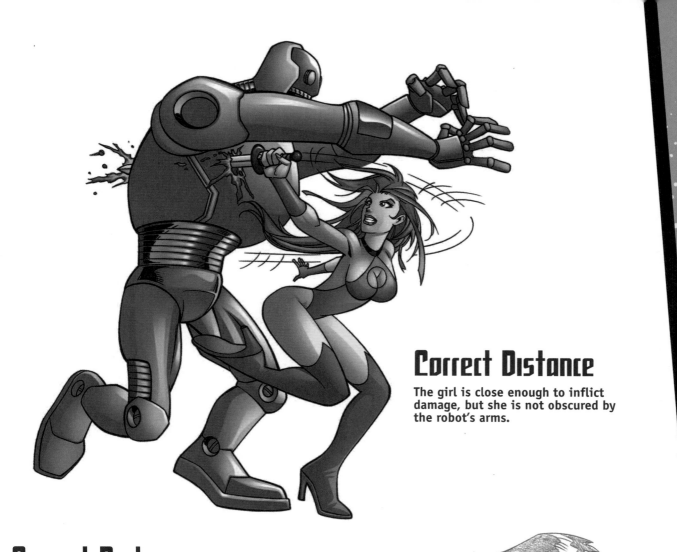

Correct Distance

The girl is close enough to inflict damage, but she is not obscured by the robot's arms.

Correct Distance

The gun is close enough to the opponent to make an impact. Too far, and it would lose its threat. Yes, the same principle that applies to fight scenes also applies to weapons: Do not touch the opponent with the tip of the gun.

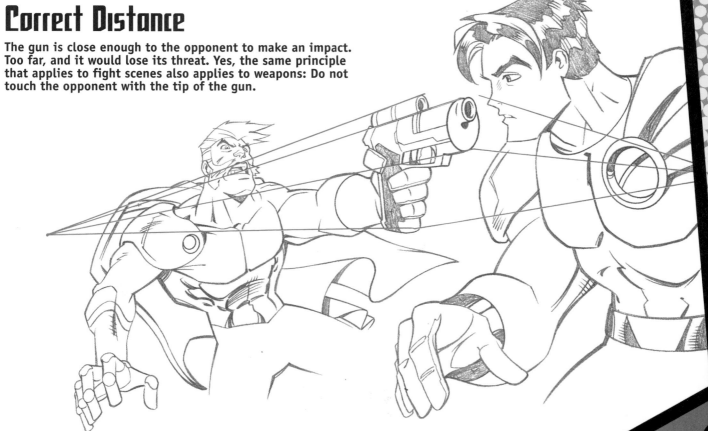

The Post-Impact Splatter

American comics have developed an important fight-scene detail that enhances combat scenes: the post-impact splatter. This element has carried over to the Fusion style, and while it sounds kind of gross, it's actually a very cool look that adds a professional touch to your work. All the top comic book artists use it. The idea is basically this: When the head of an opponent snaps back from a punch, sweat, blood, or spit will fly off him. It may seem like an unimportant detail, but it's not, I assure you. It really drives home the feeling of action. In animation this is known as *secondary action*. It's an action subsequent to the main action (in this case, the head snapping back) that emphasizes that first action; it's like a whiplash effect.

Blood Splatter from Mouth

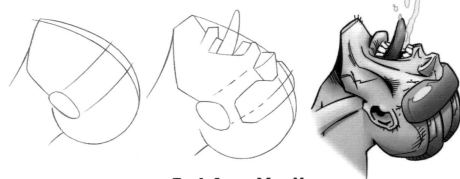

Spit from Mouth

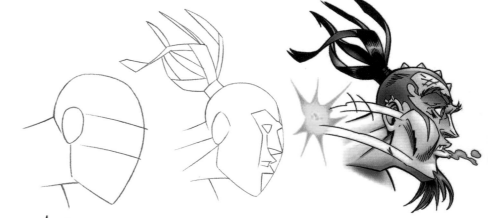

Goo from Mouth (usually green)

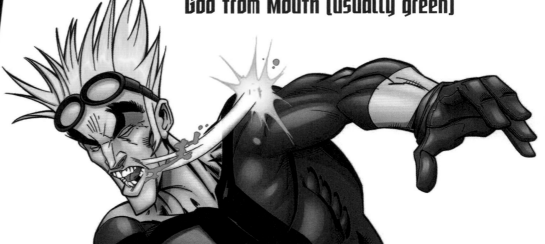

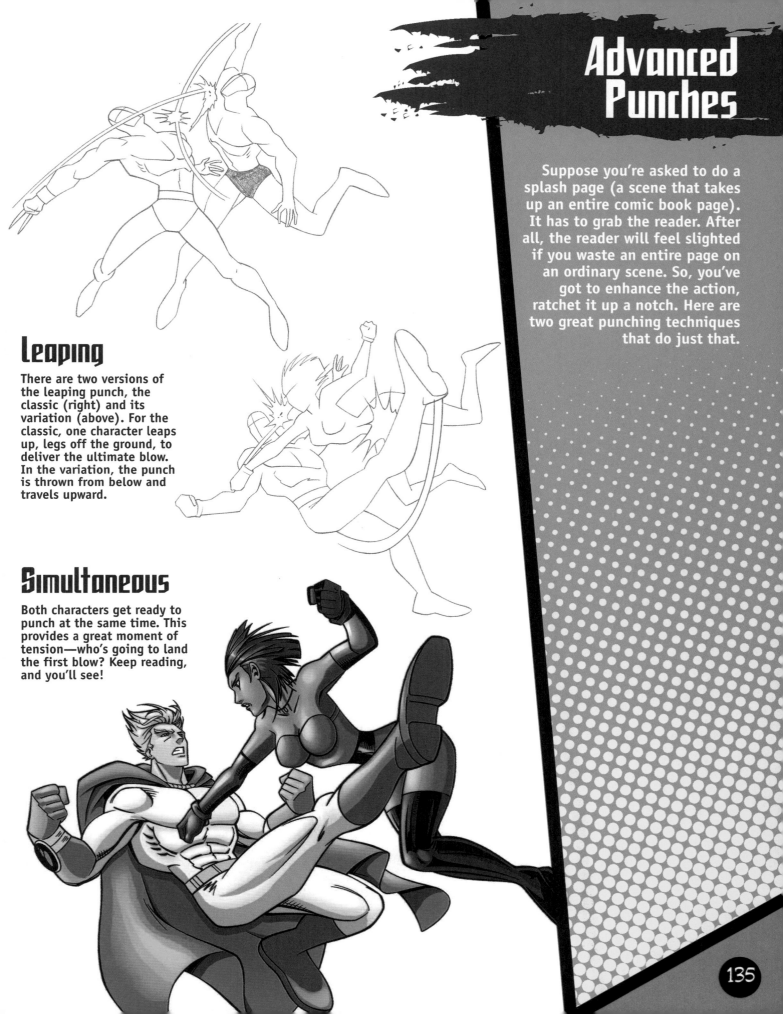

Advanced Punches

Suppose you're asked to do a splash page (a scene that takes up an entire comic book page). It has to grab the reader. After all, the reader will feel slighted if you waste an entire page on an ordinary scene. So, you've got to enhance the action, ratchet it up a notch. Here are two great punching techniques that do just that.

Leaping

There are two versions of the leaping punch, the classic (right) and its variation (above). For the classic, one character leaps up, legs off the ground, to deliver the ultimate blow. In the variation, the punch is thrown from below and travels upward.

Simultaneous

Both characters get ready to punch at the same time. This provides a great moment of tension—who's going to land the first blow? Keep reading, and you'll see!

Balance and Momentum

Nothing detracts from an image so much as a character mistakenly drawn slightly off balance. The basic concept for maintaining balance is that the body weight must be distributed evenly on either side of the point of equilibrium. The basic concept for showing momentum is that the faster a character moves, the further forward the body leans.

The Piont of Equilibrium

The point of equilibrium is the pit of the neck and is indicated by the dotted line running through the picture. The figure's mass must be evenly divided between the left and right sides of that point in order to maintain balance.

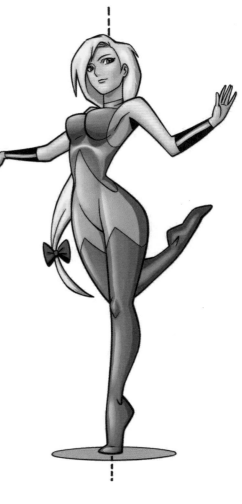

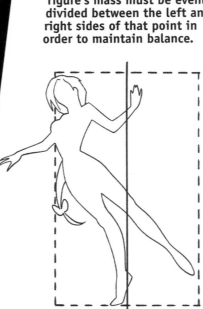

Off Balance

Since more of the character's mass falls to the left (our left) of the point of equilibrium, the figure is off balance.

Balanced

This pose, with its triangular guideline, provides a better example because the momentum of the pose travels down to a single point. If the figure were off balance in this pose, the character would clearly fall over.

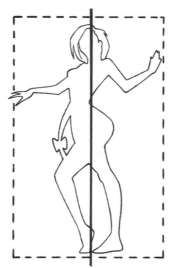

Balanced

Sketching shapes around the figure as a guide helps highlight whether or not a figure is correctly balanced. Here, the weight is evenly divided between left and right sides. However, this is a somewhat static pose, so the importance of balance may not be so evident.

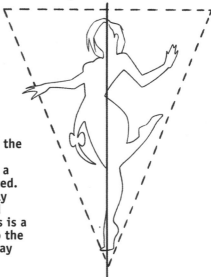

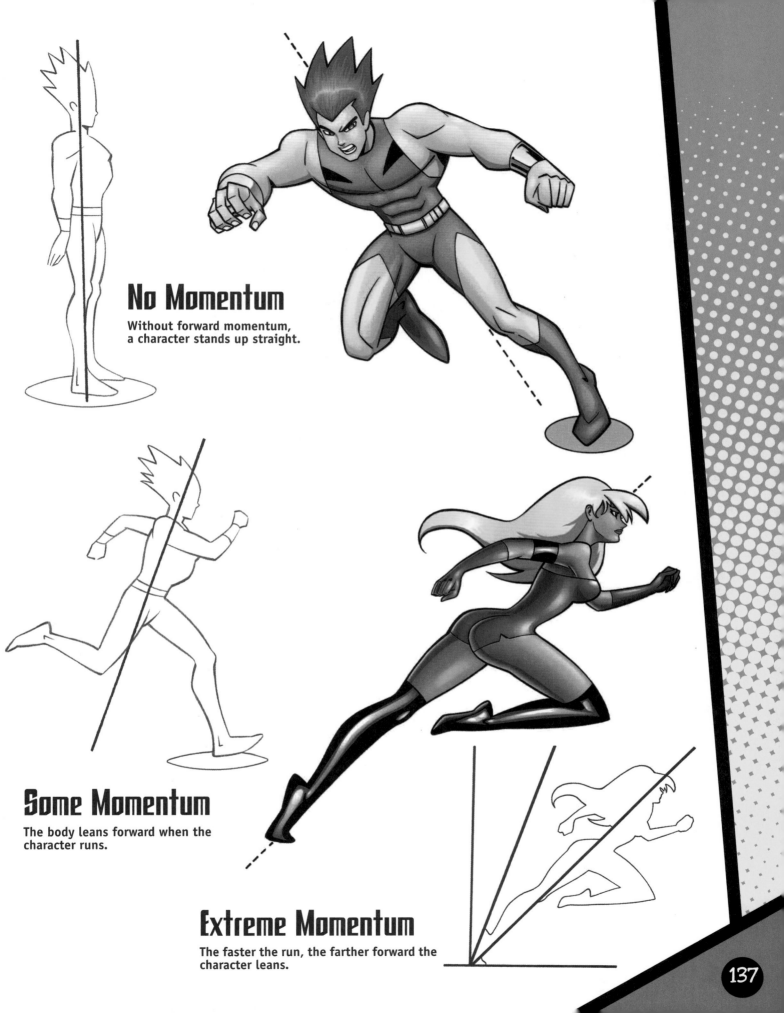

No Momentum

Without forward momentum, a character stands up straight.

Some Momentum

The body leans forward when the character runs.

Extreme Momentum

The faster the run, the farther forward the character leans.

Giant Robots

Mecha, a genre of manga that features amazing battles with giant robots, provides another kind of action in comics. These robots are controlled by pilots who sit in small cockpits inside of each robot. These robots are huge, armored fortresses that possess an array of powerful weapons.

The robots in true manga can be unbelievably complex. For that reason, many manga artists in Japan specialize exclusively in mecha design. The Cartoon Fusion style of manga uses lines that aren't ruler-straight but have a slight, pleasing curve to them, which makes them look cartoony. Since these figures are loaded up with gadgets, it's better to start with the basic foundation, so as not to get lost in the details. Begin with stick figures, just to get the placement right, and then quickly work up to a fleshed-out mannequin and, finally, the finished robot, with all the bells and whistles.

Robot with Jet Pack

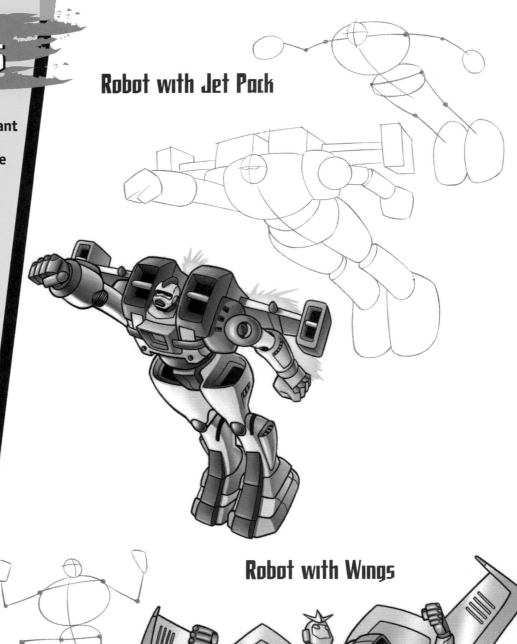

Robot with Wings

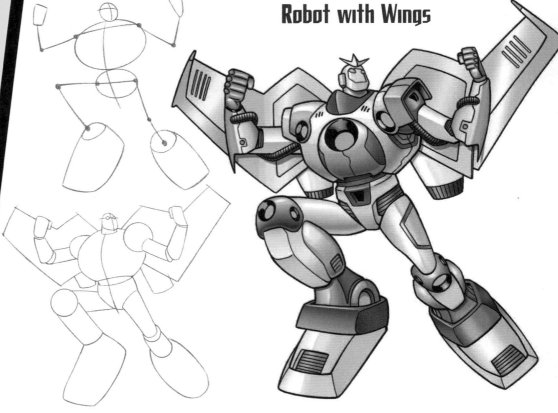

Bird of Prey Robot

Many robots are based on predatory animals. The most popular are eagles, dinosaurs, tigers, lions, snakes, and wolves.

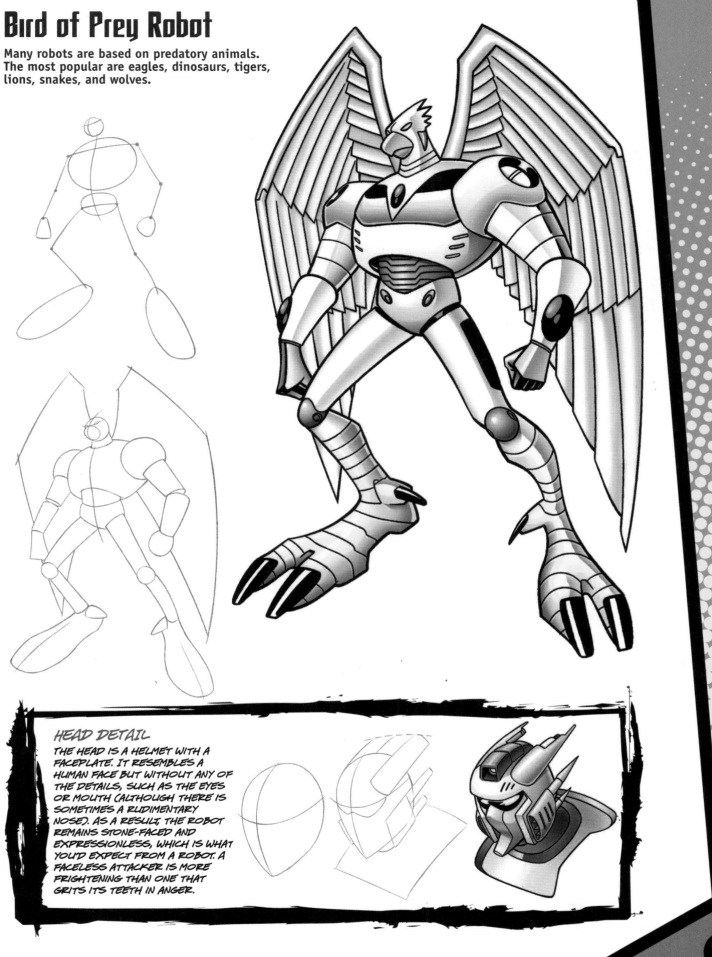

HEAD DETAIL

THE HEAD IS A HELMET WITH A FACEPLATE. IT RESEMBLES A HUMAN FACE BUT WITHOUT ANY OF THE DETAILS, SUCH AS THE EYES OR MOUTH (ALTHOUGH THERE IS SOMETIMES A RUDIMENTARY NOSE). AS A RESULT, THE ROBOT REMAINS STONE-FACED AND EXPRESSIONLESS, WHICH IS WHAT YOU'D EXPECT FROM A ROBOT. A FACELESS ATTACKER IS MORE FRIGHTENING THAN ONE THAT GRITS ITS TEETH IN ANGER.

There comes a point when every comic book artist feels the overwhelming impulse to draw a giant creature to terrify a city. I'm feeling it right now. So, without further delay, let's cause some carnage. Cartoon manga Fusion makes fantastic use of monsters—and this, again, adds action to your stories and drawings. But let's be honest, monsters are a little on the cheesy side, aren't they? Still, comic books and animation need them. The Cartoon style is perfect for this, because it gives them a little tongue-and-cheek look, which allows the monster to fit its scary role while at the same time winking at the audience. Pissed-off giant sea monsters are a popular type. They are the unintended consequences of hazardous waste being illegally dumped into the oceans. They are large—I don't mean large like an elephant, I mean large like a building. And, they're usually gigantic, big enough to floss with a submarine.

Aqua-Thing

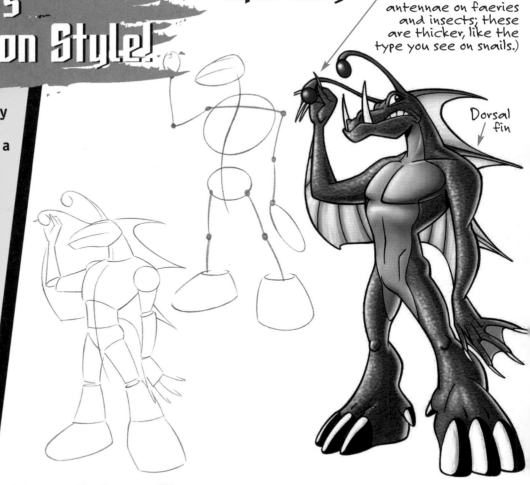

Antennae (These are different from antennae on faeries and insects; these are thicker, like the type you see on snails.)

Dorsal fin

Son of Aqua-Thing

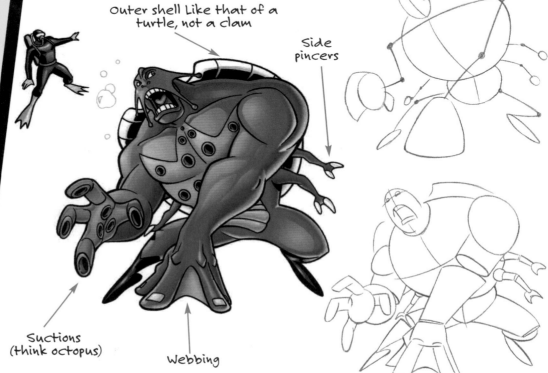

Outer shell Like that of a turtle, not a clam

Side pincers

Suctions (think octopus)

Webbing

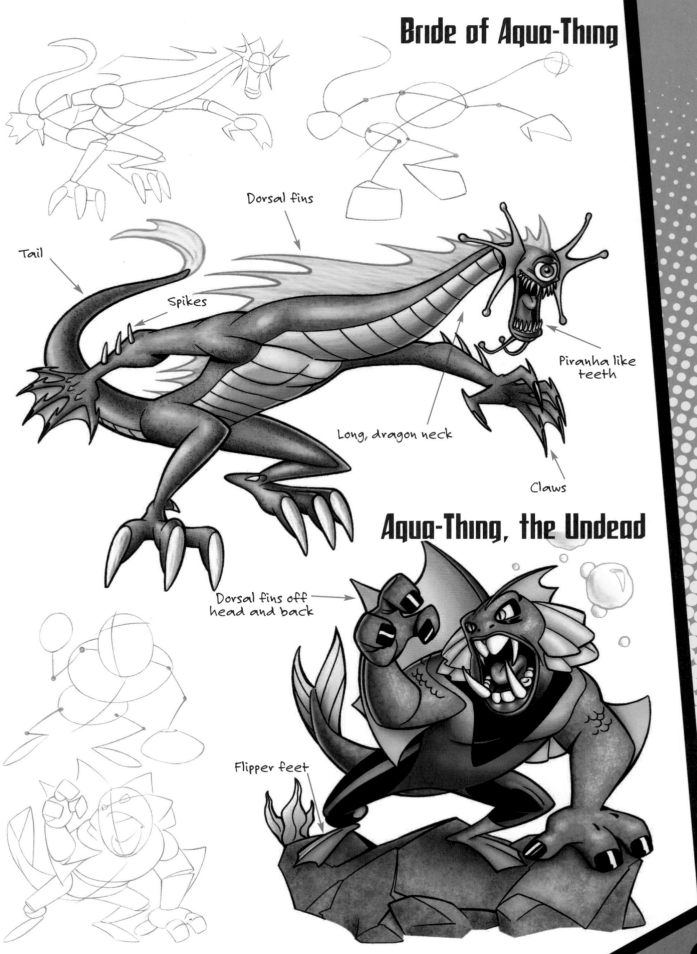

Bride of Aqua-Thing

Dorsal fins

Tail

Spikes

Piranha like teeth

Long, dragon neck

Claws

Aqua-Thing, the Undead

Dorsal fins off head and back

Flipper feet

Land Monsters

Land monsters are typically so big that they need a girdle to squeeze through the skyscrapers on a major avenue. There are two basic types: gorilla and dinosaur, although you can easily in vent more.

PUPILS FILLED IN—NOT SO SCARY; IN FACT, THIS MAKES THE MONSTER TOO CARTOONY.

PUPILS LEFT BLANK—MUCH MORE EFFECTIVE.

BIG CHEST, BIG WAIST—NOT SO SCARY.

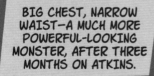

BIG CHEST, NARROW WAIST—A MUCH MORE POWERFUL-LOOKING MONSTER, AFTER THREE MONTHS ON ATKINS.

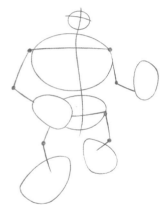

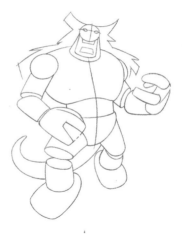

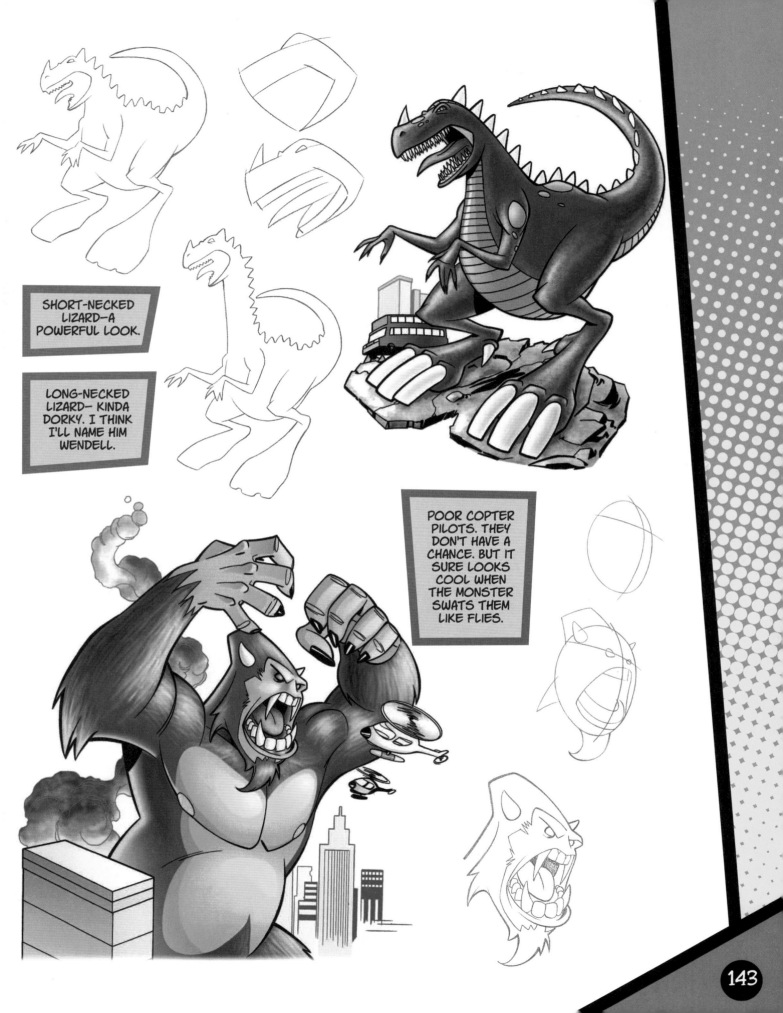

SHORT-NECKED LIZARD—A POWERFUL LOOK.

LONG-NECKED LIZARD— KINDA DORKY. I THINK I'LL NAME HIM WENDELL.

POOR COPTER PILOTS. THEY DON'T HAVE A CHANCE. BUT IT SURE LOOKS COOL WHEN THE MONSTER SWATS THEM LIKE FLIES.